Piero della Francesca

PIERO DELLA FRANCESCA

Tradition and Innovation in Renaissance Art

BRUCE COLE

IconEditions
An Imprint of HarperCollins*Publishers*

For Enzo Carli

FIRST EDITION

Designed by Abigail Sturges

Library of Congress Cataloging-in-Publication Data

Cole, Bruce, 1938–
 Piero della Francesca : tradition and innovation / Bruce Cole.—1st ed.
 p. cm.
 Includes bibliographical references and index.
 ISBN 0-06-430906-1 / ISBN 0-06-430204-0 (pbk.)
 1. Piero della Francesca, 1416?–1492—Criticism and
 interpretation. I. Title.
 ND623.P548C65 1991 90-55529
 759.5—dc20

91 92 93 94 95 DT/CW 10 9 8 7 6 5 4 3 2 1
91 92 93 94 95 DT/CW 10 9 8 7 6 5 4 3 2 1 (pbk.)

CONTENTS

LIST OF ILLUSTRATIONS

Color plates follow page 82.

ACKNOWLEDGMENTS

Piero's altarpieces, frescoes, and portraits are rooted in Italian towns, churches, and landscapes. To have, over the last quarter of a century, visited these peaceful, enchanting places still filled with Piero's presence has been life-enhancing.

Over the years I have profited from discussions with friends about Piero and his work. I am especially grateful to James Czarnecki, Sophia Wallace, Charles Mitchell, Gus Medicus, Barbara Bays, Marilyn Bradshaw, Andrew Ladis, Katy Smith, Katey Brown, Paul Barolsky, Carol Lowengrub, Peter and Julia Bondanella, Barry and Heidi Gealt, and Carey Hendron, and to Morton Lowengrub, whose office at Indiana University provided welcome financial assistance. The Samuel H. Kress Foundation helped make this book possible; I am beholden to Marilyn Perry, the Foundation's President, and to Lisa M. Ackerman, its Chief Administrative Officer. Cass Canfield, Jr., my editor at HarperCollins, gave encouragement and valuable editorial advice; my debt to him is again considerable. Doreen, Stephanie, and Ryan put up with it all with their usual understanding and patience.

B.C.

INTRODUCTION

Many signatures fill the thumb-worn pages of the visitors' register set on the entrance desk of Sansepolcro's small museum. One puzzles out names and addresses: Auckland, Stockholm, Prague, Hong Kong, Iowa City, and many other far-flung locations. All these people of widely varying religious, philosophical, and political beliefs have come to this small provincial town set deep in the Tuscan countryside for a single, unifying reason: to stand before an icon of the history of art, a small fresco of great fame, Piero della Francesca's *Resurrection of Christ* [48].

But these visitors and, indeed, the museum itself are of a recent vintage; a hundred years ago the fresco and its creator were still obscured by neglect. For centuries, Piero remained little more than a hometown curiosity, a local artist of a dim past who merited just a few pages in a famous book on artists by Giorgio Vasari, a native of nearby Arezzo.

The rise of Piero della Francesca's fame is in itself an interesting episode in the history of art. First rediscovered in the second half of the nineteenth century, his works soon entered the mainstream of European art history. Artists of the time saw in Piero's work values and ideals that they were at that moment struggling to achieve. With the triumph of a new formalism in Western art, his paintings soon rose from their centuries-long neglect to a place of international prominence. Piero's influence on artists working in all mediums has continually increased, until today the ubiquitous postcard of his Sansepolcro *Resurrection* has become a sort of miniature shrine reverently tacked on the walls of studios all over the world.

But it is not only painters and sculptors who have fallen under the spell of Piero. He has become one of the few Italian artists working before Michelangelo who is not only known but also admired on a large scale by the general public, as the visitors' book at Sansepolcro attests.

The artists' newfound interest in Piero carried the critics and art historians in its wake, but the majority of critical work on him has been concerned with individual paintings rather than with a synthetic view of

his work. The greater part of the scholarship has been devoted to the problems of attribution and dating, especially the latter. The more important, and interesting, questions of origins, influence, and meaning have, unfortunately, often been neglected.

This book is an introduction to Piero's art. In it I attempt to define concisely what is unique and lasting about his mind and hand. Thus, I have avoided, whenever possible, the smaller questions of dating (most of them insoluble and not in themselves enlightening), which have often obscured the search for the essential Piero.

Instead, in the following pages I try to give the nonspecialist a sense of the nature of Piero's painting within the artistic world from which it arose. My aim was to determine where Piero's art originated, to investigate the structure of its linked form and content, to describe what its influence was, and to ponder its meaning. I have also, through Piero's painting, attempted to investigate an important, but often overlooked, aspect of Renaissance art: the role of tradition and innovation. A survey of Piero's work will demonstrate how, while basing his art firmly on time-honored traditions, principles, and types, he was able to create a highly original style and interpretation. This ability to be innovative within the framework of tradition is foreign to twentieth-century concepts of art, but it was an integral part of the making of art in the Renaissance. It was my objective to make this surpassing artist more understandable; to see him as someone firmly embedded in his own era and, equally important, as a painter whose visions, universal in meaning, still have the power to move us profoundly half a millennium after their creation.

Piero della Francesca

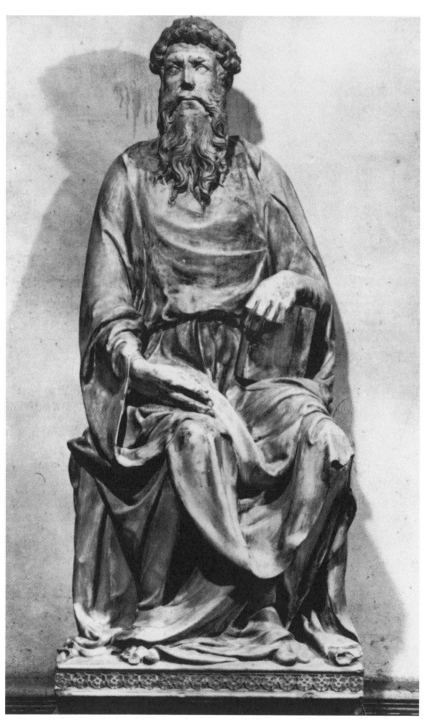

1. Donatello, *Saint John the Evangelist,* Museo dell'Opera del Duomo, Florence

I

ORIGINS AND INFLUENCES

I n September of 1439 Piero della Francesca was in Florence working
for the painter Domenico Veneziano; the two artists were engaged
on the now lost frescoes for the church of Sant'Egidio.[1] The young
Piero, probably just out of his teens, must have wandered Florence
impressed by its size and bustle, so different from the small, provincial
Borgo San Sepolcro (present-day Sansepolcro), his birthplace some fifty
miles southeast of Florence.

The Florence of the late 1430s was an exciting place for a fledgling
artist. A European power with business and banking ties to much of the
known world, the city was prospering. The men who ran the great guilds
and constituted the oligarchic leadership of the city had begun to em-
bellish it with a remarkable art and architecture, which they commis-
sioned out of personal and civil pride.[2]

In the Piazza Santissima Annunziata stood the new Foundlings Hos-
pital (Ospedale degli Innocenti), designed by Filippo Brunelleschi. In
the regularity and harmony of its form the hospital was a new vision of
clarity and order [2]. The overall serenity and the balanced relation of
the various parts of the Foundlings Hospital must have impressed the
youthful Piero, whose formal ideals were to become so compatible with
Brunelleschi's. Other buildings by the architect and his followers rein-
forced the first, indelible impressions made by the famous hospital.[3]

Older Florentine structures were also the focus of much attention
during the first decades of the fifteenth century. The massive crossing of
Florence's Cathedral, or the Duomo, clearly visible from the piazza of
the Foundlings Hospital, was being slowly spanned by Brunelleschi's
huge dome, a structure as noteworthy for its engineering as for its size.
The decoration of the still unfinished facade of the Duomo included
four statues of the Evangelists, each by a renowned Florentine sculptor.
Among them was the young Donatello, who had already completed his
Saint John the Evangelist [1] by the time Piero arrived in the city.

Across from the Cathedral, the ancient Baptistery had been decorated
with a new set of bronze doors, erected in 1424. Designed by the noted

sculptor Lorenzo Ghiberti, they were the most famous examples of contemporary art in Florence and certainly the most prestigious and costly. It is possible that Piero visited Ghiberti's large workshop, where he would have seen panels [3] being made for the sculptor's second set of doors, which were commissioned in 1424 and were well under way by the time of the young artist's stay in Florence in 1439.

Just a short way from the Cathedral and Baptistery, the old oratory church of Orsanmichele had recently become the showplace of the latest developments in Florentine sculpture. Each of the major guilds had been given a space on the outside walls of the church and had been requested to fill it with a statue [4]. The resulting works by Nanni di Banco, Ghiberti, and Donatello, among others, make the outside of the church an important monument of Western sculpture. Piero must have long studied these sculptures, each of singular importance for the development of Renaissance art.

Across the Arno River from Orsanmichele stands Santa Maria del Carmine, an ancient church in what was in his day a poor neighborhood of Florence. Here Piero would have seen the frescoes of a then-neglected genius, Masaccio [5]. These paintings, like the sculpture of Ghiberti and Donatello and the paintings of Domenico Veneziano, were destined to have a lifelong effect on Piero and to become a part of the foundation of his art. As he contemplated the many contemporary paintings and sculptures, Piero would have been aware of two major types of religious imagery, exemplified by Lorenzo Ghiberti and by Masaccio and Donatello.

2. Brunelleschi, Ospedale degli Innocenti, Florence

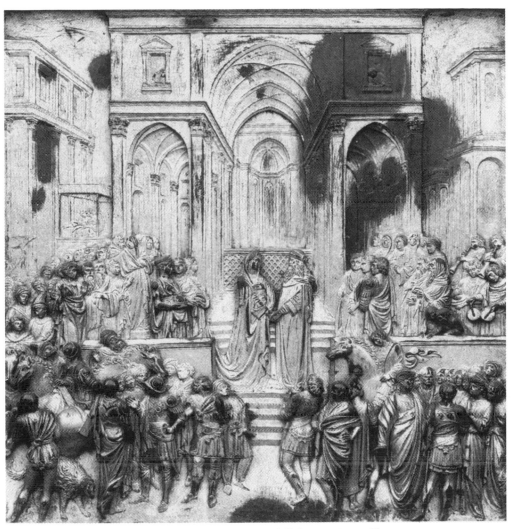

3. Lorenzo Ghiberti, *Meeting of Solomon and Sheba,* Baptistery, Florence

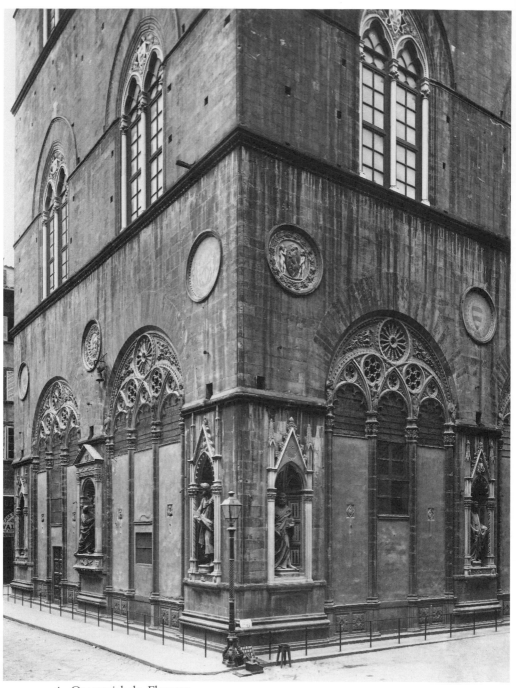

4. Orsanmichele, Florence

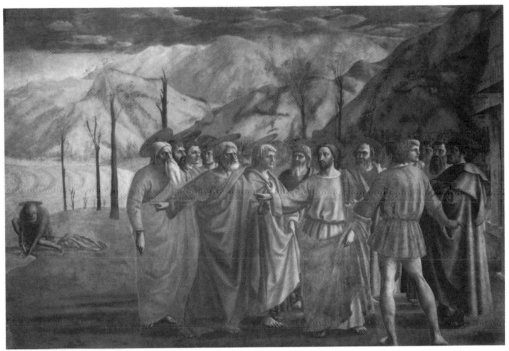

5. Masaccio, *Tribute Money* (detail), Santa Maria del Carmine, Florence

Ghiberti was a famous and fashionable artist of the early fifteenth century.[4] Entrusted with the commission for the large doors of Florence's Baptistery, he headed a workshop through which passed several notable artists. The quatrefoils of his first bronze doors are sophisticated and beautiful works by a virtuoso designer; in a way, they are the visual metaphors for Ghiberti's easy success. In the *Transfiguration* [6], for example, every element of the composition makes an elegant response to the shape of the quatrefoil. The quatrefoil's lobes are either echoed or gently contradicted by the graceful figures wrapped in flowing robes of heavy material. The flow of the lower figures, whose shapes sweep across the bottom of the bronze, is especially noteworthy.

Ghiberti understood the nature of his commission; he fully realized that his quatrefoils had to echo the function of the doors, not to contradict it. He refrained from making real or fictive space that would create a sense of deep recession. Such recession would make the door look less massively solid than it really was and thus partially negate its purpose. Instead, his space is held tightly in check, and his figures and the fields that contain them seem applied to the impenetrable bronze. This mas-

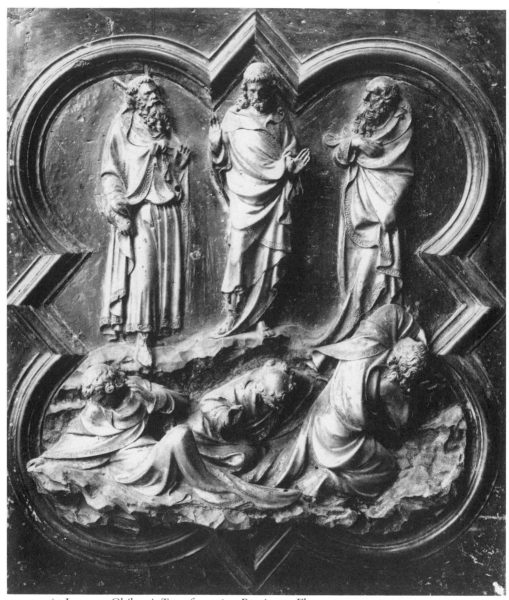

6. Lorenzo Ghiberti, *Transfiguration*, Baptistery, Florence

terful manipulation of form and space, even if it was not completely to Piero's taste, would have been highly instructive to the young artist.

Ghiberti's second doors were radically different from the first. Begun in 1425, they were equally massive and costly, but of a different design. In them, Ghiberti abandoned the simplicity and order of the earlier doors: the quatrefoil was replaced by a square field; the relation between figure and architecture was made more realistic; and the narrative became much more crowded with figures and buildings.

In *Meeting of Solomon and Sheba* (designed by 1437), Ghiberti presents the viewer with an excess of form [3]. Especially intriguing is the layering of space from the foreground, back through the area where the king and queen stand, into the depth of the templelike structure in the distance. This spatial-architectural organization and the overall symmetrical arrangement of the composition seem to have remained in Piero's mind when, years later, he painted his own version of the subject [56].

While in Florence in 1439, Piero also came into contact with the works of Donatello.[5] Although often diametrically opposed to Ghiberti in his formal and interpretative outlook, Donatello received, nevertheless, a number of important public and private commissions. That two artists with such divergent ideas both received extensive patronage by the same groups of citizens demonstrates the variety of style and interpretation possible in early Renaissance Florence.

On Orsanmichele, Piero saw one of Donatello's most renowned works, the marble *Saint George* made for the armorer's guild [7]. Like all of Donatello's early sculpture, the *Saint George* is strikingly heroic, but what must have impressed the Florentines and the young Piero alike was the vivacity of Donatello's statues and reliefs. Donatello's ability to breathe such convincing life and action into stone and bronze was unprecedented.

Donatello was a sculptor's sculptor. His ability to manipulate mass and void, the building blocks of sculpture, has seldom been equaled. The stable, alert pose of the *Saint George* and its masterful formal balance between abstraction and realism were studied by Piero, who learned much about the principles of form in space from the *Saint George* and Donatello's other freestanding works.

Piero absorbed also the spirit of these early sculptures by Donatello. In each there is a direct, vigorous, and often heroic sentiment. As in the paintings of his younger contemporary Masaccio, Donatello depicts sober, purposeful heroes who are a race apart from their mortal observers. These qualities are perhaps seen most clearly in Donatello's *Saint Mark* (c. 1412), made for the niche of the linen drapers' guild on Orsanmichele [8]. Certainly Piero must have been affected by this grave figure, whose sober presence and powerful body were unheralded in Florentine sculpture.

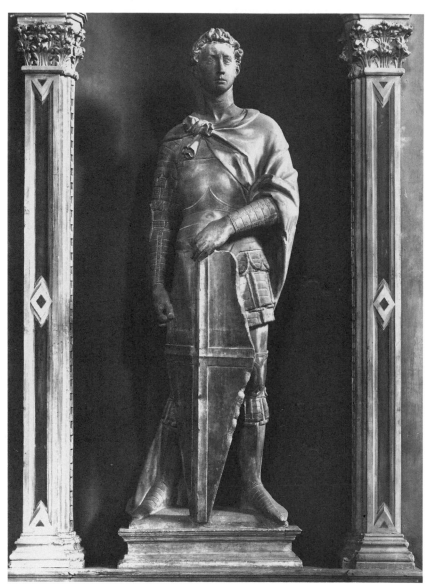

7. Donatello, *Saint George,* Bargello, Florence

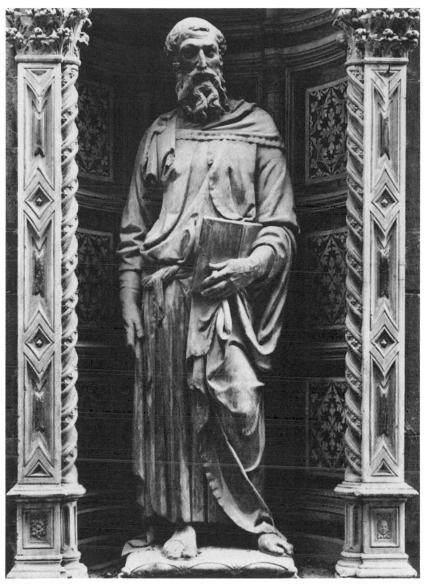

8. Donatello, *Saint Mark*, Orsanmichele, Florence

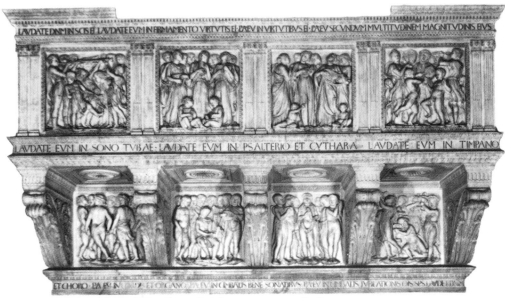

9. Luca della Robbia, *Cantoria* (plaster reconstruction),
Museo dell'Opera del Duomo, Florence

One other sculptural work in place by 1439 must have impressed
Piero while he was in Florence that year: Luca della Robbia's *Cantoria,*
or singing gallery, in the Duomo.[6] Illustrating Psalm 150, it is decorated
with carved marble panels, each [9] devoted to music-making figures.
Luca's compositions were influenced by Donatello and Ghiberti, who
taught him much about how to construct figures and groups of figures
and then set them in shallow relief space. But in the *Cantoria* there is a
fluid linking of bodies and intervals and a rhythm of extreme grace and
charm that are Luca's own. The measured beat of his figural groups,
now vivace, now allegro, now andante, was not surpassed by any other
Florentine sculptor of the time. The movement of volumetric figures
into and across the limited depth of the *Cantoria*'s carved space long
remained in Piero's mind. When faced with similar problems of figure
arrangement, he must have thought back to the solutions he had first
encountered in Luca's work.

Piero would also have carefully studied the work of older artists.
Certainly, he would have known some of the paintings by the fabled
Giotto, the revolutionary Florentine artist who had died a century be-
fore Piero's 1439 visit.[7] Giotto's major work was in the Arena Chapel in
Padua, far from Florence, but Piero could have seen important painted
chapels by Giotto in Florence, in the church of Santa Croce. Giotto's
frescoes there were copied and studied by many Florentine artists.

In Santa Croce, in the Bardi and Peruzzi chapels, Piero would have learned the brilliant organizational principles that allowed Giotto to construct dramatic scenes built around the hub of the story. Giotto created a figural, spatial, and narrative content of utmost importance. His innovative approach was appreciated immediately, and in his own lifetime he was hailed as the founder of Florentine painting.

What Piero probably most admired about Giotto's work was its clarity of construction. When, for instance, he studied the *Death of Saint Francis and the Verification of the Stigmata* [10] in the Bardi Chapel, he would have realized at once how skillfully Giotto had woven every figure and action around the recumbent Saint Francis. By paring down the narrative to its essential dramatic core, Giotto was able to engage the spectator in a new, highly personal way.

Giotto's work also offered nearly perfect solutions to many of the pictorial problems that Piero must have been pondering. From Giotto, Piero and generations of artists afterward learned how to construct figures, architecture, and space, and then to thread them together into convincing dramatic units.

Although many of Giotto's immediate followers elaborated on various

10. Giotto, *Death of Saint Francis and the Verification of the Stigmata,* Santa Croce, Florence

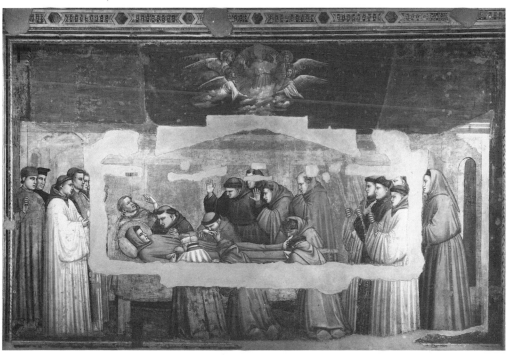

elements of his painting, no one, except his remarkable pupil Maso di Banco, really was able to comprehend the totality of his art. Florentine painting for the remainder of the fourteenth century became increasingly diffuse and anecdotal; the echoes of the concentrated drama and formal rigor of Giotto's work became ever fainter.

In the late 1420s, however, there appeared in Florence a young painter from the provincial town of San Giovanni Valdarno who, with the help of Donatello's sculpture, both revived many of Giotto's goals and brought his own style to early fruition[8] Masaccio lived only twenty-eight years and left just one partially completed fresco cycle and a handful of panel paintings, but his influence on later artists was decisive. The largest and most accessible of his works are in the Brancacci Chapel in the church of Santa Maria del Carmine in Florence. Painted toward the end of the 1420s, these frescoes [64] of the legend of Saint Peter were unlike anything else in Florence.

Using a massive figure style much indebted to Donatello, Masaccio was able to bring religious drama into the spectator's world. In his frescoes forms arise solely through the alternation of light and shadow and not from the traditional bounding lines of his Florentine contemporaries. In his paintings light gives form substance and being, as it does in the natural world. The objects in the Brancacci frescoes seem to exist in a palpable atmosphere, the same atmosphere of light and air surrounding those standing in the chapel. Moreover, the spatial construction of Masaccio's frescoes sets the spectator at the very center of the drama. Drama exists, in other words, from the onlooker's vantage point and revolves around him.

The perfection of the one-point perspective system; the birth of town planning on a rational, human-centered basis; and the new interest in the individual and his history are all indicative of the early fifteenth-century's desire to make the world more explicable and controllable. Masaccio's frescoes with their realistic spatial construction, light, and volume are really another facet of this same aspiration: to make both the material world and the spiritual world more concrete and graspable, and more closely tied to the individual.

The protagonists of Masaccio's frescoes are, like Donatello's saints, models of moral probity. By their sheer weight and volume they are rooted to the earth; they are the most serious and deliberate of men. There is also something elemental and sacred about the actors and the space they inhabit; all accidents of nature and all anecdotal detail were suppressed as Masaccio strove to present the dramatic essence of the story, much the same way Giotto had done a century before.

The monumental figures of the Brancacci Chapel were to leave an indelible impression on Piero. In fact, they were soon to constitute much of the basic formal and emotional foundation of his own sacred protag-

onists. Memories of Masaccio's Brancacci figures probably often min-gled with thoughts of Donatello's heroes in the mind of the maturing Piero.

In 1439, Piero must also have looked with considerable interest at the elegant, dreamlike frescoes and altarpieces of other Florentine painters who were then working daily on these pictures. One of the more inter-esting places to see paintings was the small church of Santa Trinita near the Arno. Here Piero could have studied a recently completed chapel with frescoes and an altarpiece [11] by Lorenzo Monaco, perhaps the most sought-after painter in the city.[9] A few steps from Monaco's paint-ings is the large sacristy, which then held two new and noteworthy altarpieces: one by Gentile da Fabriano, a painter from the Marches in central Italy, and another by the Dominican Fra Angelico. Though very different in style and meaning, the splendor, elegance, and color of both of these major paintings would have impressed Piero.[10]

But the contemporary painter who most influenced Piero was his colleague Domenico Veneziano, with whom he worked on the frescoes for Sant'Egidio in 1439.[11] The exact professional relation between the two men is unclear. A document of 1439 tells us only that Piero was assisting Domenico. Hence, we do not know if Domenico was Piero's master or if Piero was simply an assistant hired on an ad hoc basis. Recently discovered documentation reveals that Piero had already worked with one Antonio d'Anghiari, a minor painter in Sansepolcro, but this does not exclude the possibility that Piero was in Florence for further training.[12] Little is known of Domenico's own training or origins, but by the time Piero was with him, he had already developed a strong personal style, best seen in his Saint Lucy altarpiece, now in the Uffizi Gallery [12].[13] Probably finished about 1430, the work reveals Domeni-co's study of both Masaccio and Donatello—the latter's influence is especially clear in the Saint Zanobius figure, based on Donatello's bronze statue of Saint Louis of Toulouse, which was then on Orsanmi-chele.[14] Moreover, Domenico's picture is articulated by a very up-to-date loggia, certainly much indebted to Brunelleschi. The entire picture has about it that clear, crisp formal logic shared by the early Donatello, Masaccio, and Brunelleschi.

But above all, it must have been the radiant silence of Domenico's altarpiece that most intrigued Piero. Throughout the painting the im-mobile figures are touched and given existence by light; this remarkable luminosity floods the entire altarpiece, making it glow brilliantly. Purer, more diffuse, and steadier than natural illumination, this light seems a divine emanation conferring stillness and grace to this delicately bal-anced composition. Figures, architecture, and color seem elevated to a more immaculate realm.

The years around the completion of the Saint Lucy altarpiece also saw

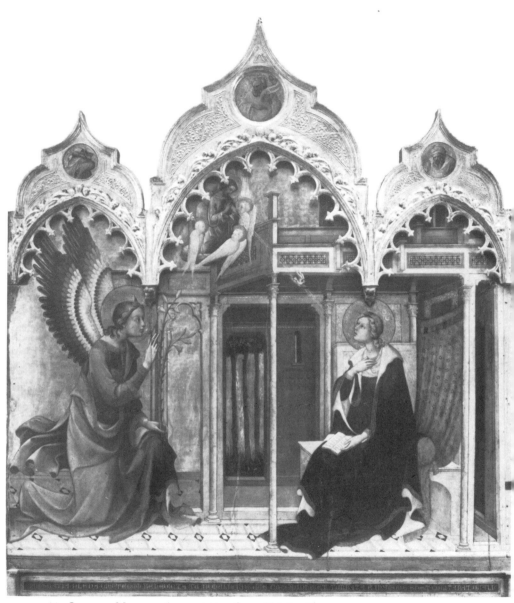

11. Lorenzo Monaco, *Annunciation,* Santa Trinita, Florence

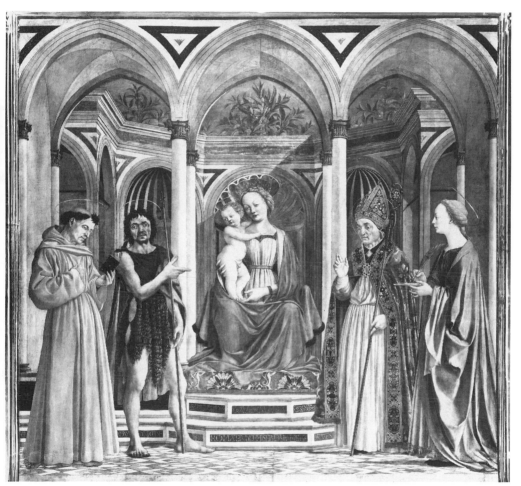

12. Domenico Veneziano, Saint Lucy altarpiece, Uffizi Gallery, Florence

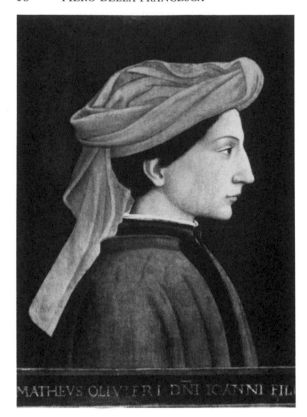

MATHEVS OLIVIERI DÑI IOANNI FIL

13. Domenico Veneziano, *Matteo Olivieri,* National Gallery, Washington, D.C.

the beginnings of Florentine portraiture. One of these early portraits, that of Matteo Olivieri [13], has been attributed to Domenico Veneziano, and it, or another similar portrait by Domenico, must have been studied closely by Piero.

Works by his own hand reveal that Piero admired Domenico's ability to abstract and stylize the structure of the human face. The earliest Florentine portraits are profiles. They present the sitter in his or her least revealing pose; direct eye contact is avoided, and the gaze is always away from the onlooker. Instead of gaining insight into the sitter's mind and mood—the object of modern portraiture—one sees only a highly formalized, impersonal profile. In Domenico's portrait, the shape made by the forehead, nose, and chin is nearly as abstracted as those made by the turban and the clothes. Pattern, line, and the crucial relation between mass and void are the dominating elements of the *Matteo Olivieri* and of many other portraits by Domenico Veneziano and his Florentine contemporaries.

One of these, Paolo Uccello, may also have influenced Piero.[15] Like Domenico Veneziano, Uccello owed much to Masaccio's concept of monumental form placed in a definable atmosphere and space. Uccello's work, however, is filled with a delight in shape, pattern, and fantasy not seen in Masaccio's art. Uccello's paintings are difficult to date, and exactly when Piero may have seen work by him is unclear. He may have known some of Uccello's finest frescoes, in the Chiostro Verde of Santa Maria Novella, and he certainly saw the fresco *Sir John Hawkwood,* painted by Uccello in the Cathedral in 1436 [14]. This fresco depicts the English soldier of fortune Sir John Hawkwood, whom the Florentines wished to commemorate, with this larger-than-life image, for his service to their city.

Piero was probably fascinated by the way Uccello was able to abstract the various physical features of horse and rider into an interlocking series of arches, angles, curves, and circles. The fantastical quality of the *Hawkwood,* created by the large decorative shape and pattern, is typical of Uccello's eccentric, playful nature. The perspectival construction of the base, which supports horse and rider, is complex and skillful. Uccello depicted this base as seen from below and receding toward the background, thereby making it and the equestrian group loom above the onlooker. Such logical picture-making was new in Florence, and it must have been noted by Piero during his stay in 1439.

Uccello was taken with perspective, not for the realistic effects it could provide, but for the sense of fantasy and unreality it allowed him to introduce into his paintings. Nowhere is this better seen than in the Uffizi *Rout of San Romano* [15], of c. 1450, one of three battle pictures Uccello executed for the Medici. This depiction of a historic battle has been removed from the realm of bloody reality by the high style of its space, its riders, and their mounts. Like the face of Matteo Olivieri, the forms have become so abstracted and reduced that we see them as shape and note their carefully planned interrelation rather than read the picture as a convincing narrative. Uccello's painting is not about human conflict; instead it has been made into a fantastic costume ballet in an outdoor setting. The *Rout of San Romano* was destined to decorate a room in a home. There, it and its two companion pieces provided a remarkable display of color, shape, and line. It was the tapestrylike appearance of Uccello's painting, achieved through formal reduction, that must have impressed the young Piero.

In the late 1430s and early 1440s, about the time he worked with Domenico Veneziano, Piero must often have compared the art he saw in Florence to that of his native city of Sansepolcro.[16] Sansepolcro was, and remains, a provincial place mainly dependent on agricultural production for its existence. Too small and isolated to develop its own culture and style of art, it was heavily influenced by the major urban

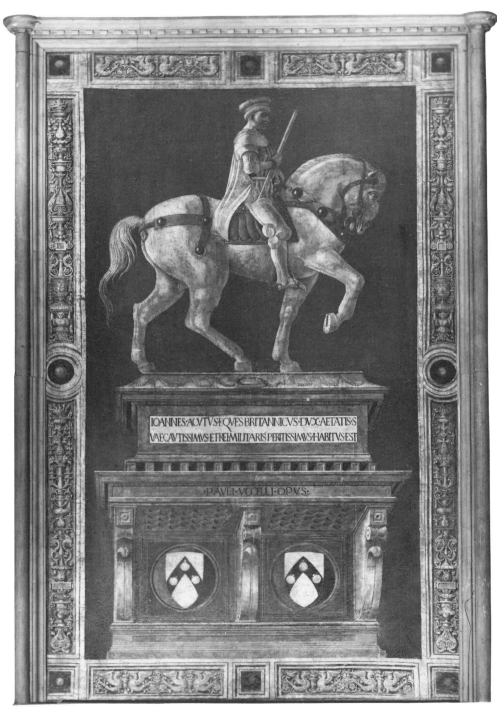

IOANNES ACVTVS EQVES BRITANNICVS DVX AETATIS S
VAE CAVTISSIMVS ET REI MILITARIS PERITISSIMVS HABITVS EST

PAVLI VCCELLI OPVS

14. Paolo Uccello, *Sir John Hawkwood,* Cathedral, Florence

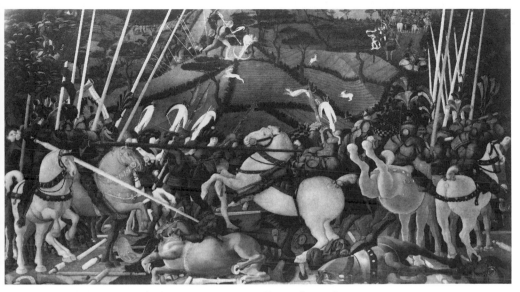

15. Paolo Uccello, *Rout of San Romano,* Uffizi Gallery, Florence

centers of Tuscany. The nearest important city was Arezzo, itself buffeted by waves of successive stylistic influence emanating from Florence and Siena, the great powers of the area.

Little is left in Sansepolcro from the period before Piero's time, but what remains demonstrates that the city employed Sienese artists for some of its most important commissions.[17] One of the few surviving large-scale altarpieces, in the Cathedral, is the *Resurrection* [16], painted by a talented follower of Pietro Lorenzetti, a major Sienese artist of the first half of the fourteenth century. This altarpiece, with its looming Christ and stern saints, which Piero must have known from his earliest childhood, was to influence his own *Resurrection* [48], painted for the town hall (now the Pinacoteca) which was right across the street.

Another Sienese work of considerable importance for Sansepolcro was the large, double-faced Saint Francis altarpiece painted for the church of San Francesco. This painting was commissioned from Antonio d'Anghiari, a local painter with whom Piero's name appears, for the first time, in a document of 1436.[18] For some unknown reason the Saint Francis commission was never executed by Antonio and was instead awarded to Sassetta, a remarkable Sienese painter who installed the altarpiece in 1444, just one year before Piero's first known commission in Sansepolcro.[19] Such a large and distinguished work by a talented and well-known artist was certainly the object of Piero's careful scrutiny.

16. Follower of Pietro Lorenzetti, *Resurrection,* Cathedral, Sansepolcro

Sassetta's altarpiece, while a highly personal painting, is also very much within the Sienese tradition—a tradition that Piero knew well from other Sienese paintings and sculptures he saw in Sansepolcro and, most likely, in Siena itself. Very imaginative and dreamlike, the narratives of Sassetta's Sansepolcro altarpiece exhibit the visionary, lyrical qualities common to Sienese painting of the fifteenth century. Sienese art differs from the more straightforward, realist tradition of Florentine painting that Piero encountered while working with Domenico Veneziano. With few exceptions, Sienese artists wished to avoid the measurable, finite world of many of the Florentines influenced by Masaccio. Instead, the Sienese painters placed their images and religious drama in an ethereal fantasyland with ambiguous space, exquisite form, and subtle, varied color. There is much emotional tension and religious fervor in Sienese painting, but it unfolds in a world distanced from the mundane existence of the onlooker.[20]

17. Sassetta, *Mystic Marriage of Saint Francis with Poverty*, Musée Condé, Chantilly

In the *Mystic Marriage of Saint Francis with Poverty* [17] or in any of the other panels from the Sansepolcro altarpiece, we can see how sensitive Sassetta was to the use of form and color for decorative effects. Sienese artists excelled both in the invention of colors and in the banding of these colors in fields across the surface of their paintings. Overall decorative pattern, achieved through the use of color, form, and, in Sassetta's case, an elegant and sprightly bounding line, was a salient characteristic of Sienese painting throughout its entire history.

Like Piero himself, Sienese painters had observed the developments in Florentine painting of the early decades of the fifteenth century with considerable interest. They borrowed from the Florentines, but they made substantial modifications of what they took; for example, conventions—such as one-point perspective—used by many Florentines for increased realism were utilized by the Sienese for the creation of a heightened sense of fantasy and unreality. In Sassetta's altarpiece and other works by his Sienese contemporaries, Piero would have seen how form and color were used both to create narrative and to serve as abstract patterns of light and color; he would also have observed how sacred drama could be set in a realm of sophisticated and elegant fantasy.

In 1445, a year after Sassetta's altarpiece was placed in the church of San Francesco, Piero was given a contract to paint one of his first major commissions, the altarpiece of the Misericordia. This painting is probably Piero's earliest surviving work, and as such it assumes particular importance for what it reveals about his artistic origins, education, and the fundamentals of his art. The Misericordia altarpiece stands at the end of Piero's beginnings, at the outset of what was to be a career marked by a series of remarkable works.

NOTES

1. Piero in Sant'Egidio: The most complete collection of documents pertaining to Piero is found in E. Battisti, *Piero della Francesca,* 2 vols., Milan, 1971. For the Sant'Egidio documents see Battisti, vol. 2, p. 219. For Domenico Veneziano's work in Sant'Egidio, see H. Wohl, *The Paintings of Domenico Veneziano,* New York, 1982.

2. Early Renaissance Florence: G. Holmes, *The Florentine Enlightenment, 1400–1450,* New York, 1969; and G. Brucker, *Renaissance Florence,* Berkeley, 1983.

3. Brunelleschi and the architecture of Early Renaissance Florence: L. Heydenreich and W. Lotz, *Architecture in Italy, 1400–1600,* Harmondsworth, 1974; P. Murray, *Renaissance Architecture,* New York, 1971; P. Murray, *The Architecture of the Italian Renaissance,* New York, 1986.

4. Lorenzo Ghiberti: R. Krautheimer, *Lorenzo Ghiberti,* 2 vols., Princeton, 1956; J. Pope-Hennessy, *Italian Renaissance Sculpture,* New York, 1985.

5. Donatello: M. Crutwell, *Donatello,* London, 1911; H. W. Janson, *The Sculp-*

ture of Donatello, 2 vols., Princeton, 1963; J. Pope-Hennessy, *Italian Renaissance Sculpture,* New York, 1985; F. Hartt, *Donatello: Prophet of Modern Vision,* New York, 1973.

6. Luca della Robbia: J. Pope-Hennessy, *Luca della Robbia,* Ithaca, 1980.

7. Giotto: A. Martindale and E. Baccheschi, *The Complete Works of Giotto,* New York, 1966; B. Cole, *Giotto and Florentine Painting, 1280–1375,* New York, 1976.

8. Masaccio: P. Volponi, *L'Opera completa di Masaccio,* Milan, 1968; B. Cole, *Masaccio and the Art of Early Renaissance Florence,* Bloomington, 1980.

9. Lorenzo Monaco: O. Sirén, *Don Lorenzo Monaco,* Strasbourg, 1905; L. Bellosi, *Lorenzo Monaco,* Milan, 1965; M. Eisenberg, *Lorenzo Monaco,* Princeton, 1989.

10. Gentile da Fabriano: E. Micheletti, *L'Opera completa di Gentile da Fabriano,* Milan, 1976; K. Christiansen, *Gentile da Fabriano,* Ithaca, 1982. Fra Angelico: E. Morante and U. Baldini, *L'Opera completa dell'Angelico,* Milan, 1970; J. Pope-Hennessy, *Fra Angelico,* London, 1974.

11. For Domenico Veneziano, see note 1.

12. Piero worked with Antonio d'Anghiari on a papal insignia in 1436; Antonio seems to have been resident in Sansepolcro at that time. A recent archival discovery proves that Piero was at least eighteen in 1436 and so cannot have been born later than 1418. See F. Dabell, "Antonio d'Anghiari e gli inizi di Piero della Francesca," *Paragone* 35, no. 417 (1984): 73–94.

13. For Domenico Veneziano, see note 1.

14. Donatello's *Saint Louis of Toulouse:* J. Pope-Hennessy, *Italian Renaissance Sculpture,* New York, 1985, pp. 256–57.

15. Paolo Uccello: J. Pope-Hennessy, *Paolo Uccello,* London, 1969.

16. For the city of Sansepolcro see: G. Sacchetti, *Sansepolcro,* Sansepolcro, 1888; O. H. Giglioi, *Sansepolcro,* Florence, 1921; *Toscana: Guida d'Italia del Touring Club italiano,* Milan, 1974, pp. 424–29.

17. Sienese painting in Sansepolcro: The paintings that remain in Sansepolcro from before Piero's time are almost exclusively by Sienese artists. Although this is an incomplete picture—there must certainly have been works by artists from nearby Umbria—it suggests that Sansepolcro was under the strong influence of Siena. After Piero's death, however, Florentine artists were often commissioned for sacred paintings in Sansepolcro.

18. For Antonio d'Anghiari, see note 12.

19. Sassetta: B. Berenson, *A Sienese Painter of the Franciscan Legend,* London, 1909; E. Carli, *Sassetta e il Maestro dell'Osservanza,* Milan, 1957; J. Pope-Hennessy, "Rethinking Sassetta," *Burlington Magazine* 98 (1956): 364–69.

20. J. Pope-Hennessy, *Sienese Quattrocento Painting,* London, 1947; E. Carli, *Sienese Painting,* New York, 1982; B. Cole, *Sienese Painting in the Age of the Renaissance,* Bloomington, 1985.

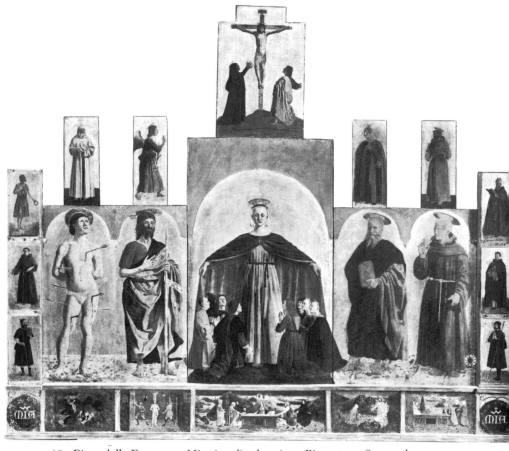

18. Piero della Francesca, Misericordia altarpiece, Pinacoteca, Sansepolcro

II

THE ALTARPIECES

P iero's Misericordia altarpiece [18] was commissioned by the brotherhood of the same name for its oratory (Santa Maria della Misericordia) in Sansepolcro. The painting is a polyptych of a type common throughout Tuscany during the first half of the fifteenth century: the Madonna is on a central panel, flanked by images of standing saints and surrounded by subsidiary images in the predella (the painted scenes at the bottom of the altarpiece), pilasters, and pinnacles. Here and throughout his career, Piero worked with well-established altarpiece shapes.[1]

Already flourishing by the middle of the fourteenth century, the Misericordia was a lay confraternity with an extensive membership throughout the Italian peninsula. The confraternity grew in size and importance after the Black Death of 1348, during which its members tended the sick and buried the dead. Expected to do good deeds anonymously, the members performed their tasks wearing a black hood such as worn by the man kneeling to the left of the Virgin in Piero's altarpiece.[2]

The contract, dated 11 June 1445, for the Misericordia altarpiece survives, and though it gives us no indication of when Piero finished the painting, it does contain some valuable information about the commission. Most noteworthy is the provision that bound Piero to paint the altarpiece in the manner of a preexisting painting: "to make, paint, embellish and erect the said picture according to the size and type of painting which is there [in the Oratory] at present."[3]

During the Renaissance the copying of older paintings was common. Many painted images had time-honored histories and often attracted a special veneration. The old paintings were frequently copied in the hope that the copies would share their sanctity; miracle-working images were imitated in the expectation that the copies would also work miracles. Sacred images lost to flood, fire, or time were also imitated, in the belief that the copies would be able to resurrect part of the ancient holiness.[4] Some of these factors may have been part of Piero's patron's desire for an altarpiece that imitated, at least in size and type, an older painting.

25

Earlier images of the Madonna della Misericordia, both in painting and in sculpture, were of a fairly defined type, the major feature of which was, as in this picture by the Sienese Niccolò di Segna of around 1330, a large standing Madonna holding her mantle open to cover the tiny kneeling supplicants of the Misericordia confraternity [19].

Piero, like all Italian fifteenth-century artists, thought in terms of types. When commissioned, he first carefully reviewed the formal and iconographic traditions of previous examples of the type he was about to paint. Renaissance artists were deeply conservative, and their art was strongly dependent on the past. They also considered the end purpose for which the religious and secular works they painted were to be used. Such conservatism did not, however, stop Renaissance artists from being highly original.

That originality is demonstrated in Piero's transformation of the Misericordia image [20]. He clearly based his painting on a traditional polyptych type, which was composed of a central panel depicting the Madonna, flanked by four panels, or wings, two to either side. Each panel was painted with an image of a saint (these flanking panels were probably originally framed by slim, wooden, twisted columns now lost).[5] Although Piero incorporated many traditional elements into his altarpiece, he at the same time simplified it. He reduced the number of figures, endowed them with a new monumentality, and gave the entire altarpiece a coherent focus by making the Madonna the compositional and spiritual linchpin of the painting. For Piero, simpler was better.

To see how logical and coherent his Misericordia image is, one need only compare it with a version [21] of the same subject by Parri Spinelli, an artist from nearby Arezzo. Painted in 1435–37, Parri's altarpiece may well have been studied by Piero as an important contemporary example of the subject. But Piero, while incorporating many of the traditional aspects of the Misericordia type found in Parri's altarpiece into his own work, gave the image new formal and emotional meaning. The additive structure of Parri's painting, with its many separate, independent elements, was rejected by Piero, who made his own version much more unified and logical. In Piero's painting the Madonna is the magnet toward which every other element moves in an interlocking web of form and color; she has become its physical and spiritual center. Moreover, he has imbued the ancient image with a presence that reemphasizes and reinvigorates its original intertwined meanings of supplication and protection.

Piero has, for example, placed the group occupying the central panel on a plinth painted to look like variegated marble [20]. This plinth, which raises the Madonna over all the forms in the altarpiece, is different in color and fictive material from the ground on which the figures in the flanking panels stand. The plinth makes the Madonna and her wor-

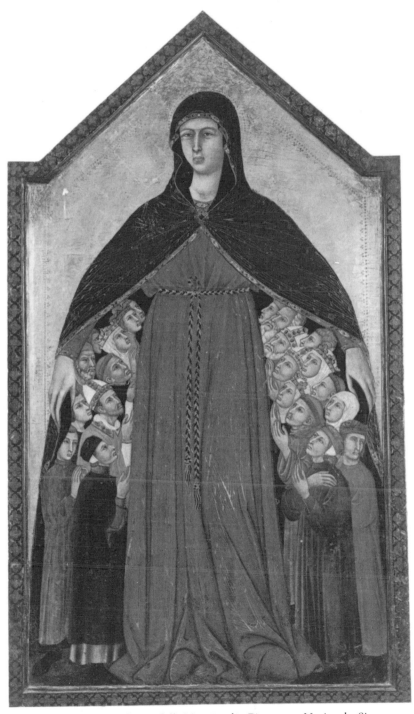

19. Niccolò di Segna, *Madonna della Misericordia,* Pinacoteca Nazionale, Siena

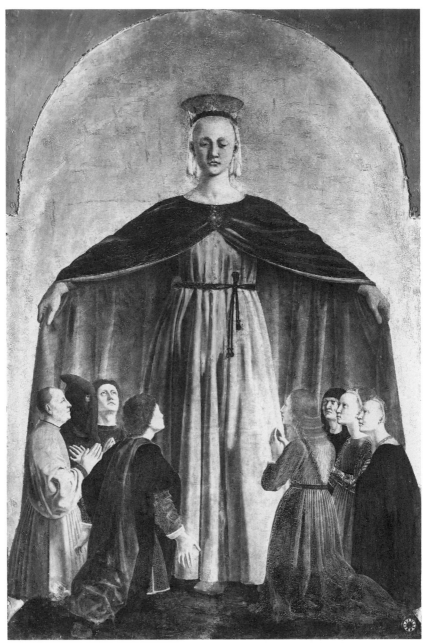

20. Piero della Francesca, *Madonna della Misericordia* (detail of center panel), Pinacoteca, Sansepolcro

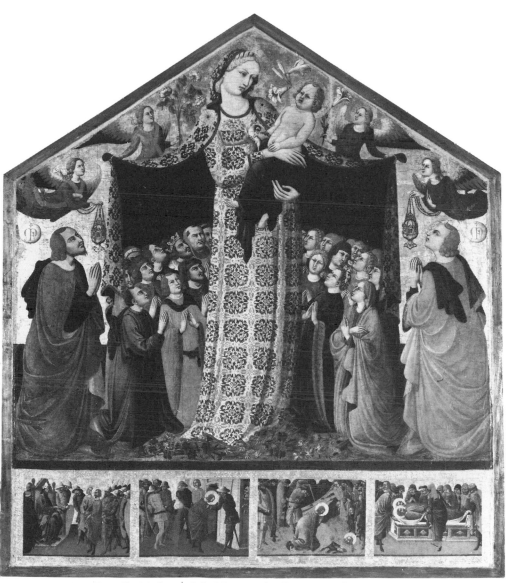

21. Parri Spinelli, *Madonna della Misericordia,* Pinacoteca, Arezzo

shipers seem statuelike, as though they were some stone or terra-cotta group existing before the viewer in real space.[6] The Madonna della Misericordia image was frequently carved in relief on stone, and it is possible that Piero may also have thought of these carvings when he planned the central panel of his altarpiece.

The syntax of Piero's visual language is expressed in the altarpiece with a singular logic and clarity. His forms and images are of the utmost simplicity and directness, revealing, even in this altarpiece, the nature of all his work.

Our attention is immediately riveted on the Madonna. Placed in the middle of the composition and filling much of the center panel with her large body and widespread cloak, she is a commanding figure. Her presence is, moreover, intensified by her body and spatial position. She is a stable, rooted figure whose appearance of volume and bulk results from the reduction of her body to a massive cylinder. The weight and rotundity of this simple geometric shape is made even more obvious by the folds of the dress, each of which echoes the Virgin's cylindrical form, much like fluting on a column.

The Madonna's form is also repeated by her outspread cloak. This semicircle, in turn, is mirrored by the kneeling spectators below; these figures complete the circle, so that the cylinder of the Madonna's form exists within the circle made by her cloak and the kneeling supplicants. The further reduction of forms to simple geometric shapes can be seen in the Madonna's ovoid face, the circle of her halo, the spheres of the worshipers' heads, and the rough triangles of their bodies. Such geometry of form does not mean the altarpiece is static: Piero has carefully placed the various elements of the composition just off center and slightly off balance to endow the painting with a subtle movement and variety. We see, for example, that the Madonna's hands are on different levels, that the tie of her belt is off center, and that the supplicants are varied in both pose and gesture. Such painstaking variation within a carefully balanced whole is part of the foundation of Piero's art.

Color also plays a major role in the intricate subtleness of the work. The dominant note is struck by the pinkish red of the Madonna's dress that centers the composition and gives it focus. Similar, but not identical, reds are found in the tunics, cloaks, dresses, and belts of the kneeling figures; such asymmetrical reflection of a major color is characteristic of almost all of Piero's paintings. Fields of color—blue, black, and deep brown—are banded across the entire surface of the painting, imparting a variety and liveliness. Piero does not use a vast range of colors, but those he employs are worked in large areas that serve both to build form and to act as independent decorative elements existing close to the picture plane. This way of working with color may have been partially learned from Domenico Veneziano.

Formal harmony untrammeled by obtrusive individual emotional expression is one of the cornerstones of Piero's art. The men and women of the Misericordia altarpiece gaze at the towering Virgin with rapt attention; it is clear that they worship and adore her, but their attitudes are to be understood by the subtle gestures of their bodies rather than by their facial expressions. In fact, in this and Piero's other works, emotion is conveyed not through the face, which almost always remains impassive, but by the force of movement and shape. Figures are purposefully given static, inarticulate, and, on occasion, ambiguous facial expressions so as not to detract the spectator's attention from shape and its interrelations, the real conveyers of Piero's emotional messages. In Piero's art one is not involved with individual expressions; the working of the psyche is subsumed in and expressed by the all-important configuration of form, color, and line.

In contrast to their generalized facial expressions, the dress of Piero's figures is specific and detailed. Close attention to costume and an understanding of how it is made and worn is a trait of all Piero's paintings. Dress meant much to the artist, not only for the color but also for the formal possibilities its shape and material offered. Piero's figures are often dressed in the actual costumes of the period, which he depicts with scrupulous care.[7]

Each of the gowns worn by the women in the Misericordia altarpiece could probably have been seen on the streets of Sansepolcro, although the expensive gold-embroidered sleeves of the third woman to the right of the Virgin would have been worn only for some special occasion, such as the one occurring in Piero's altarpiece. The men also wear contemporary costumes, with short jackets and high necks. The Madonna wears a simple Renaissance dress. Such careful attention to costume must have anchored the altarpiece in contemporary reality and made the vision of the gigantic Virgin seem more immediate.

The saints who flank the Madonna are, from left to right: Sebastian, John the Baptist, John the Evangelist, and Bernardino of Siena. The combination of saints on Renaissance altarpieces is seldom fortuitous; rather, the choice and arrangement usually express some message or aspiration of the patrons.

Undoubtedly, Saint Sebastian was chosen for his association with the plague, the epidemic disease with which the Misericordia was so often concerned. Because he had not died from his many arrow wounds, Sebastian, it was believed, could prevent the disease and death. Throughout the Italian peninsula he was often invoked as a protector against the plague. The choice of Sebastian for an altarpiece commissioned by the Misericordia is therefore not surprising.

Saint John the Baptist, the figure to the right of Sebastian, was also commonly depicted on altarpieces. One of the major saints, he was

especially venerated in Tuscany, where he appears on scores of altar-pieces at the Madonna's dexter side, the position of major heraldic importance. Often Saint John the Baptist is linked with his namesake and fellow companion of Christ, Saint John the Evangelist. The figure to the right of the Madonna is the grave, graybeard type almost always used for this saint.[8]

The saint to the viewer's far right is Bernardino of Siena, a famous Franciscan who was canonized in 1450, only five years after the Miseri-cordia altarpiece was commissioned.[9] Bernardino was a preacher whose fame spread throughout the Italian peninsula during the second half of the fifteenth century. But his inclusion as a saint in Piero's painting does not help with its dating, since contemporary holy men were sometimes depicted with haloes even before they were canonized. Many cities in Tuscany and Umbria had a special devotion to Bernardino of Siena. Moreover, he often appears on altarpieces and banners with imagery designed to ward off or stop the plague; like Sebastian, he was invoked against epidemics.

There are numerous other saints on the Misericordia altarpiece, both above and to the sides of the large figures on the main register.[10] These smaller flanking saints are a mixed group, both in form and in regard to the handling of paint. They seem to be close to the style of Piero, but not of the quality or skill of the Madonna and the four large saints.

In the single-figure panels of the uppermost register of the Misericor-dia altarpiece, one also finds stylistic divergences from the large figures below. The *Crucifixion* [22], which has always been attributed to Piero, is a powerful painting that undoubtedly owes much to Masaccio's ver-sion of the same subject, executed in 1426 for an altarpiece destined for the Carmine church of Pisa [23]. The boldly foreshortened Christ of the Misericordia *Crucifixion* ultimately depends on Masaccio's work, or something quite similar to it by him, as revealed by the similarities between the awkward attachment of the neck to the torso and the knurled legs.

Some of the power of Masaccio's revolutionary composition is also shared by the figures of the Virgin and Saint John the Evangelist. In them is captured the compressed grief of Masaccio's still but expressive figures. The heartbreaking gesture of sorrow of Masaccio's Magdalen must have been the source for the outstretched arms of Piero's stunned John the Evangelist. The handling of the heavy drapery, the modeling of the skin, and the general expressive tenor are similar. Also dependent on Masaccio's panel is the precise outline of the figures that makes them stand out so starkly against the glittering gold background.

Yet, all this said, there is an ineptness and crudeness about Piero's *Crucifixion* (note the Virgin's hands, the spindly Christ, and the awk-ward construction of the robes) that set it apart from the large panels of

the Madonna and saints below, which are finer in both design and execution. Moreover, the strident expressive tone of the image is something not seen in any other work by the controlled, usually much cooler Piero. There can, however, be no doubt that Piero had, either directly or indirectly, a role in the Misericordia *Crucifixion*. It is so close to his idiom that it was either planned by him and, perhaps, drawn out on the panel in preliminary fashion or else done by an artist who had thoroughly absorbed his style. The two flanking figures of the angel and the Virgin of the *Annunciation* are by the same hand, which also appears to have done most of the small saints on the pilasters and the predella.

The panels of the predella are of a quality inferior to the large standing figures, the *Crucifixion,* and the flanking *Annunciation* panels. The five scenes that constitute the predella are: *Agony in the Garden, Flagellation, Entombment of Christ, Noli me tangere,* and the *Three Maries at the Tomb.* Each of these small panels is, once again, heavily influenced by Piero's style, but each also displays a crudeness, an almost primitive quality, that excludes them from Piero's more accomplished body of works. Some of the same gesticulating expressiveness of the Misericordia *Crucifixion* appears in the predella, for example, in the figures and large hands of the *Entombment* [24]. There is also a general awkwardness about the figures and their movements that ties them to the other smaller panels of the Misericordia altarpiece. The stylistic dichotomy of the work is hard to understand, and one can only make educated guesses about what happened. The following may be postulated: Piero took a long time finishing the altarpiece (he appears to have been an extremely slow painter) and seems to have been still at work on the Misericordia altarpiece as late as 1462.[11] Perhaps, even after his final payment for the job, the altarpiece remained unfinished, with only the major panels of the Madonna and saints completed. The Misericordia then hired another painter—someone who knew Piero's work well, perhaps a student —to complete the work.[12] This painter then finished the pinnacles, which had been already designed, and perhaps started, by Piero; furnished a set of pilaster saints; and made a predella. Although influenced by Piero, the predella is a wholly independent composition, with characteristics derived from Piero but not directly copied from his work. This scenario would account for the pictorial closeness of the *Crucifixion* to Piero's manner and the stylistic disparity of the predella, which is related to it in some important ways. Whatever happened, it is certain from the stories on the predella that it is an integral part of the altarpiece and was planned from the very beginning. The central vertical axis of the altarpiece—the predella *Entombment,* the Madonna della Misericordia, and the pinnacle *Crucifixion*—all stress the role of Mary: she appears in all three scenes and grieves in two, an appropriate state for an altarpiece made for a confraternity that dealt with plague victims.

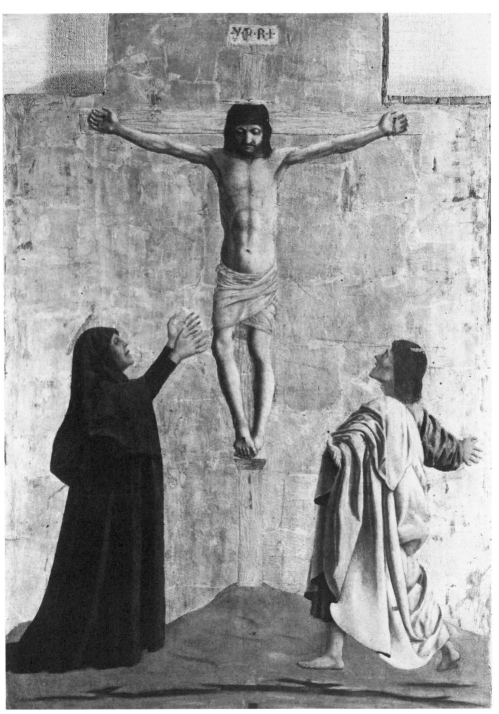

22. Piero della Francesca, *Crucifixion,* Pinacoteca, Sansepolcro

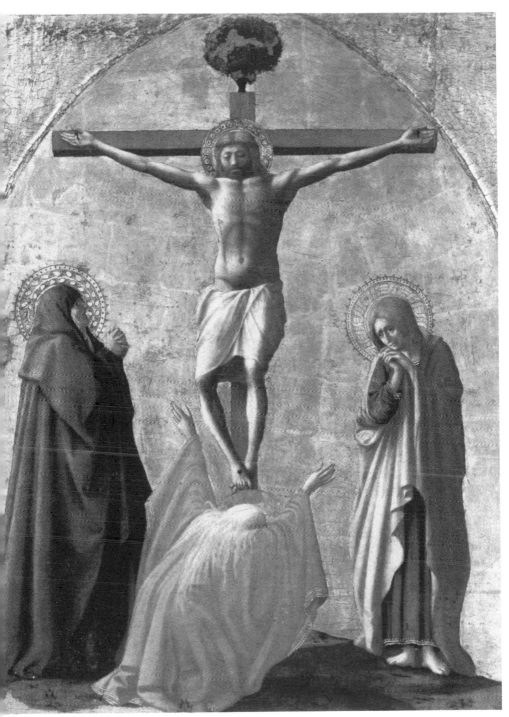

23. Masaccio, *Crucifixion,* Capodimonte Museum, Naples

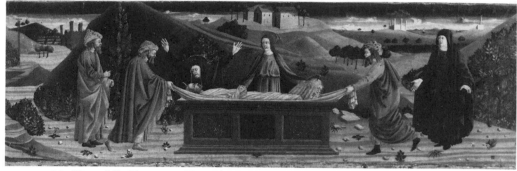

24. Piero della Francesca, *Entombment,* Pinacoteca, Sansepolcro

This central vertical axis also emphasizes the liturgical function of the altarpiece. Christ's Crucifixion and Entombment frame the great icon image of his mother. It is she who was seen both as intercessor between the communicant and Christ and as the sacred tabernacle that once held the precious body of Christ, just as the actual tabernacle of stone or terra cotta encloses Christ's body in the shape of the sacred wafer. And it was the miraculous transformation of this wafer (along with the sacramental wine) into the body and blood of Christ, during the Mass performed on the altar, which demonstrated Christ's, and the communicant's, victory over the death so graphically shown in the *Crucifixion* and the *Entombment.*

Christ's triumph over death is also seen in the *Noli me tangere* and in the *Three Maries at the Tomb.* These episodes, which emphasize Christ's supernatural power over death, must have had also an extra-liturgical purpose: in their roles as helpers of the sick, especially those stricken with the plague, and as the buriers of its victims (the predella's *Entombment* may also have reference to this role), the members of the Misericordia were often involved with dying and death. The solace offered by the tangible presence of Piero's sheltering Madonna della Misericordia and the depiction of Christ's triumph over death must have been of considerable comfort to the members of the confraternity and to those they attended. Moreover, the various pictorial references to Christ's tomb would have been particularly noted by the residents of a town named after the Holy Sepulcher.

Another predella panel, the *Flagellation,* also held special significance for the members of the Misericordia. The Sansepolcro brotherhood was a flagellant confraternity, one of many such Renaissance organizations.[13] Flagellants undertook processions and pilgrimages, during which they ritually flogged themselves to expiate their sins. Often they wore a hood,

which masked their identity. Quite naturally, the flagellants commissioned images of Christ's Flagellation for their meeting house and the banners they carried in processions. It must, consequently, have seemed necessary to the members of the Sansepolcro Misericordia to include an image of the Flagellation on the predella of their new altarpiece.

Many of the components of the Misericordia altarpiece—the reductive, geometrical figure construction; the formal relations between the abstracted elements of the composition; the adherence to a previous type; and the substantial debt to the art of the immediate past, both in Florence and Siena—also appear in a puzzling altarpiece by Piero that is now in the Galleria Nazionale dell'Umbria in Perugia [25]. This rather large, awkward work is centered in a triptych containing the Madonna, the Child, and four saints. The triptych surmounts a two-tiered predella, and is topped by a large *Annunciation* [26].

The overall impression derived from this altarpiece is perplexing. The Madonna and the central saints seem lost among the surrounding panels; the uppermost predella, with its three roundels, makes an awkward transition between the predella base and the central triptych. The *Annunciation* seems too heavy and too large for the rest of the altarpiece.

While there were no rigid rules of size for Tuscan altarpieces painted about the middle of the fifteenth century, there did exist certain proportional arrangements and relations that were common; the Perugia altarpiece conforms to none of these.[14] The discordant relation between the various elements of the Perugia polyptych and its lack of adherence to even the roughest canons of contemporary altarpiece design suggest strongly that its shape is not original but rather the result of some later adjustment.

There has been debate over exactly what changes, if any, were made to the Perugia altarpiece.[15] These arguments may be summarized as diverse in their suggestions and inconclusive in their results. Yet, one can see that the Perugia altarpiece appears, in its present state, to have been made up of the disparate parts of several altarpieces. These parts seem to have been combined, but not necessarily in the present arrangement, since the middle of the sixteenth century, when the altarpiece was described by Vasari:

> In the church of the nuns of S. Antonio of Padua, he [Piero] painted on a panel in tempera the Virgin and Child, St. Francis, St. Elizabeth, St. John and St. Anthony of Padua. Above this he made a fine Annunciation with an angel which really seems to have come from heaven and what is more, an admirable perspective of diminishing columns. In the predella are scenes in small figures of St. Anthony raising a boy, St. Elizabeth saving a child which has fallen into a well and St. Francis receiving the stigmata.[16]

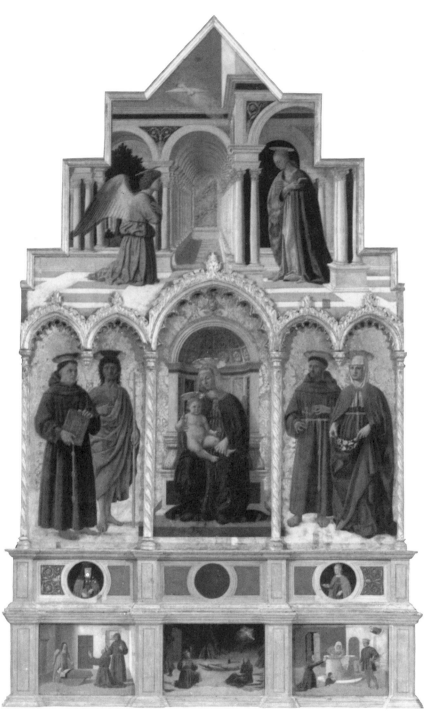

25. Piero della Francesca, altarpiece, Galleria Nazionale dell'Umbria, Perugia

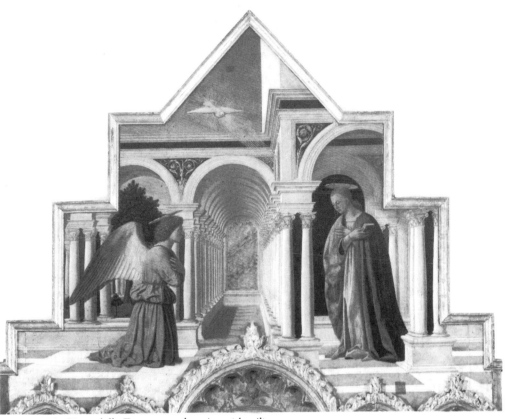

26. Piero della Francesca, altarpiece (detail),
Galleria Nazionale dell'Umbria, Perugia

Why these panels that Vasari describes should have been arranged in
their awkward present-day form is a mystery, but that all—with the
exception of the two small roundels—are by Piero and his shop is
certain.

The most plausible explanation is that the *Annunciation* was originally
a separate rectangular altarpiece that was altered to its present shape
when it was utilized to make a gable for the triptych of the Madonna
and the saints. Below the *Annunciation,* in its original form, was a pre-
della, probably the one now decorated by the strange little roundels of
half-length female saints. These little paintings seem modern and, in
fact, may be substitutes for the narrative scenes of Christ's life that
would have been the usual subject for a predella under an Annunciation
altarpiece.[17]

Why the *Annunciation* and its predella were separated, altered, and

then attached to another altarpiece—the triptych of the Virgin and the Child, with four standing saints and a predella—is unclear, but the resulting combination of the major panels of both altarpieces, each by Piero, forms one grand, but unwieldy, assemblage.

Although this theory of what happened seems the most plausible of all the possibilities, it raises several crucial, unanswerable questions: Why was there not a fourth predella panel, with a scene of John the Baptist (or perhaps the Baptism itself), placed under the Madonna and the Child of the triptych? Why do the predella panels seem so large in comparison to the Madonna and her court of standing saints? And why were the two major and independent works combined in the first place?

Fortunately, several things about the Perugia polyptych are more certain. That the main section, with the Madonna and the saints, was commissioned for the convent of the nuns of Saint Anthony in Perugia, where Vasari saw it, seems beyond doubt. The iconography of the altarpiece proves that this convent was the original destination, for the altarpiece not only depicts Saint Anthony, on the dexter side (the most important side of the Madonna and the Child), but also, to the right of the Madonna, Saint Francis of Assisi, the founder of the Franciscans— the order to which both Saint Anthony and probably the nuns of the Perugia convent belonged.

The iconography of the altarpiece suggests that these nuns were concerned with the care of children, perhaps orphans. In two of the predella panels children play a central role. In the scene taken from the legend of Saint Elizabeth, a drowned child is resurrected by the saint, who appears in the upper right corner.

In the second scene centered on a child, Saint Anthony, flanked by a friar, prays in front of a baby's cradle while a distraught mother looks on. This scene is usually called the resurrection of an infant, and it appears to be just that, although such an episode does not figure in the hagiography of Saint Anthony. Perhaps it was a local legend that did not find popularity outside Perugia and its surroundings. Whatever the case, the legend involves children, their worried mothers, and the miraculous healing power of a saint, all of which suggests that the nuns of the convent of Saint Anthony in Perugia were concerned with children.

Between the two panels just discussed is the central predella painting, the *Stigmatization of Saint Francis.* Why exactly this should be placed under the Madonna is unclear. The painting is, in any case, a dramatic, skillfully done work that sets the Stigmatization at night, something very rarely shown. The effects of the illumination from the blazing crucifix against the inky darkness of the background are remarkable.

Each of the three predella panels of the Perugia altarpiece is just far enough removed from Piero's idiom that one hesitates to ascribe them to his hand. Like the peripheral paintings of the Misericordia altarpiece,

they seem to be based on Piero's work, perhaps even on his designs, but his hand seems absent from them. They were, in all likelihood, left to an assistant to finish after Piero had completed the large panels of the Madonna and the standing saints.

More problems about this already problematic altarpiece are raised by a closer examination of the style of the large panels. In all respects, the Madonna, the Child, and the saints are close to the figures of the Misericordia polyptych; they seem to come from Piero's design and hand. The weight and presence of the bodies and the gravity of their expression link them solidly to all Piero's holy figures. Quite different, however, is the space of this altarpiece, which is flattened by the gold pattern of the background. This pattern, which resembles patterns found on fabric of the period, was undoubtedly requested by the nuns to enrich their altarpiece. In the Misericordia polyptych the gold behind the figures seems limitless, a shimmering expanse of sacred space. Here it appears merely flat and alive with pattern; the result is that the figures seem slightly planar and more tightly confined to a narrow spatial platform. The nuns must have been pleased with this central part of the Perugia altarpiece, because it is, in many ways, the traditional type, in both the shape and the disposition of figures against the gold.

The *Annunciation,* now crowning the altarpiece, is one of the glories of Piero's imagination. What is immediately striking about this scene is the serene luminosity created by the pure, steady light—a light that bathes the architecture and figures alike, imparting to them a freshness and radiance of exceptional beauty. Although this *Annunciation* is one of Piero's most personal works, its roots lie deep in Domenico Veneziano's paintings, especially the *Annunciation* from his Saint Lucy altarpiece [27], which Piero obviously admired for its color, its architecture, and, above all, its light.

The structure of the central panel of the Misericordia altarpiece is grounded in the geometric construction of the Madonna's body; similarly, the Perugia *Annunciation* has been given structure and meaning by its architecture. The handsome building with its arcade and cloister (both resembling the harmony and simplicity of Brunelleschi's buildings in Florence, especially the portico of the Ospedale degli Innocenti) establishes the relation between the Virgin and the angel. Separated by columns—the Virgin is also enclosed by them—the protagonists are nonetheless linked by the arches that so gracefully spring above their heads. The architecture must have been even more effective before it was cut by the strange profile of the panel's now altered shape. The logic and the simple geometry of the arrangement, and the particular quality of the cool, purifying light evoke the tranquil interiors of Brunelleschi's buildings.

The patterns of arch and column, and the marching rhythm of their

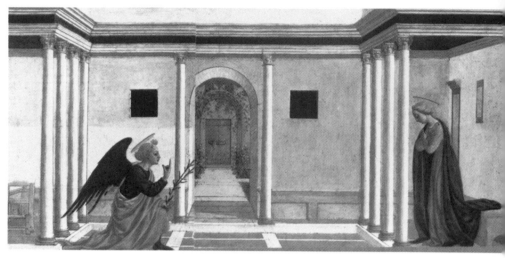

27. Domenico Veneziano, *Annunciation,*
Fitzwilliam Museum, Cambridge, England

slender shapes enliven the scene and impart stability and grace, traits the composition shares with the best of Piero's paintings. There is a preternatural stillness about the green, leafy cloister behind the angel and a transcendental brilliance in the stony white and terra-cotta colored tunnel of architecture and space that transport the scene to the highest realms of painting and poetry. The *Annunciation* seems enveloped in a gauze of beatific silence and purity that somehow perfectly expresses the miraculous and hopeful meaning of the event.

Piero's only other known polyptych survives in fragmented and scattered form. Four large saints (each c. 133 x 60 cm) are all that remain of what was once a substantial altarpiece that seems to have been commissioned for the church of Sant'Agostino in Sansepolcro. Documents demonstrate that in October 1454, Piero was commissioned by one Angelo di Giovanni di Simone d'Agnolo to paint a polyptych for Sant'Agostino. The commissioning contract is an interesting document, revealing that Piero took not only money but also a piece of land as his payment.[18] The work was to be painted on a panel (paid for by the donor) and to be completed within eight years—this very long contractual time may indicate that the donor knew well just how slow a worker Piero was. In fact, a document from fifteen years later (November 1469) appears to indicate the final payment for the altarpiece.[19] This may mean that the Misericordia altarpiece (contracted 1445, final payment 1462), the rearranged polyptych in Perugia, and the Sant'Agostino altarpiece were, at various times, together in Piero's shop. Piero appears to have been a

meticulous, slow worker who kept patrons waiting for years. With so much time between contract and final payment and with so many works in the shop at the same time (there were probably more than just three altarpieces in question), it is no wonder that it is impossible to chart the development of Piero's style.

From the remaining fragments—*Saint Augustine* in Lisbon [28], *Saint Michael* in London [29], *Saint John the Evangelist* in New York [30], and *Saint Nicholas of Tolentino* in Milan [31]—it is certain that the polyptych consisted of a central panel surrounded by four wings, each with a standing saint [32], a highly traditional type that finds its origin in the fourteenth century. It is also certain that Saints Michael and John the Evangelist flanked the central panel. This is proved by fragments of a throne step (partially covered by brocade) in the lower right of the Michael panel and in the lower left of the Saint John. Thus, a throne in the middle panel originally extended into the flanking panels, much in the same way it does in the Perugia altarpiece [25]. From the throne fragments it is clear that Michael was to the left and Saint John to the right of the central panel.

The subject of the missing center panel is unknown, but the presence of a throne suggests a Madonna and Child, the most common subject for the central panels of Italian fifteenth-century altarpieces. It is also possible that a Coronation of the Virgin, another frequently portrayed subject, might have occupied the center of the Sant'Agostino polyptych.[20] Whatever the subject of the central panel was, the altarpiece in its original form must have resembled the Misericordia polyptych with its four standing saints.

Like the Perugia altarpiece, the polyptych from Sant'Agostino in Sansepolcro mirrors the circumstances of its commission. The two outer saints—Augustine and Nicholas of Tolentino—reflect the Augustinian provenance of the work: Augustine was the order's founder, and Nicholas of Tolentino wears the Augustinian habit with its large belt. Saint Michael is a rather rare figure on fifteenth-century Tuscan altarpieces, and his placement in the position of honor, the dexter side of the central panel, must have resulted from the fact that he was the donor's (Angelo di Giovanni di Simone d'Agnolo) patron saint; also, the Saint John (Giovanni) might reflect the donor's name. (The practice of including the patron saint of the donor on altarpieces was widespread during the Renaissance.)

The Sant'Agostino saints are closely related to those in the Misericordia altarpiece. Grave, weighty, and still, each endowed with a palpable presence, they are the heirs of Masaccio's heroic saints. Piero's ever-present fascination with light and its reflections on the surface of objects is especially evident in the Sant'Agostino saints. For instance, the gleam of Michael's steel armor, the myriad glittering reflections on his jewel-

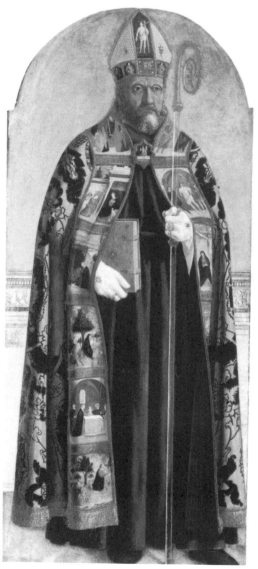

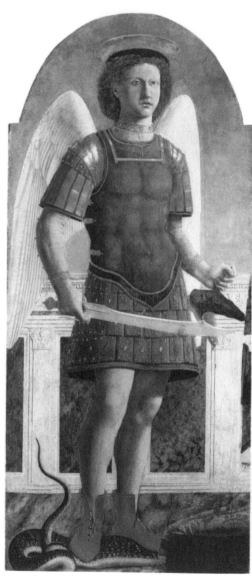

28. Piero della Francesca, *Saint Augustine,*
Museu de Arte Antiga, Lisbon

29. Piero della Francesca, *Saint Michael,*
National Gallery, London

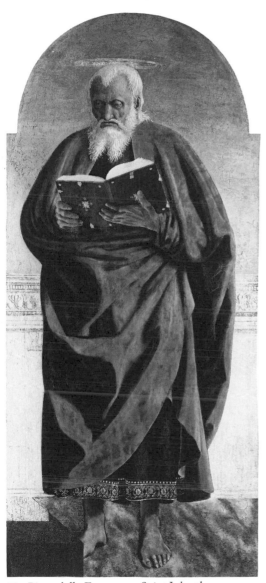

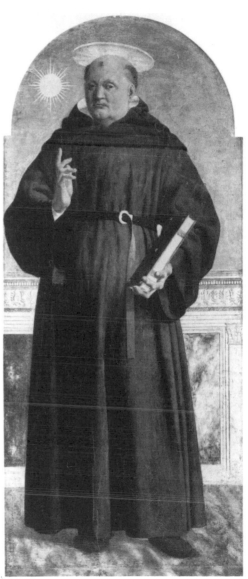

30. Piero della Francesca, *Saint John the Evangelist,* Frick Collection, New York

31. Piero della Francesca, *Saint Nicholas of Tolentino,* Museo Poldi Pezzoli, Milan

32. Reconstruction of the Saint Augustine altarpiece

encrusted skirt, and the glow of the variegated marble help create a delicate atmosphere of color, light, and air.

There is, however, one important difference between these panels and those from Piero's Perugia and Misericordia altarpieces: a new conception of space. In the Sant'Agostino altarpiece the figures are not placed against gold, but occupy a narrow space set before a marble railing with capitals and moldings inspired by Brunelleschian decoration. By making the background blue sky instead of gold and then separating the figure from the sky by the railing, Piero has suggested an unlimited envelope of space into which the figures have been inserted. The sacral, indeterminate aura of gold has been replaced with a seemingly real space that accords perfectly with the weight and solidity of Piero's earthbound saints.

The gold background, almost universal in earlier paintings, began to be replaced by painted backgrounds of landscape and architecture in the early fifteenth century. By the 1430s, gold backgrounds had become rare. The Madonna and the saints of the Saint Lucy altarpiece [12] by Domenico Veneziano were set in a framework of architecture and light. About 1440, when Piero began the Misericordia polyptych, a gold background for altarpieces, in Florence at least, was quite old-fashioned.

The members of the Misericordia in Sansepolcro and the nuns of the convent of Saint Anthony in Perugia, however, wanted the more traditional gold. Moreover, both in Sansepolcro and in Siena altarpiece design tended to be conservative: the type of Piero's altarpieces for Sansepolcro and Perugia was already a bit out-of-date in Florence by 1445.

But for a painter like Piero, who was conscious of the latest develop-
ments in Florence and was under the sway of Masaccio, the opportunity
to place his figures in a painted, instead of a metallic, space must have
been a welcome challenge. The geometric solidity of Piero's colum-
nar bodies could now be realized in a space filled with light and
air.

In his *Baptism* [33], now in the National Gallery, London, Piero
placed his figures in a fully developed and remarkable landscape. The
provenance of this altarpiece cannot be proved, but the work appears
to have come from the priory of San Giovanni Battista in Sansepolcro;
that the altarpiece comes from Sansepolcro is beyond doubt.[21] Thus,
with the Misericordia altarpiece and the Sant'Agostino polyptych, the
Baptism is yet another work that was created for Piero's hometown.
Other important commissions from Sansepolcro were also to come to
Piero, and throughout his life his native city was to remain the base for
all his artistic activities. Unlike Giotto, Masaccio, and Leonardo da
Vinci, all of whom were born in out-of-the-way places and made their
way to Florence, Piero seems to have been content to live and work in
the rather provincial setting of Sansepolcro. Because he had so much
work in that town, he probably had little inclination even to consider
transferring permanently to one of the larger Tuscan cities. In Sansepol-
cro he was, without a doubt, the principal painter and a source of still-
flourishing civic pride.

It is unlikely that Piero's *Baptism* for Sansepolcro is now in its original
state; it was probably meant to be flanked by two wings, each containing
a standing saint. This form of Baptism altarpiece was popular during
the late fourteenth and early fifteenth centuries; a good example is
Niccolò di Pietro Gerini's *Baptism,* now also in the National Gallery,
London [34].

Piero's *Baptism* once had wings [35]. These were not by him, but by
Matteo di Giovanni, a talented artist probably born in Sansepolcro and
influenced by Piero. Matteo's wings, and an accompanying predella also
by him, were with the altarpiece when it was described in the early
nineteenth century.[22] All the pieces were then in the Cathedral of San-
sepolcro, to which they seem to have been moved after the suppression
of the priory of San Giovanni Battista in 1808.

Matteo's wings and predella accord with Piero's *Baptism.* The Peter
and the Paul of the side wings were Apostles, and their deeds, like
John's, were fundamental for the development of the early church. The
predella is composed of stories of the life of the Baptist, and at the
center is the *Crucifixion,* over which the *Baptism* would have been
placed. Thus, it seems likely that the wings and predella were painted
by Matteo specifically for Piero's *Baptism.* These wings could have been
stipulated in the original contract (now lost) drawn between Piero and

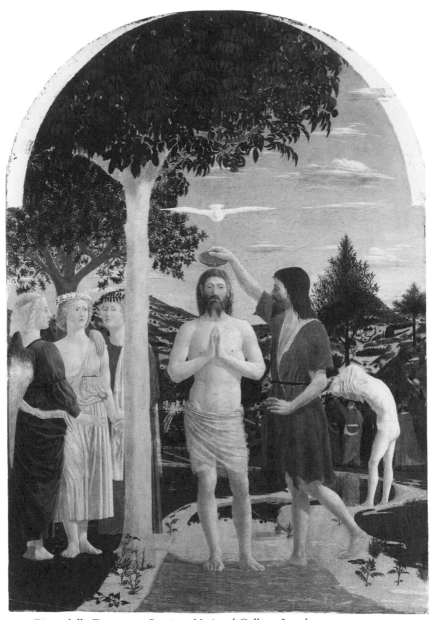

33. Piero della Francesca, *Baptism,* National Gallery, London

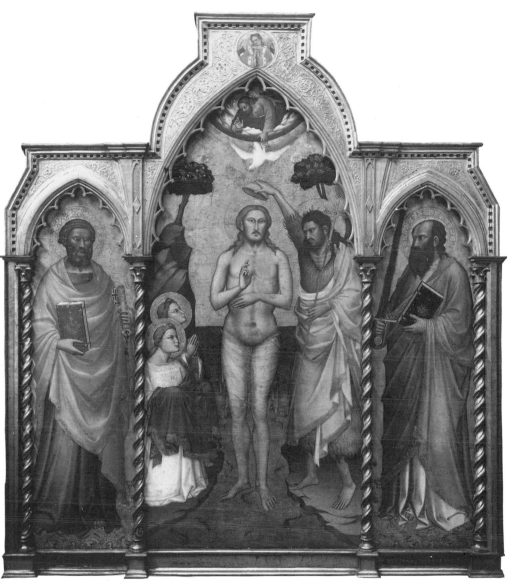

34. Niccolò di Pietro Gerini, *Baptism,* National Gallery, London

35. Matteo di Giovanni, *Saints Peter and Paul,* Pinacoteca, Sansepolcro

his patrons. It is unlikely that Piero painted wings and a predella that were lost, because Matteo's works are from his early period and date about the 1460s or early 1470s; they are, in other words, quite close in time to Piero's *Baptism.* Most probably Piero was originally responsible for the wings and predella, but, as in the case of the Misericordia and Perugia altarpieces, never fulfilled his contractual obligations. The incomplete work was then given over to Matteo, who furnished the wings, predella, and pilaster saints. It is also likely that there was a pinnacle painting over the *Baptism,* but its subject and fate remain a mystery.

There are, however, some puzzling anomalies between the paintings of the two artists: Matteo's wings are backed by gold, instead of the sky

seen in Piero's *Baptism;* when the panels were seen together, this would have created a striking difference. Moreover, there is a decided difference in scale between the figures. When placed next to the *Baptism,* the Matteo saints must have towered over the much smaller figures by Piero. Why such striking disparities exist is unknown.[23]

Whatever its relation to Matteo's paintings, Piero's *Baptism* must have impressed his Sansepolcro audience deeply, for it made the story of the Baptism very immediate while elevating the onlookers' own surroundings to a level seldom attained by a contemporary altarpiece. This immediacy is achieved in several ways. First, the protagonists have been brought near the front edge of the picture, close to the communicant. Second, the observer makes immediate contact with them: the rightmost angel looks out, establishing a direct linkage between the onlooker and the painted space. And third, the drama occurs in a familiar, recognizable location—the cultivated, rolling countryside around Sansepolcro. It has even been claimed that the hill town behind Christ is Sansepolcro, but this seems farfetched and contrary to the spirit of Piero's landscapes, which are never mere literal portraits of one specific location. Here are hills, fields, crops, and sky that evoke the look, feel, and even smell of the Tuscan countryside. Piero's landscapes remind one of Picasso's statement that artists do not imitate nature, but, rather, create as nature does.

By placing his *Baptism* within the Tuscan hills (a daring innovation for a painting destined for a church in the conservative and traditional Sansepolcro), Piero made the environment of the communicant sacred; the very roads and fields so familiar to him have become the location of a solemn and holy event. Of course, Piero was not the first painter to locate religious drama in a recognizable setting, but rarely has it been done with the brilliance of the Sansepolcro *Baptism.*

Piero's landscape is filled with that cool light already seen in the Perugia *Annunciation.* It falls everywhere in the picture, defining the rhythmically placed frieze of figures in the foreground, imparting substance to the white tree that demarcates the left third of the scene, and illuminating the glowing sky. Light creates and separates form, then imbues it with divinity.

This is no more a mundane, literal portrait of everyday light than is the light of a Vermeer interior. Rather, Piero's light is pure and unwavering, an ethereal manifestation of divinity on earth. The world of Piero's *Baptism* is pantheistic—a spiritual force inhabits everything from the angels to the smallest flowering plants. The preternaturally placid water of the stream, with its colored reflections of hills and sky, is transformed into a magic mirror reflecting a higher, more pristine reality. All is suspended in an immaculate state of beauty and grace.

The stability and permanence of the *Baptism* have been achieved by

the disposition of forms in the painted space. Each of the figure groups —the angels to the left, Christ and Saint John the Baptist at the center, and the figures in the right background—is composed of Piero's abstracted, reductive types, seen in the paintings already discussed. All the figures are carefully strung together by touch, gesture, or spatial interval, and all are sheltered under the leafy umbrella of the tree, whose branches appear to move out into the viewer's plane, bridging real and painted space.

Interval, the void between the painted solids, is an integral part of Piero's art; it paces his narrative, giving relief and form to the substantial masses placed in his painted space. All good painters are aware of the arrangement of voids and solids in their art, but seldom are they able to dispose their forms with the feeling of immutability found in all Piero's major works. The seamless, inevitable quality of the paintings makes it appear as if each form and each void had somehow been preordained, that each of Piero's compositions is in perfect formal, spiritual, and emotional balance.

Color plays a key role in the brilliance of Piero's *Baptism.* The lighter tones are rhythmically placed across the surface: the purple-tinged white of the middle angel's robe, the grayish white of the tree trunk, the shining pink flesh of Christ, and the robes of the man pulling off his lavender-touched shirt. Darker, denser colors—roses, pinks, golds, and greens—enliven the surface of the painting, giving it depth, buoyancy, and tonal variety. The browns, olives, and greens of the hills help create further recession, by leading the eye back, beyond the lighter, foreground figures.

Color in the *Baptism* has been used in the construction of form and space, and as an independent decorative element, but it is the latter function that is the most evident. Piero's use of color fields strategically distributed across the paintings, and his care in the choice and construction of hue and its value seem to have been strongly influenced by the Sienese painting he saw in Sansepolcro. This use of color as a major independent decorative element is one of the most characteristic and important components of Sienese art throughout its long and distinguished history; surely such skillful use of color must have impressed the young Piero as he stood before the great altarpiece by Sassetta in Sansepolcro or as he saw other Sienese paintings in his travels through Tuscany.

Piero's skill as a colorist is seen again in his *Adoration of the Christ Child,* in the National Gallery, London [36]. This painting is said to have remained in the possession of Piero's heirs until the middle of the nineteenth century, when it was sold to Alexander Barker of London.[24] It entered the National Gallery in 1874, just slightly later than the museum's two other Piero panels, the *Baptism* and the *Saint Michael* from

the Sant'Agostino altarpiece. These acquisitions reflect the beginnings of Piero's revival in the late nineteenth century.

It is possible that the *Adoration* remained with Piero's descendants because it was unfinished at the artist's death and was inherited by them along with the contents of his workshop. Large areas of the panel are devoid of paint or are covered only with what appears to be a ground or underpainting; the earth in the foreground and the group of two shepherds and Joseph seated on a saddle seem to lack final finish.

Discussion of the *Adoration* is complicated by the fact that it has been overcleaned. Overcleaning, at least in this case, means an unwarranted removal of the original paint film. Consequently, it is often difficult, even impossible, to say if a certain passage has been left unfinished or is merely overcleaned. Piero painted thinly, probably with a combination of oil and tempera, and he painted objects nearer the picture plane over those farther back. He painted, for instance, a wall or a landscape and then overlapped the completely finished and detailed structure with a figure—the London *Saint Michael* and the wing of the rightmost angel in the London *Baptism* are good examples of this. Piero's thin layers of paint could have been abraded just by the effects of time, and they are easily removed by uninformed or overzealous cleaning.

The subject of the *Adoration* is not common in Italian painting about the middle of the fifteenth century, although it is known in several important examples—most notably Filippo Lippi's *Adoration* [37], now in Berlin but originally in the chapel of the Palazzo Medici in Florence.[25] Lippi's altarpiece and the copies it inspired do not have side wings, and it is unlikely that Piero's painting was originally equipped with them.

It has been suggested that Piero borrowed the motif of the Child lying on the ground from Netherlandish painting. Piero was probably familiar with Northern painting, which he saw in Urbino and, perhaps, in Florence. It is even possible that Piero knew one of the most famous of all Flemish paintings in Italy, the Portinari altarpiece by Hugo van der Goes, the *Adoration of the Shepherds* [38]. This altarpiece was commissioned about 1475 by Tommaso Portinari, a Florentine banker living in Bruges. Shortly thereafter the painting was sent to Florence and installed in Sant'Egidio, where Piero had worked with Domenico Veneziano in 1439.

There are certain iconographic motifs—the Child on the ground, the half-ruined shed—shared by the Portinari altarpiece and Piero's London *Adoration,* but these do not prove direct influence; Piero could have borrowed the motifs from Florentines who had taken them from Northern paintings. But while the question of the sources for the *Adoration* is of some interest, it is only of peripheral importance, because whatever Piero borrowed, and he borrowed much, he so transformed it that he made it his own.

36. Piero della Francesca, *Adoration of the Christ Child,* National Gallery, London

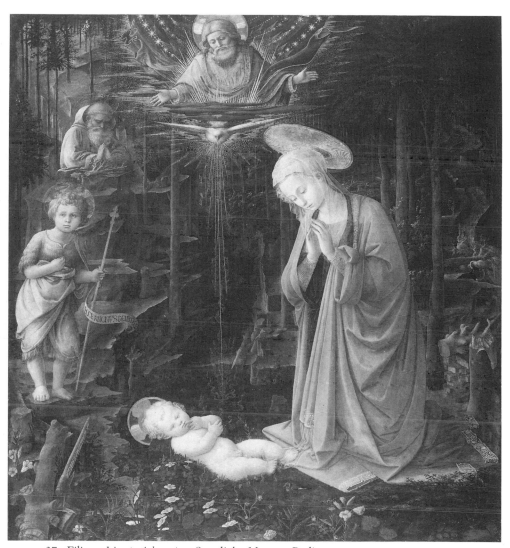

37. Filippo Lippi, *Adoration,* Staatliche Museen, Berlin

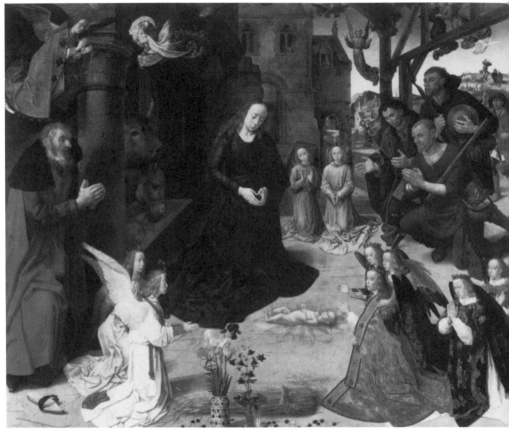

38. Hugo van der Goes, *Adoration of the Shepherds,* Uffizi Gallery, Florence

This is especially true of the angel musicians who sing and play before Christ in Piero's *Adoration.* The group is certainly dependent on a relief [39] from Luca della Robbia's *Cantoria* of c. 1438. Along with Donatello's contemporary *Cantoria,* Luca's work was in the Florence Duomo, where it must have been studied by Piero.

But Piero did not simply copy certain passages of Luca's *Cantoria* and set them down unaltered in his *Adoration;* rather, he absorbed and then rethought their stylistic principles. For his musician angels he took the stately rhythms of the *Boys Singing from a Scroll* [39] and the grace of the middle musicians in the *Cithara Players* [40]. Yet, these reliefs by Luca served only as springboards from which Piero's own imagination could leap. The andante rhythms of the singing and playing angels

emerged wholly from Piero's own fertile mind. (An amusing gloss on the angelic music is furnished by the donkey, which lifts his head and emits what certainly must be a cacophonous bray, much as a dog will howl when his master sings or plays the piano.[26] This bit of fun cannot be unintentional and provides a rare glimpse of Piero's sense of humor.)

Piero's fascination with drawing is seen throughout the London *Adoration*. In the garments, especially those of the angels, it is evident that the intricate fold patterns could have been painted only with the aid of cartoons. Such cartoons were fashioned after the artist made a series of studies on paper. These studies, usually done in charcoal or ink, allowed him to explore the structure and forms of what he was drawing. When the object—say, a tree or a foot—was analyzed to the artist's satisfaction, he would transfer his drawing by means of a grid to a full-size cartoon. This quite complete drawing was then either pricked or incised along its major contours and laid on the area of the panel, canvas, or fresco to be covered. Charcoal was pounced through the holes or a stylus or pencil run along the incisions. When the cartoon was removed, the essential elements of the tree, foot, or whatever object the artist had worked up on the series of paper studies were registered and ready to be painted.

In earlier Italian painting, preparatory drawings were drawn on the surface of the panel itself, but in the middle of the fifteenth century a growing desire for more complex form and space made such simple preparation impossible. Artists, including Piero, became increasingly fascinated with complex figure construction and the difficult problems of foreshortening the human body and setting it into space correctly and convincingly. Such complicated figures could be worked up only in paper drawings.

Piero, in fact, wrote a treatise dealing with these problems of representation. This illustrated book, *De prospectiva pingendi,* which exists in a number of manuscript copies, was meant for the instruction of the fledgling painter. It showed him how to construct objects in space according to a set of rules that Piero himself must have used in many of his preparatory drawings and paintings. A sort of exercise manual, the *De prospectiva pingendi* graphically illustrates how measurement, perspective, and drawing were to be used to represent the world. This book confirms, in words and diagrams, something one sees in Piero's painting: the searching of a probing, analytical mind to discover the essential nature of what is being represented. Such a pursuit was part of much Renaissance thought. In philosophy, science, cartography, history, and in many other fields of endeavor, one finds a questioning and empiricism that were to find expression in several of the greatest Renaissance quests, including voyages of discovery (Columbus discovered America in 1492, the year of Piero's death) and Leonardo da Vinci's *Notebooks.*[27]

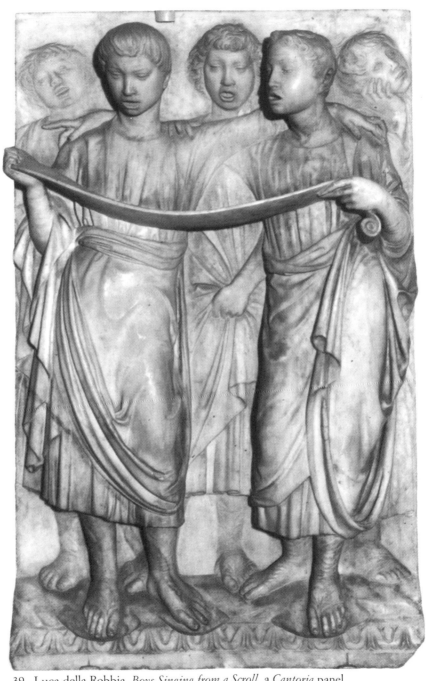

39. Luca della Robbia, *Boys Singing from a Scroll,* a *Cantoria* panel,
Museo dell'Opera del Duomo, Florence

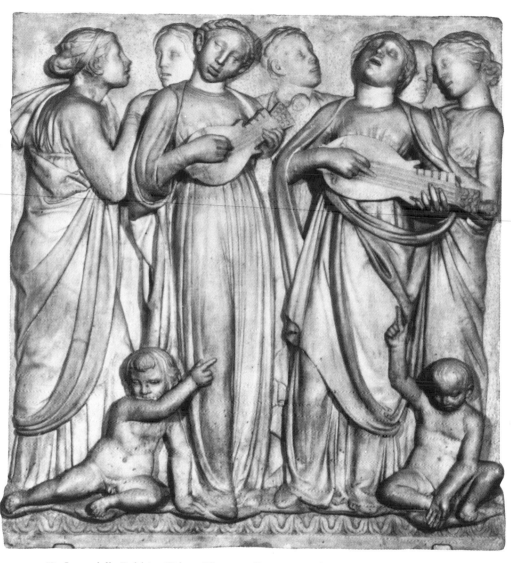

40. Luca della Robbia, *Cithara Players*, a *Cantoria* panel,
Museo dell'Opera del Duomo, Florence

41. Ambrogio Lorenzetti, *Good Government* (detail), Palazzo Pubblico, Siena

A figure such as the seated Joseph in Piero's *Adoration* demonstrates his skilled draftsmanship. Behind the complex pose lie many figure studies on paper and a cartoon. The art of drawing—the skill in rendering the figure that Piero displays in the *Adoration* and his other works—was to become an important element of painting. Piero is one of the pioneer draftsmen of the Renaissance; his achievements in the analysis and drawing of the human figure were to have considerable impact on several talented artists, most notably his pupil Luca Signorelli, who, in turn, was a source of inspiration for the young Michelangelo.

The landscape that unfolds in the left background of the *Adoration* is like that of the London *Baptism.* Once again the scene is set in a fertile Tuscan landscape with hills, valleys, placid streams, and small towns. The beauty of Piero's landscape complements the feeling of holiness arising from the still figures set in the unwavering light.

Both Piero's depiction of the town with tall towers and crowded, narrow streets leading to a large church and his treatment of the panoramic landscape were probably influenced by one of the earliest paintings of the Tuscan city and countryside, Ambrogio Lorenzetti's *Good Government* fresco in the Palazzo Pubblico, Siena, painted about 1340 [41]. If Piero saw it—and it would be surprising if he did not know such a famous work—he certainly would have been impressed by its remarkable naturalism. The light, the view of the landscape, and the depiction of the extensive hill town (Siena) of this fresco would surely have remained in a mind as visually acute and retentive as Piero's.

One of Piero's most important altarpieces [42], now in the Brera Museum in Milan, comes from Urbino, a hill town in eastern Umbria.

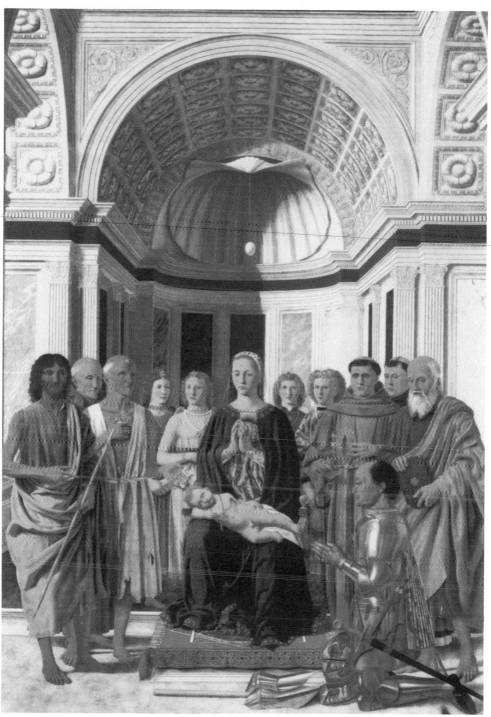

42. Piero della Francesca, altarpiece, Brera Museum, Milan

It was for Urbino that the artist executed several commissions for Duke Federico da Montefeltro, a famous soldier, sagacious patron, and benevolent ruler.[28] Federico understood well the memorializing and aggrandizing potential of art, and his patronage of Piero and other talented painters and sculptors, including Francesco di Giorgio and Francesco Laurana, has made his name and image still recognizable some five hundred years after his death. Urbino was also the birthplace of Raphael, whose father, Giovanni Santi, had been a mediocre painter at the court there.

In the early 1800s, Piero's altarpiece was removed from the church of San Bernardino, Urbino, where it had been on the high altar since at least 1703. It is, however, unclear if the work was commissioned for the church or was placed there at a later date. It has been suggested that the church of San Donato, Urbino, was the altarpiece's first destination, and that the painting was moved from that church to the neighboring San Bernardino after the latter was finished around 1490. Federico da Montefeltro's tomb was originally in San Donato, but it was later moved to San Bernardino.[29] In whichever church the Brera painting was first placed, it must have been one of the principal altarpieces.

All the figures stand in what appears to be the crossing of a Renaissance church. The size and grandeur of this structure and its implied extension of space beyond the borders of the picture (a device suggesting even greater size) make this one of the first truly monumental altarpieces of the fifteenth century. The formality of the carefully proportioned and decorated space, relieved and given substance by light and shadow, increases the stately, serious nature of the work.

As we shall see in a subsequent chapter, Piero's Brera altarpiece was to influence several later painters, including the Venetian Giovanni Bellini. Through Bellini and others, the idea of the monumental altarpiece whose figures are placed within a great church was to become a popular type in religious painting during the sixteenth century. Certainly Piero derived part of this impressive complex from the study of contemporary architecture. It has, in fact, been plausibly suggested that he was responsible for part of the design of the imposing but harmonious palace at Urbino. However, the major impetus for the altarpiece's architectural concept seems to have come from his own mind, a mind that anticipated by over half a century the heroic settings of the High Renaissance.

Before the apse are grouped four angels and six saints: from left to right, the saints are John the Baptist, Bernardino of Siena, Jerome, Francis, Peter Martyr, and John the Evangelist. In their midst the Virgin sits with the sleeping Child on her lap; to her left kneels Federico da Montefeltro in full armor, with his gauntlets, baton, and helmet on the floor before him.

The Mass performed before the Brera altarpiece was a mystical ritual

in which Christ appeared among the believers. His painted image, and the depictions of the angels and saints around him, had a potency hard even to imagine today. Intimately associated with the Mass and with a fervent belief in the animism of icons, pictures of Christ and the saints were a central part of the faith of every communicant.[30]

Often altarpieces were depictions of the Mass's invisible miracles; they were painted to make the invisible visible to the believer. This is certainly true of Piero's painting, where the worshiper is presented with a vision of the living Christ among the holy figures in the crossing of a church, the exact spot where the high altar and its altarpiece would have been placed.

It is thus no accident that the configuration of the Madonna and saints resembles an altarpiece within an altarpiece. The image of the Madonna and Child with angels surrounded by six saints, three to a side, would have strongly reminded the viewer of the figure arrangement in many contemporary altarpieces. In a certain sense it is as though a painted altarpiece has come to life and its protagonists miraculously stand in the sacred location of the altar. This feeling, along with the unwavering illumination (now visible after a recent restoration) and the monumental setting, makes the painting particularly moving and authoritative.

Part of the stillness and gravity of the work has been achieved through architecture and light, but much also comes from the figures and their grouping. The geometry of the bodies and the intervals of their place-ment are similar to those of every painting by Piero discussed so far. Undramatic, undemanding, isolated by thought, each figure remains wrapped in his or her own sacred meditations. They have no overt message, none wishes to convert or preach; their holiness and spirit exist, rather, in their quietude and presence in a serene, radiant atmo-sphere. The illumination of Piero's Perugia *Annunciation* and London *Baptism* [26, 33], here brought indoors, emphasizes the distilled shape of the holy figures.

In the Brera altarpiece, the semicircle of figures around the Madonna recalls the central panel of the Misericordia altarpiece [18]. The Brera Virgin, like the Madonna of the Misericordia altarpiece, is the physical and spiritual hub around which all else revolves. Further integration of the space has been achieved by the way the placement of the Virgin's court mimics the apse itself; another echo of the same shape is in the large masonry shell, from which hangs a large egg, probably that of an ostrich. And further tying the composition together, the walls of the church's nave frame the outermost saints, just as the apse echoes the innermost figures.

But something important is missing from the Brera altarpiece: the major shape of the kneeling duke is not counterbalanced by a similar form at the left; the painting, in other words, seems unbalanced, too

heavy on the right. Moreover, the duke is looking not at the Virgin and Child but straight ahead, toward the spectator's left. Yet when one follows the duke's gaze, there is nothing but empty space to be seen.

As all Piero's other paintings demonstrate, he was a painstaking composer. Everything in his work is the result of careful cogitation and calculation; nothing was left to accident. It seems, therefore, implausible that such an imbalance could have been accidental, the result of some oversight. Nor does it seem possible that some counterbalancing form on the left side was intended but not painted, even though Piero often painted foreground figures over those farther back; too many essential narrative and compositional elements—the gesturing and pointing hands of Jerome and John the Baptist, for example—would have been lost if other forms had been placed over them. Thus, the void at the left must have been carefully planned as an integral and important part of the picture's meaning.

This meaning may be gathered if we observe several other elements of the altarpiece. The sleeping Child, while not unique, is uncommon in fifteenth-century Tuscan painting.[31] Wearing a necklace of coral (a stone believed to ward off misfortune), the Child sprawls across his mother's lap in a deep sleep. The physical relation between the Madonna and the Child would have reminded the communicant of that other scene where Christ lies insensate across his mother's body—the Pietà. The association of the sleeping Child with the dead Christ was intentional, and it is just one of several allusions to life and death found throughout the Brera altarpiece.

Another is the large egg suspended above and behind the figures.[32] The egg has long been a symbol of birth and rebirth; even today, Easter celebrations would be incomplete without eggs and that other universal symbol of fertility, the rabbit. The egg is hung from a shell, yet another symbol of birth and life; one has only to think of the birth of Venus, with the young goddess rising from the sea on a shell, to realize the antiquity of the symbol.[33] In Piero's painting the shell is that of a scallop, worn by pilgrims in the Middle Ages. In the Brera altarpiece the scallop shell may be a reference to the long pilgrimage of life between nothingness and the Last Judgment. Such obvious, and yet unusual, pictorial allusions to life, death, and rebirth are connected with the strangely unbalanced nature of the Brera altarpiece, which is, it may now be postulated, a memorial to Federico's wife, Battista Sforza. There is visual evidence that leads to such a conclusion.

That the altarpiece has several unusual and prominent references to death and rebirth has already been seen. That the duke appears alone, while not conclusive evidence, strongly suggests that Battista was no longer alive, for large altarpieces such as this one often depicted husband and wife kneeling to either side of the Virgin.[34] Moreover, the

place where one would expect to find Battista, or the donor's wife, is the very location that seems so strangely empty and so contrary to Piero's normal mode of composition; it is also the focus of the glances of the duke and the Virgin.

Renaissance men and women had patron saints; these were either their name saints, or they were chosen for some other association. For instance, Saint Michael was the patron saint of the donor of Piero's Sant'Agostino altarpiece. Saint John the Evangelist, behind Federico, would have been a natural choice for the duke, because John's symbol was the eagle, the bird that was the Montefeltro symbol and as such appears on Federico's coat of arms. The leftmost saint is John the Baptist (San Giovanni Battista), the patron saint of Battista Sforza. But no donor is kneeling in front of the Baptist. Surely the citizens of Urbino who saw this painting would have been reminded of Battista by the presence of her saintly namesake and the portrait of her husband.

If this interpretation is correct, Battista is, by her absence, conspicuous. The sense of loss and emptiness that death creates among the living is then profoundly expressed by the void at the left of Piero's altarpiece. As in all great art, here the simplest elements of mass and space have been used to create sensations that are at one and the same time highly personal and universal. The memorial function of Piero's altarpiece was perfectly appropriate to an altarpiece before which the rebirth of Christ and the consequent hope of salvation and eternal life were expressed through the miraculous rite of the Mass.

That the Brera altarpiece was an extremely important commission is evident from the way Piero lavished so much attention upon its color and detail. The figures are both linked and separated by color; the grays and gray-greens of the saints are punctuated by the red of John the Evangelist's robe and by the greens and reds of the angel's clothes. Yet the palette of the Brera altarpiece remains essentially the same as the one used in most of Piero's works. The earthy greens and grays, the pearly hue of the skin, and the brilliant punctuating notes of red, yellow, and green are unchanging elements in his art.

Particular attention has been paid to the surface of objects in the Brera altarpiece. The play of light on Federico's shiny parade armor, the reflections on the hard surface of the marble, the light-absorbing qualities of the heavy cloaks, and the sparkle and luster of the precious stones are all depicted with consummate skill. It may be that a study of Netherlandish painting, which Piero could have seen in Urbino, inspired him to paint such masterful surfaces and textures, but he is no mere imitator, for these surfaces are an integral and crucial part of his quiet, sacred world where light sanctifies everything from a pearl to a church.[35]

In many ways the Brera altarpiece is among Piero's most important works; it is singular in its composition and in its memorial function. It

is also flawlessly planned, painted, and colored, a memorable image both in its entirety and in its finely wrought details, and, as we shall see, it is probably Piero's most prophetic and influential work. Moreover, it is a moving, profound image that addresses the core of the miraculous rite of the Mass and the universal human emotions of loss and hope.

The original function of the Brera painting is clear: it is an altarpiece meant to be placed on an altar table in a church in Urbino; its size, shape, and iconography all identify it as a specific type. In contrast, Piero's *Flagellation of Christ* [43], now in the Galleria Nazionale delle Marche in Urbino, has so few of the usual indicators of type that its very function and purpose are unknown. It is, in fact, Piero's most perplexing and debated work.[36]

The facts that surround the *Flagellation* are few indeed. Absolutely nothing is known about its commission, and there is no mention of the painting before the nineteenth century, when it was recorded in the sacristy of the Cathedral of Urbino. It is, of course, possible that the *Flagellation* was painted for the Cathedral, but without a contract or some other primary documentation, its origins and original location remain a mystery.

Any investigation of the *Flagellation* might profitably begin by asking what it is. Its small size (59 x 81 cm) and its subject do not suggest an altarpiece. Although the Flagellation often appears as part of an altarpiece (on the predella of Piero's Misericordia polyptych, for example), it seldom, if ever, was used for the central panel. The shape and dimensions of Piero's Urbino *Flagellation* also make it unlike any known altar wing or pinnacle.

The *Flagellation* in Urbino seems too large for a predella, but also too small for an altarpiece; it could, however, have formed part of a larger altarpiece complex, although it is difficult to imagine (based on what we know from surviving altarpieces) what such a construction could have looked like. Perhaps the *Flagellation* was one of a series of panels decorating a sacristy press (it was first cited in the sacristy of the Cathedral of Urbino) or one of several paintings inserted in the paneling of a room.

Piero worked for a flagellant confraternity in Sansepolcro (the Misericordia), and it is possible that the Urbino *Flagellation* was made for one of the many such organizations then active in Umbria. It is even possible, although unlikely, that the *Flagellation* was carried in one of the processions that were so much a part of the life of the flagellant societies.[37]

The Urbino *Flagellation* is divided into two sections by the fluted column set near the center of the picture: at the left, Christ is flagellated in the interior of an open building; at the right, three men stand in front of a street with a bell tower and a palazzo.

These three men, their relation to the Flagellation, and their identities

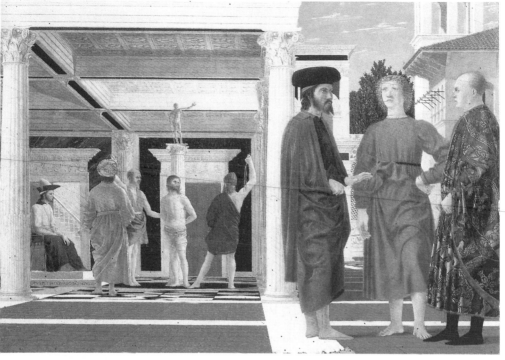

43. Piero della Francesca, *Flagellation of Christ,*
Galleria Nazionale delle Marche, Urbino

have long fascinated scholars. Perhaps more words have been written
on this aspect of the *Flagellation* than on any other subject of Piero's
work. Many theories, some of them learned and wise, some of them
learned and nonsensical, have been advanced toward the identification
and purpose of the three mysterious men.[38]

Not one of their faces seems quite individualistic enough to be an
actual portrait; instead, each appears to be drawn from Piero's reper-
toire of faces and types. Since these are not portraits, it is most likely
that the three men are simply bystanders who discuss the event
occurring in the left background. A number of other paintings of the
Flagellation also depict bystanders, although none give them such prom-
inence.[39] Why Piero chose to place these three figures so close to the
picture plane and to make them such an important part of the narrative
remains a mystery.

The *Flagellation* demonstrates Piero's unceasing interest in the sim-
plest, most elemental aspects of painting. Each side of the composition
is an echo of the other. To the right, the mass of the three figures is set

before a spatial cube; in the left half, a rush of space back from the foreground leads to figures and a wall. The abstract balance and harmony achieved by this alternation of void and mass is not unlike the composition principles behind the Brera altarpiece or any of Piero's more obvious geometric compositions.

Although the *Flagellation* is in battered condition, with considerable paint loss, it is still possible to see that it glows with the otherworldly light of Piero's *Baptism* and Brera altarpiece. The radiance of the coffered ceiling above Christ (which seems to be lit by his divine presence) and on the black-and-white floor pattern around his feet is especially noteworthy.

In the *Flagellation* Piero treads a fine line between representation and pattern. Bodies, columns, floor tiles, and trees all are recognizable and convincing depictions; yet, these same objects are each integral parts of a system of overall pattern that enlivens the painting and makes it exist on another, nonrepresentational plane. In a way, Piero has retained in the *Flagellation,* as in his other paintings, the sense for the abstract and decorative that was the principal characteristic of Tuscan painting in the thirteenth and fourteenth centuries. Paintings from these centuries narrated stories within a highly formal framework of line, pattern, and color. This can easily be seen in the Sienese *Resurrection* altarpiece in Sansepolcro, which was an inspiration for Piero's fresco of the same subject.

However, by the fifteenth century, artists—Masaccio foremost among them—had begun to puncture the picture with one-point perspective and to lessen the role of pattern in favor of clear and dramatic narrative. In Masaccio's *Tribute Money* [5], for example, pattern and the abstract play of line and color are subsumed by the desire to narrate a story in a realistic, straightforward, and dramatic manner. Narrative now takes precedence over shape and form. To put it another way, the primary role of painting now is to tell the story. Overall formal considerations, so crucial in earlier painting, have become less important.

By the time Piero began to paint, most Florentine artists had moved a considerable distance from the earlier, more abstract and decorative style of their artistic ancestors. This was not, however, true in Siena, where the influence of the founders of the school was still powerful. It is likely that Piero acquired his unceasing interest in painting that was highly decorative and abstract in its overall design from his Sienese contemporaries. Since he was by nature conservative, it is also possible that he studied the sources of contemporary painting by investigating and learning to understand the art of the past. Piero's understanding of abstraction in painting is especially evident in his fresco cycle of the True Cross, in Arezzo (see Chapter 3), but it is native to all his works.

Pattern, of both shape and color, is a major element in Piero's *Madonna of Senigallia* [44]. The picture was once in the church of Santa

Maria delle Grazie in the small Umbrian town of Senigallia, on the Adriatic coast, but because it is unrecorded in primary documentation, it is not even certain that Senigallia was its original location. In fact, the painting's small size, its rather intimate nature, and its painted setting (the rooms of a Renaissance palazzo) suggest that it may have been made for private devotion in a home.

The type of the *Madonna of Senigallia* (three-quarter-length Virgin and Child flanked by angels) was popular about the middle of the fifteenth century in Tuscany, but this remains the only example of it in Piero's work. The specific sources for the panel appear to be in contemporary Sienese painting, but as in all cases of Piero's borrowing, the source serves only as an inspiration for something quite different.[40]

Flemish paintings have also been suggested as possible inspiration for the *Madonna of Senigallia,* and in fact the light streaming through the windows and reflected on the back wall and the particular opalescent quality of the pearls recall Northern paintings, especially those by Jan van Eyck and his followers. It is likely that Piero knew Northern works either in Florence or at the court of Urbino, where Federico da Montefeltro employed at least one Fleming.[41] But, although Piero may indeed have been influenced by contemporary Tuscan artists and by Flemish paintings, these were only superficial sources of motif and observation; in no way did they substantially alter the style and meaning of his work.

In all its aspects, the *Madonna of Senigallia* remains one of Piero's most characteristic works. The absolute stillness of the room and its unwavering light touching every object and surface are nearly identical with the Brera altarpiece; in the *Madonna of Senigallia,* however, the mood is more intimate, and the holy figures seem more aware of the observer.

The *Madonna of Senigallia* is a reticent and sober image. An adagio of mass and void is traced across the picture plane by the voluminous bodies of the holy beings; further rhythms are created by the nearly monochromatic fields of meticulously placed color. Despite its damaged and abraded condition (much of the subtle modeling has been lost, and the Madonna's robe has oxidized from blue to a dull blue-black), the subtlety of color is still impressive. The Madonna's clothes are fields of rose, blue, and gray-green; delicate variants on these colors are found in the gray and pink of the angels' robes. All the colors have been given an added brilliance by the blond hair and the luster of the pearls. The patterns of space, color fields, figures, and architecture, all characteristic of Piero's other paintings, create a stable, balanced, and satisfying work. Everything about the picture seems preordained and essential, as though no object or color could be removed or even slightly altered without the whole falling to pieces. The painting has all the rightness and inevitability of a Titian, Rembrandt, or Degas.

The *Madonna of Senigallia,* like the other altarpieces discussed in this

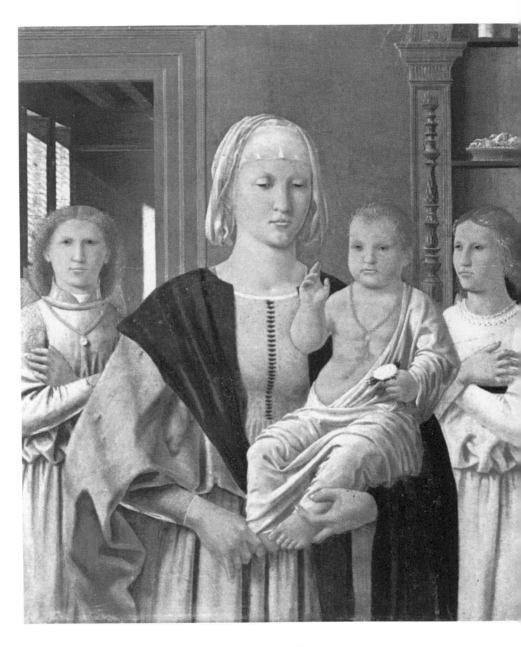

44. Piero della Francesca, *Madonna of Senigallia*,
Galleria Nazionale delle Marche, Urbino

chapter, is the thoughtful expression of Piero's artistic, spiritual, and emotional nature.[42] For both the types and the subjects of his altarpieces, Piero found sources in the fertile seedbed of the art of his own time. He, like almost all the artists of his day, eschewed invention in favor of tradition. This was true also in the development of his own style, which depended on the works he knew in Sansepolcro and on the paintings and sculpture he saw in Florence in 1439 when he worked with Domenico Veneziano. Piero borrowed with both hands from the past and from his own time; this was the time-honored way Renaissance artists learned and then developed their art.

Yet, Piero's altarpieces are strikingly original. In them one finds the rethinking and transformation of contemporary conventions. The holy figures and their environment are now visualized with a new lucidity and rationality that elevates them into the realm of transcending art. Piero's restrained beings have a presence and weight that gives them resonance in the luminous and ordered world they inhabit. These characteristics were for Piero metaphors of rightness and divinity, and as such they confer an ineffable grace and permanence to the tempered universe of his vision. Yet, the challenge and demands of the altarpiece were matched, and perhaps superseded, by the complexities facing Piero when he worked at large-scale painting in fresco, a demanding medium that offers additional insight into his artistic and emotional constitution.

NOTES

1. The type of Piero's Misericordia altarpiece was common about the middle of the fifteenth century. With the exception of his portraits of Federico da Montefeltro and Battista Sforza (see Chapter 4), Piero seems to have worked in traditional types that depict traditional subjects and stories.

2. Misericordia: R. Weissman, *Ritual Brotherhood in Renaissance Florence,* New York, 1981.

3. Contract for the Misericordia altarpiece: For a transcription of the contract see E. Battisti, *Piero della Francesca,* Milan, 1971, vol. 2, p. 220; an English translation is found in D. Chambers, ed., *Patrons and Artists in the Italian Renaissance,* Columbia, S.C., 1971, pp. 52–53.

4. Imitation of older images: B. Cole, "Old in New in the Early Trecento," *Mitteilungen des Kunsthistorischen Institutes in Florenz* 17 (1973): 229–48.

5. The Misericordia altarpiece is now displayed in a stark, modern frame, which gives little clue as to how the painting looked in its original, more ornate and gilded, frame. Moreover, the surface of the painting is for the most part in poor condition.

6. Perhaps this placement on a fictive plinth owes something to statues of the Madonna della Misericordia. Piero might have been influenced by the old sculptural tradition of this image type.

7. For Renaissance dress see: E. Birbari, *Dress in Italian Painting, 1460–1500,* London, 1975.

8. The exact identity of this figure has been debated. Recently the figure has been called Saint Andrew, but the Saint John the Baptist to the Madonna's right makes Saint John the Evangelist the more likely possibility.

9. Bernardino da Siena: I. Origio, *The World of San Bernardino*, New York, 1962.

10. For a listing of these saints see: P. de Vecchi, *The Complete Paintings of Piero della Francesca*, New York, 1967, and E. Battisti, *Piero della Francesca*, Milan, 1971, vol. 2, p. 124.

11. For information on the last payment documents for the Misericordia altarpiece, see E. Battisti, *Piero della Francesca*, Milan, 1971, vol. 2, p. 225.

12. During the Renaissance several workshops occasionally worked on the same project. For the Brancacci Chapel, for instance, three separate workshops seem to have painted on the same fresco cycle at different times. Also in Florence, the painter Fra Angelico finished an altarpiece of the Deposition begun by Lorenzo Monaco, an older artist who apparently died after completing only the pinnacles of the painting.

13. Flagellant confraternities: R. Weissman, *Ritual Brotherhood in Renaissance Florence*, New York, 1981.

14. Discussion of altarpiece types: B. Cole, *Italian Art, 1250–1550: The Relation of Renaissance Art to Life and Society*, New York, 1987, pp. 98–121.

15. Theories on the present shape of the Perugia altarpiece: E. Battisti, *Piero della Francesca*, Milan, 1971, vol. 2, pp. 22–75.

16. G. Vasari, *The Lives of the Painters, Sculptors, and Architects*, trans. by A. B. Hinds, London, 1966, vol. 1, p. 335.

17. Scenes from the lives of the Virgin and Christ appear in the predellas of Annunciation altarpieces painted during the late fourteenth and early fifteenth centuries. For two examples, see B. Berenson, *Italian Pictures of the Renaissance: Florentine School*, London, 1963, vol. 1, plates 463, 498.

18. Contract for the Sant'Agostino polyptych: E. Battisti, *Piero della Francesca*, Milan, 1971, vol. 2, p. 222. For an English translation, see D. Chambers, ed., *Patrons and Artists in the Italian Renaissance*, Columbia, S.C., 1971, pp. 9–10.

19. Final payment for the Sant'Agostino polyptych: E. Battisti, *Piero della Francesca*, Milan, 1971, vol. 2, p. 228.

20. Possible reconstructions of the Sant'Agostino altarpiece: M. Davies, *The Earlier Italian Schools*, London, 1961, pp. 428–33; M. Meiss, *The Painter's Choice*, 1976, pp. 82–104.

21. Provenance of the London *Baptism:* M. Davies, *The Earlier Italian Schools*, London, 1961, pp. 426–28; E. Battisti, *Piero della Francesca*, Milan, 1971, vol. 2, pp. 17–19.

22. Side wings of the London *Baptism:* E. Battisti, *Piero della Francesca*, Milan, 1971, vol. 2, pp. 17–18.

23. It is difficult to understand why there is such a disparity in size and style between the *Baptism* and the panels by Matteo di Giovanni that once surrounded it.

24. Provenance of the National Gallery *Adoration:* M. Davies, *The Earlier Italian Schools*, London, 1961, pp. 433–34.

25. Filippo Lippi's Berlin *Adoration:* G. Marchini, *Filippo Lippi*, Milan, 1975.

26. This amusing detail was first noted by Paul Barolsky. See P. Barolsky, "Piero's Native Wit," *Source* 1 (1982): 21–22.

27. *De prospectiva pingendi* and Piero's other writings: Piero della Francesca, *De prospectiva pingendi*, ed. G. Fasola, Florence, 1952; M. Davis, *Piero della Francesca's Mathematical Treatises*, Ravenna, 1977.

28. Federico da Montefeltro: J. Dennistoun, *Memoirs of the Duke of Urbino*, vol. 1, London, 1851; W. Tommasoli, *La vita di Federico da Montefeltro*, Urbino, 1978.

29. Documentation of Brera altarpiece: E. Battisti, *Piero della Francesca*, Milan,

1971, vol. 2, p. 230; M. Meiss, *The Painter's Choice,* New York, 1976; M. Meiss, *La Sacre Conversazione di Piero della Francesca. Quaderni della Pinacoteca di Brera,* Florence, 1971.

30. Supernatural power of images: B. Cole, *Italian Art, 1250–1550: The Relation of Renaissance Art to Life and Society,* New York, 1987, pp. 75–148.

31. The sleeping Child in Renaissance painting: M. Meiss, *The Painter's Choice,* New York, 1976, pp. 117–19.

32. Egg symbolism: M. Meiss, *The Painter's Choice,* New York, 1976, pp. 105–29.

33. Shell as symbol: M. Meiss, *The Painter's Choice,* New York, 1976; and C. Gilbert, "On Subject and Not-Subject in Italian Renaissance Pictures," *Art Bulletin* 34 (1952): 202–16.

34. Many altarpieces and frescoes painted during the fourteenth and early fifteenth centuries depict a husband and wife kneeling before the Virgin or other sacred figures. Perhaps the most famous of these is Masaccio's *Trinity,* in Santa Maria Novella, Florence, painted about 1425 and almost certainly known to Piero. It is possible that the kneeling donors, the coffered barrel vault, and the classically inspired architectural ornament of the *Trinity* influenced Piero's conception of the Brera altarpiece. In a forthcoming article Barbara Bays will suggest that Piero added four extra figures, including the Saint Bernardino, to the Brera altarpiece, perhaps because it was originally intended for another site and subsequently placed in the church of San Bernardino. Such a change would help to explain the large number of figures in the painting.

35. History of Netherlandish painting: M. Friedlander, *Early Netherlandish Painting,* trans. H. Norden, New York, 1967–76; E. Panofsky, *Early Netherlandish Painting,* 2 vols., New York, 1971; M. Friedlander, *From Van Eyck to Bruegel,* London, 1981.

36. References to the Urbino *Flagellation:* M. Lavin, *Piero della Francesca: The Flagellation,* London, 1972.

37. Banners made for Umbrian flagellant confraternities: F. Santi, *Gonfaloni umbri del Renascimento,* Perugia, 1976.

38. For the various theories on the *Flagellation,* see note 36. For the one plausible alternative interpretation of the subject, as the Dream of Saint Jerome, see John Pope-Hennessy, "Whose Flagellation?" *Apollo* CXXIV, no. 295 (September 1986): 162–65.

39. Flagellations with bystanders: C. Gilbert, "On Subject and Not-Subject in Italian Renaissance Pictures," *Art Bulletin* 34 (1952): 208–9.

40. Piero may have derived his composition from the half-length Madonna, Child, angels, and saints format used by his Sienese contemporaries Matteo di Giovanni and Neroccio de' Landi. For examples of these pictures, see B. Cole, *Sienese Painting in the Age of the Renaissance,* Bloomington, 1985, figs. 60, 70, 71.

41. For Justus of Ghent, the Flemish artist who worked for Federico da Montefeltro, see M. Salinger, "Justus of Ghent," *Encyclopedia of World Art,* New York, 1963, vol. 8, pp. 946–47.

42. Among the several altarpieces and altarpiece fragments occasionally attributed to Piero only one, in my opinion, merits serious consideration. This is the small *Madonna and Child with Four Angels* in the Clark Institute, Williamstown, Conn. Although often accepted as an autograph work, this painting, to my mind, remains problematic. Certainly the style resembles Piero's, but the proportional and spatial characteristics of the figures and architecture seem foreign to his autograph work. Especially divergent is the indeterminate and perplexing relation between the patternlike Madonna and the surrounding architecture.

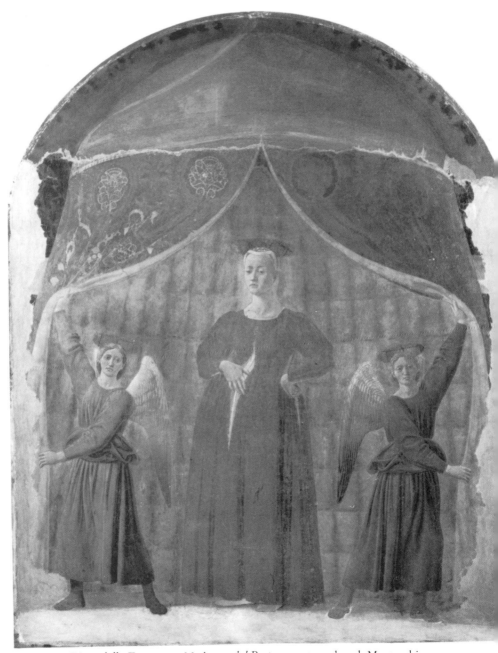

45. Piero della Francesca, *Madonna del Parto,* cemetery chapel, Monterchi

III

THE FRESCOES

U nlike altarpiece painting in tempera or oil, the difficult medium
of fresco demands a large-scale plan, rapid execution, and a
sure, sweeping brush. Where and when Piero learned to paint
in the fresco medium remains unknown, but in his surviving works in
the medium he demonstrates a mastery of the art.[1]

The fresco [45] of the *Madonna del Parto* (the pregnant Madonna) is
located in a cemetery chapel just outside Monterchi, a village near San-
sepolcro. This small chapel was originally part of the church of Santa
Maria di Momentana; already mentioned in the thirteenth century, the
church was a small provincial structure located in a rather isolated and
rustic place. In 1785, it was decided to establish a new cemetery on the
church grounds. To obtain space, roughly two-thirds of the church was
demolished, and the remaining part of the building was turned into a
chapel, probably because this part of the edifice contained Piero's fresco
of the *Madonna del Parto*. There can be little doubt that the fresco was
saved precisely because it contained powerful messages of life and hope
that were appropriate for its new function as an image in a cemetery.[2]

The fresco is in rather bad condition; there are large paint losses at
the sides of the tent, and the conical shape that now tops the structure
is new, an attempt to approximate what the lost upper part of the fresco
might have been. The feet of the angels are also only partially original.
Overall, there has been a considerable loss of detail, color, and model-
ing; nonetheless, much of the splendor of the original concept is still
dimly visible. Piero seems to have worked with a combination of true
fresco (a demanding, highly durable medium applied to wet plaster) and
the less permanent tempera technique called *fresco secco,* in which the
pigment, carried in the yolk of eggs, is applied to the dry plaster of the
wall.

Although several other examples of the *Madonna del Parto* are known
from the fourteenth and fifteenth centuries, the image is a rare one.[3] In
Piero's fresco, Mary's pregnancy is shown by her protruding abdomen,
which she touches with her right hand, and by the maternity dress with

expandable pleats. Her stance, with the left hand supporting the hip, is characteristic of pregnant women as they seek to balance their newly acquired weight.

Flanking the Madonna are two angels holding the sides of a tentlike structure. These angels are mirror images of each other, and were made with the same cartoon. (This was done by holding the cartoon to the wall and sketching in one angel; the cartoon was then flipped and the other angel drawn on the plaster, thus creating a mirror image of the first.)

Before the middle of the fifteenth century, fresco compositions were worked up on the actual surface of the wall to be painted, and cartoons were used mainly for intricate border decoration or other equally repetitious tasks. Piero was one of the first artists to make extensive use of the cartoon in fresco, and probably in panel painting as well. In the *Madonna del Parto,* and especially in his large True Cross cycle in Arezzo, he utilized a small number of cartoons extensively, making them serve as the basis for numerous figures. The use and reuse of the same cartoons impart an overall harmony and stability to Piero's frescoes, which is probably one of the principal reasons why he utilized them so frequently.

In the *Madonna del Parto* all the figures are placed in a conical, tentlike structure opened to view by the angels, who pull back the flaps. The inside of the structure is lined with fur, while the outside is splendidly embroidered with a pomegranate motif. The central Madonna, the mirror-image angels, and the enclosing conical tent all work together to create a composition of stability and balance. In many of its formal elements—the geometry of the Madonna's body, the echoing shapes of the solids, the enclosing semicircle of the tent, and the deposition of figures, which seems so permanent and right—this fresco is very much like the *Madonna della Misericordia* and the Brera altarpiece.

Yet, Piero was unwilling to make the fresco too symmetrical or too balanced; he chose instead to give it subtle variety and relief through form and color. Piero realized that a fully frontal Madonna would create the sort of static form he wished to avoid. So, although the Madonna occupies the central position, her body is turned slightly sideways. This turn both accentuates her pregnancy and moves her form into the picture.

Color also helps enliven the painting. The blue of the Madonna's gown anchors and centers the picture, while the brown of the fur lining forms a neutral expanse before which the figures stand. But the angels are more varied: the green robe on the left is repeated in the wing and stockings of the right angel, whose brown robe is, in turn, echoed by the stockings of his companion. A rather different note is sounded by the mauve wing of the left angel (further higher-pitched colors would have been furnished by the multicolored pavement upon which the

figures probably originally stood). The overall effect of these brighter colors was to give relief and movement to the surface of the fresco while creating a rough color balance among the fresco's various parts. Throughout there also appears, in spite of the many surface abrasions, that luminous tonality found in all Piero's frescoes and panel paintings.

Color and form, light and composition are the various visual elements by which Piero expressed the central message of this fresco: hope and rebirth. The state of pregnancy, the fact that new and divine life is in the womb, underlies all else in the fresco. Like the tent enclosing the figures, the Madonna here contains Christ. During the Middle Ages and the Renaissance, the Madonna was often figuratively called the tabernacle of the Lord (the Latin word *tabernaculum* means "tent"), a role she plays literally in Piero's fresco.[1]

That Piero and his contemporaries thought in these terms is proved by a tabernacle for the preservation of the Host. This glazed terra-cotta object by the school of Luca della Robbia [46] is in the Cathedral of Sansepolcro, and was probably known to Piero. As in the *Madonna del Parto,* two angels pull aside the flaps of a tent, or tabernacle. But, instead of the Madonna in the center, one here sees the chalice and the Host placed above the little door behind which the actual Host is kept.[5]

Piero's brilliant composition of the *Madonna del Parto* may have arisen from his contemplation of this tabernacle or one like it. The connections between the two are strong indeed. What Piero has done is to humanize the tabernacle type by making the Madonna herself into the tabernacle, the fleshy receptacle in which Christ's body is held. The angels and the tent are derived from the Sansepolcro tabernacle or another close to it, but they now surround the living mother of Christ rather than a simple depiction of the Host. This transformation is a brilliant expression of Piero's thought, and the fresco a dazzling example of how he recombined highly traditional forms and ideas to create works that fundamentally reinterpret time-honored types.

Birth and fecundity are also alluded to by the pomegranate motif on the outside of the Madonna's tent. Since antiquity the pomegranate with its many seeds has been considered a symbol of fertility: in the ancient world, it was associated with Proserpine, who was thought to bring spring and regeneration each year.[6] Christians saw the pomegranate as a symbol of rebirth and resurrection, and the Child often holds the fruit as he sits on his mother's lap.

The communicant who stood before Piero's *Madonna del Parto* would have been conscious of its obvious references to the Mass and the resurrection and rebirth of Christ; but he would also have been acutely aware of his own mortality and ever-present hope for personal rebirth and salvation. This awareness would have been heightened by Piero's conscious reutilization of figures long associated with tomb sculpture.

Beginning in the thirteenth century, recumbent carved images of the

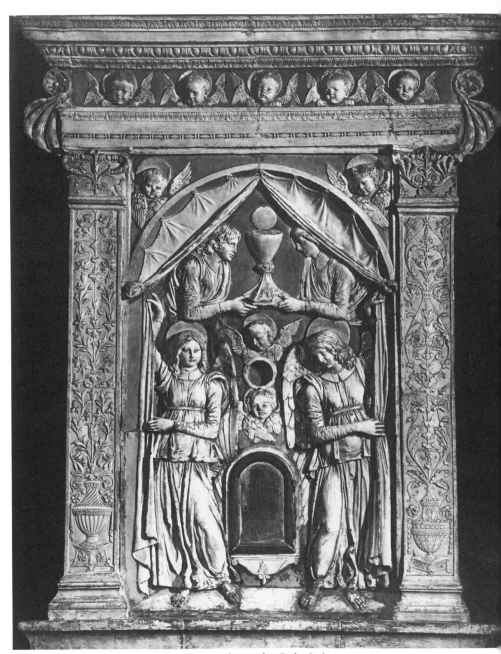

46. School of Luca della Robbia, tabernacle, Cathedral, Sansepolcro

deceased revealed to the onlooker by two figures began to appear on tombs in Tuscany.[7] Piero and his contemporaries must have known several examples of the type, including the imposing Tarlati monument of the early fourteenth century [47], in the Duomo of Arezzo, a substantial provincial city with which Sansepolcro had many ties. The Tarlati tomb presents a transitory drama of angels (other similar contemporary tomb types occasionally depict deacons) granting the onlooker one last glance at the deceased before the curtains are closed forever. As in a play, when the curtains shut, the action ends.

In Piero's *Madonna del Parto* the two angels, who closely resemble their counterparts on tombs, push aside the embroidered material, revealing the Madonna. But here, instead of death, one finds life and the hope of resurrection and salvation nascent in the body of the pregnant Madonna. The melding of the curtain-opening angels from tombs (and from sacramental tabernacles) with the Madonna was, it seems, deliberate and meant to further emphasize the powers of the Virgin and Christ over death.

Piero's *Madonna del Parto* is, as we can now see, a highly complex, multilevel work; yet, it presents its messages through forms that are simple and direct. There is a remarkable clarity about this fresco that makes it memorable; it is, in fact, an icon that still works its supernatural power. (When it was suggested that the fresco be moved from its chapel to a museum, the women of nearby Monterchi objected. For them it was a potent talisman of fertility and birth, a living presence. The awe and respect that these women had for the *Madonna del Parto* was, in truth, much closer to fifteenth-century veneration of the fresco than is our more distant, archaeological view.)

Similar strong feelings were provoked by Piero's *Resurrection of Christ* [48], in the town hall (now the Pinacoteca) of Sansepolcro. For many, the *Resurrection* has become the touchstone of Piero's style and the work that best represents his artistic personality. It is certainly one of his masterpieces and, like the *Madonna del Parto,* it is a complex, many-layered work with messages that deal with essential aspects of Christian faith. Moreover, the *Resurrection* has another dimension, for it was not only a religious icon but a civic one as well, since those Renaissance citizens who saw it in the town hall (or the Palazzo dei Conservatori, as it was then called) would have realized immediately that the image of the Resurrection was Sansepolcro's coat of arms. According to ancient legend, the city had been founded by pilgrims just returned from the Holy Land who had brought with them relics of Christ's tomb—hence the name Sansepolcro, or Holy Sepulcher. By the sixteenth century the Resurrection had become the city's coat of arms, and it appears that the use of the image dates back much earlier.[8] Any citizen seeing the *Resurrection* would have immediately associated it with Sansepolcro and the origin of the city's name.

47. Agostino di Giovanni and Agnolo di Ventura, Tarlati monument, Cathedral, Arezzo

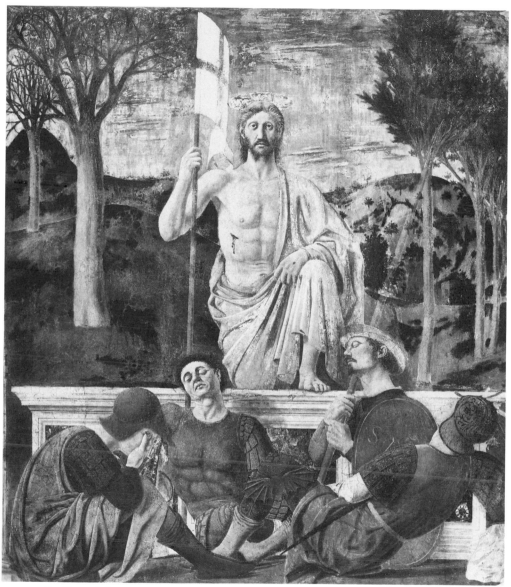

48. Piero della Francesca, *Resurrection of Christ,* Pinacoteca, Sansepolcro

Such a mixture of the sacred and the civic was one of the salient features of Renaissance life.[9] There was no separation, in our modern sense, of church and state; religious and secular life intermingled in government, trade, and at all levels of daily life. For example, Tuscan Maestà paintings, with the Madonna, Child, and a court of saints and angels, would often include religious personages of decidedly local significance. Saints and *beati* (men and women who were beatified either officially by the church or in the minds of their contemporaries) were often the object of fervent devotion in their native cities.

Consequently, in an altarpiece such as Duccio's *Maestà* [49], made for the high altar of the Siena Cathedral in 1311, the standard theme of the enthroned Madonna and Child with saints and angels is given a civic meaning by the inclusion of the four protector saints of Siena, who kneel in the very front of the picture.[10] A similar intermingling of sacred and civic is found in Piero's *Resurrection* for the town hall of Sansepolcro. In fact, the civic meaning of the fresco was inexorably connected to its role as a sacred image. Christ rises out of the holy tomb whose relics figure in the founding of Sansepolcro, but the event transcends mere civic or communal significance, for it is a central event in the Christian drama. Its meanings of triumph over death and of rebirth were crucial to all who yearned and prayed for salvation. It is this ever-present hope for life after death, for rebirth and redemption, that Piero has put forth so brilliantly in the *Resurrection*.

In his beautiful passages on the Sansepolcro *Resurrection,* Kenneth Clark discusses the primordial nature of the scene.[11] Here Christ is the savior of mankind, but he is also a universal symbol of rebirth; the potent regenerative power of the image would surely have been recognized by Piero's Tuscan forerunners, the Etruscans and Romans, for example, who had worshiped gods of fertility and renewal. This is not to suggest that Piero consciously melded Christ with an ancient earth god, for such an action would have been contrary to the deeply felt Christian spirituality of all his religious paintings. However, there arises from the work such an inevitable, immutable, and profound spirit, a spirit that is connected with the rhythms of life and nature, that one cannot but see Piero's great *Resurrection* as something that transcends all narrow temporal and sectarian boundaries.

Christ himself is an integral, vital part of the natural world; he seems not to dominate it, but to be like it, imbued with the same mystical regenerative forces found in the seed or the egg. The shining white form of his still body stands straight like the trees behind and, like the trees at the right, it has been reborn. The dawning sky, the scudding clouds streaked pink from the sun still hidden behind the hills, the dormant but fecund soil, and the freshness of the morning are all pregnant with the mystical pulse of rebirth.

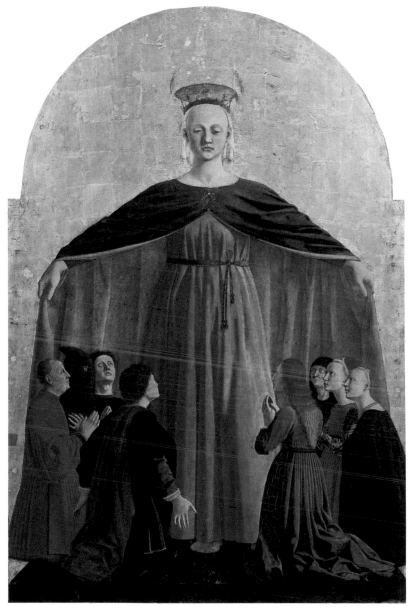

Plate 1. *Madonna della Misericordia* (detail of center panel), Pinacoteca, Sansepolcro (Scala/Art Resource, NY)

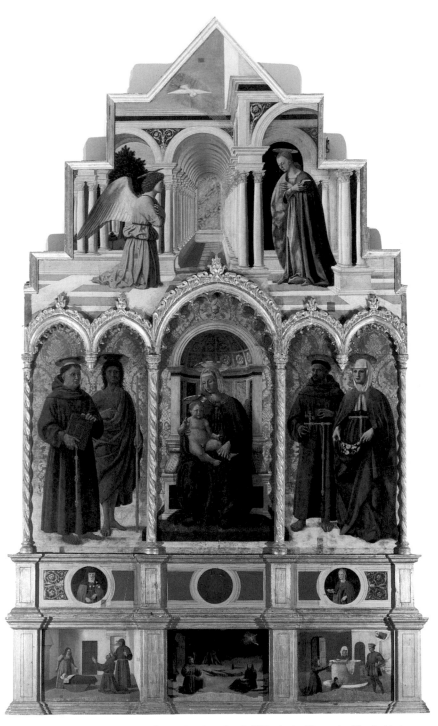

Plate 2. Altarpiece, Galleria Nazionale dell'Umbria, Perugia (Scala/Art Resource, NY)

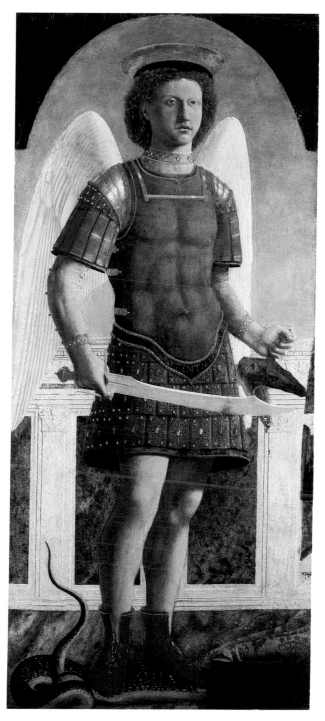

Plate 3. *Saint Michael*, National Gallery, London

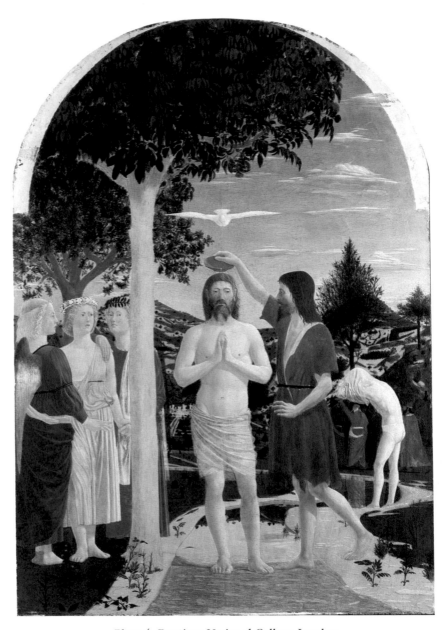

Plate 4. *Baptism*, National Gallery, London

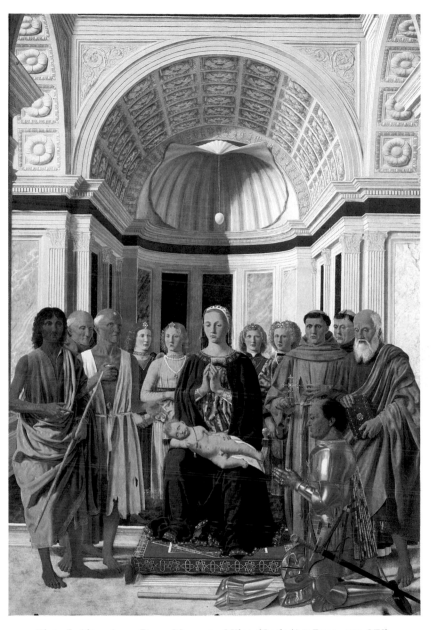

Plate 5. Altarpiece, Brera Museum, Milan (Scala/Art Resource, NY)

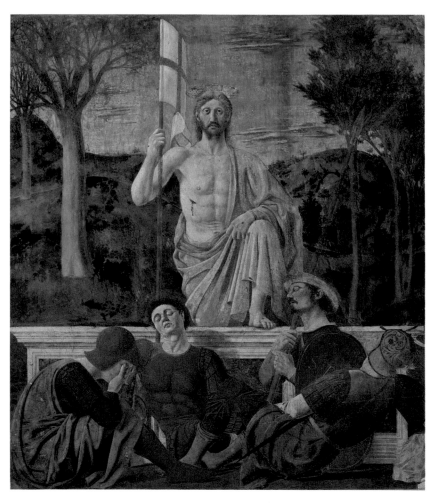

Plate 6. *Resurrection of Christ*, Pinacoteca, Sansepolcro (Scala/Art Resource, NY)

Plate 7. *Dream of Constantine*, San Francesco, Arezzo (Scala/Art Resource, NY)

Plate 8. *Saint Jerome and a Donor*, Accademia, Venice (Scala/Art Resource, NY)

49. Duccio, *Maestà,* Museo dell'Opera del Duomo, Siena

Much of the sense of permanence and stability that emanates from the *Resurrection* comes from the sophisticated geometry of its composition. The heart is the implied triangle that finds its apex in Christ's head and its sides along his arms and the bodies of the soldiers below. Not only does this triangle create stability and order, it also rises from a wide base to the most important part of the picture, the staring, sphinxlike head of the resurrected Christ.

The triangle is relieved visually by the horizontal of the sarcophagus and by the grid of trees behind Christ. Other major rhythms are furnished by the undulating hills and the jumble of the soldiers' sleeping bodies, which contrasts so sharply with the stable figure of the glowing Christ, the trees, and the tomb.

Color also plays a crucial role in this masterpiece. It establishes variety and movement while helping to create an overall unity so necessary for a fresco that had to be both image and wall decoration. Throughout the *Resurrection,* the artist employs fields of nearly monochromatic color that continually bring the viewer's eye back to the surface of the painting. The browns, reds, greens, and blues of the soldiers' clothes and armor all help to construct the individual forms, but they are also decorative entities in their own right, as is the central pink expanse of Christ's robe, which acts as the focal point of hue and light.

Again, Piero's use of color and form recalls the highly decorative paintings of both his Sienese contemporaries, such as Sassetta and Mat-

teo di Giovanni, and his distant Tuscan ancestors, beginning with Cimabue in the last decades of the thirteenth century. The fresco's geometry, the stillness of its figures, their careful arrangement, and the decorative use of color all help remove it from a crude quotidian reality. In his major religious pictures Piero, one feels, wanted to deny the increasing realism and drama of Florentine paintings, such as Andrea del Castagno's *Resurrection* [50] of about 1450, which might have, in other ways, influenced Piero's conception of the subject. Castagno's hard-edged, assertive, and expressive realism was not for Piero, who, one senses, wanted to preserve the detached, supernatural power of the old icons that were all around him, icons still being replicated in Sienese painting.[12]

Although he held fast to the ancient ideals of religious narrative, Piero used up-to-date methods. His drawing, for example, is highly intricate and modern. The *Resurrection,* like all his other frescoes, was constructed with cartoons worked up from a series of paper sketches and drawings.[13] Piero's draftsmanship is especially noteworthy in the bodies of the sleeping soldiers where he demonstrates a skill and knowledge of drawing seldom encountered in previous Tuscan painting.

Aside from the *Resurrection,* there remains only one other fresco by Piero in his native city, a small fragment of a saint [51] discovered in 1954 in the apse of the church of Sant'Agostino in Sansepolcro (this is the same church that once housed the altarpiece by Piero; see Chapter 2). Although the saint is often called Julian, there is no certain proof of his identity. Originally he must have been full length, standing, and perhaps part of a series of other holy personages. (The Sansepolcro fragment probably originally resembled a small fresco [52] of a powerfully sculptural Saint Mary Magdalen in the Cathedral at Arezzo by Piero.) In the *Saint* there are passages—such as the face and crown of hair and the mottled green background—of considerable excellence, but the creased mantle rests unconvincingly on the shoulders, and the figure's right arm is ineptly drawn. Some of this awkwardness may be due to the large paint loss the fragment has suffered, or, perhaps, it may betray the hand of an inexperienced assistant. Fresco is a medium that demands careful planning and rapid execution. Even in relatively small paintings, a skilled team of masters and apprentices is necessary for successful execution. For all his works in fresco, Piero must have had a number of assistants who helped with the difficult tasks of laying in the fresh plaster, placing the cartoons, and painting in the fast-drying plaster. The seamless nature of all Piero's frescoes testifies to the fact that he rigorously supervised and controlled all aspects of the work from first design to final painting.

Piero's most sustained and extensive work in fresco is the cycle of the legend of the True Cross in the choir of the Franciscan church of San

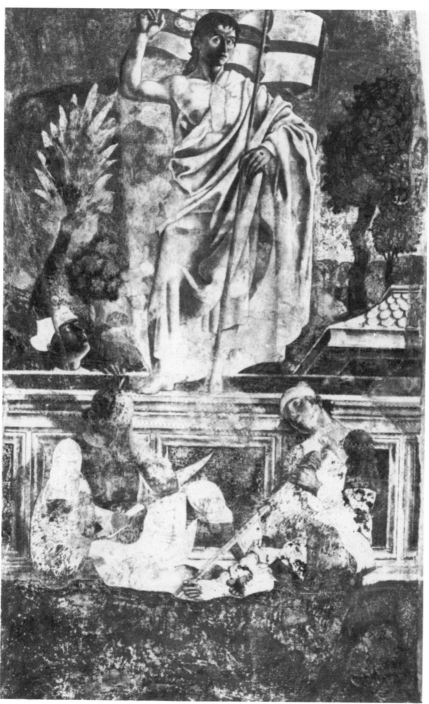

50. Andrea del Castagno, *Resurrection,* Cenacolo di Sant'Apollonia, Florence

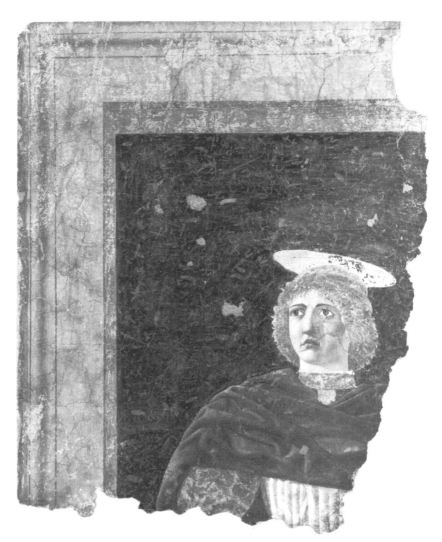

51. Piero della Francesca, *Saint,* Pinacoteca, Sansepolcro

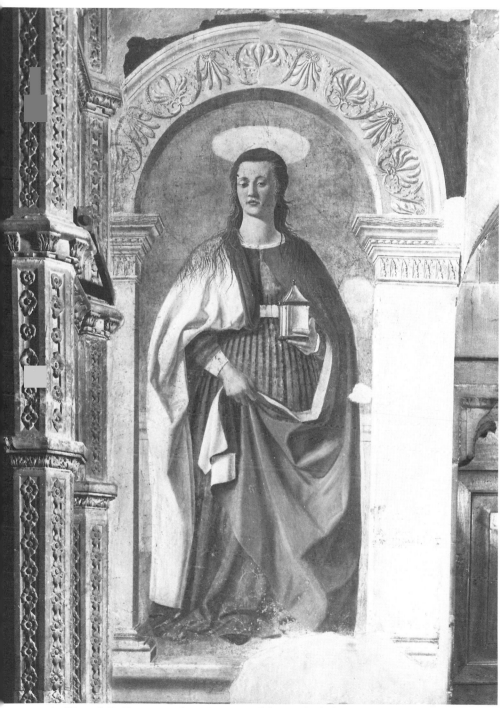

52. Piero della Francesca, *Saint Mary Magdalen,* Cathedral, Arezzo

53. San Francesco, Arezzo, view into the choir

Francesco in Arezzo [53]. Although not the major church of the city, San Francesco was an important building, and such a large commission for it clearly demonstrates recognition of Piero's talent beyond the confines of Sansepolcro.

Moreover, the commission was given by the Bacci, one of the most powerful families of Arezzo.[14] The first documents mentioning the decoration of the choir of San Francesco date from 1408, but actual painting did not begin until much later.[15] This was originally entrusted not to Piero, but to the Florentine Bicci di Lorenzo, who began work only about 1445. Bicci, however, was able to paint only the Four Evangelists in the vault, several saints on the entrance arch, and a large *Last Judgment* on the chapel's outside entrance arch before he returned to Florence in 1450, where he died two years later.

Piero probably received the commission to finish the frescoes of the choir about 1450, although this date, like almost every other attempt to fix a time for the cycle's execution, is the result of educated guesswork. Piero seems to have finished work in the chapel by 1466, for in that year he is mentioned as the painter of the choir in San Francesco.[16]

What is noteworthy about the scarce documentary history of the cycle is that the Bacci family chose the mediocre Bicci di Lorenzo over Piero, a figure whom we now consider one of the most important of all Renaissance artists. The family's first choice indicates that they were conservative in their artistic taste. Bicci di Lorenzo was a highly traditional artist whose style and narrative ideas were heavily dependent on the fourteenth century; what he took from his contemporaries, such as Masaccio and Domenico Veneziano, amounted to little more than a gloss over his basically conventional style. Bicci remained marvelously free from either distinction or invention; therefore, he was just the sort of artist who would have appealed to conservative businessmen living in the provincial center of Arezzo.

It is interesting that the Bacci then picked Piero della Francesca to finish the commission. This choice seems to suggest that they must have considered him also a conservative artist, who could be trusted to paint stories in a traditional manner. They were in fact quite right, for Piero's frescoes, as we shall see, while among the finest of their period, tell their stories in a manner that surely would have been fully acceptable to patrons whose first choice was Bicci di Lorenzo.

One of the pitfalls of writing or thinking about history is the tendency to project our own values onto the past. Today Piero is considered a major Renaissance artist. Modern ideas about importance in art often revolve around innovation. But to speak of Piero as an innovative artist in our sense of the word is to misunderstand fundamentally the nature of his painting and his character. The Renaissance was an intensely conservative period, which did not value change for change's sake;

rather, it prized tradition. Piero was a highly inventive artist, but also one who worked well within the established boundaries and traditions of current taste; this is undoubtedly why the Bacci hired him after Bicci di Lorenzo withdrew from the job.

The subject of Piero's frescoes was traditional for choirs or chapels of Franciscan churches. The prototype was Agnolo Gaddi's True Cross cycle, painted about 1390 for the Franciscan church of Santa Croce in Florence.[17] Gaddi, by combining two separate episodes (the Invention of the True Cross and the Exaltation of the True Cross) from *The Golden Legend,* a compilation of religious tales and anecdotes, set the pictorial boundaries of the story. By their important location in one of the great Franciscan churches of the Italian peninsula, Gaddi's paintings exerted a strong influence on the several True Cross cycles that followed, including Cenni di Francesco Cenni's in San Francesco, Volterra (1410), and Masolino's in Sant'Agostino, Empoli (1424).[18] Surely the Bacci must have been aware of the Gaddi cycle or its derivatives, perhaps through the friars at San Francesco. And at least part of their motivation for the commission must have been the desire to imitate, and perhaps rival, the frescoes in the choir of Santa Croce, the major Franciscan church in Florence.

Thus, many factors of history, tradition, and patronage made a True Cross cycle the logical choice for the choir of San Francesco, Arezzo. But there were also other compelling reasons for the selection of the subject. The Cross of Christ was an object of special veneration for Saint Francis, whose crowning earthly experience was the Stigmatization. This event was centered on Saint Francis's vision of the crucified Christ, and it occurred on the feast day of the Exaltation of the True Cross, September 14. This day is also the celebration of an important event in the True Cross story: the return of the Cross to Jerusalem by the emperor Heraclius. Moreover, the legend of the True Cross was viewed as a concordance between the Old and the New Testament, as opposing events before and after Christ's death and resurrection, and as the world before and after grace.

The True Cross story also had a personal significance for the communicant. Christ's Crucifixion, Resurrection, and Ascension, the miraculous facts of his rebirth that the Mass celebrates, all offer the promise of salvation and new life. These hopeful themes are elucidated by the True Cross story, where contact with the miraculous wood of the Cross leads to the possibility of salvation both for humankind and for the communicant, who, as he or she heard the Mass at San Francesco, would have seen some of the great themes of the liturgy writ large on the choir walls.[19]

But what strikes one first about the choir of San Francesco is not the individual frescoes that tell the story of the True Cross, but the overall

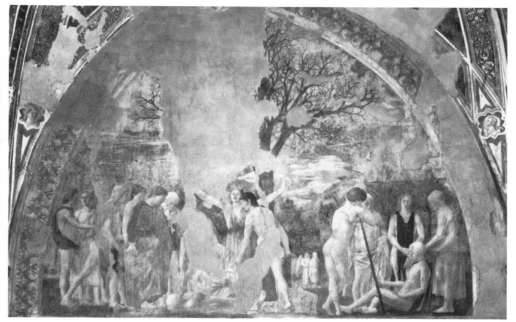

54. Piero della Francesca, *Death of Adam,* San Francesco, Arezzo

impression of color and shape. To view the fresco cycle as a whole is to see subtle widespread patterns of whites, browns, roses, orange-golds, maroons, and various blues combining and recombining in a symphony of hue and form that unites the frescoes and gives them a rhythm and variety quite independent of the individual narratives. Like all good fresco painters, from Giotto to Veronese, Piero understood that wall painting was not only narrative, but decoration as well. The interlocking of color—which seems almost to float on the wall—and shape gives the choir an overall abstract beauty that is not its least impressive aspect.

The True Cross story begins in the lunette [54] on the wall to the right of the worshiper, as he faces the altar. This lunette narrates what might be called the prehistory of the wood of the Cross: the ailing Adam sent his son Seth to the Garden of Paradise to ask for some drops of oil from the Tree of Mercy. This request was refused by the Archangel Michael, who told Seth that men could not obtain the oil of mercy for five thousand years—that is, until Christ's sacrifice. Instead, Seth was given a branch (some legends say it was part of the apple tree from which Adam ate and sinned) and was told that when the tree again bore fruit (the body of Christ), Adam would be redeemed. Seth planted the branch over Adam's grave (the location at Golgotha where Christ would

be crucified), and by Solomon's time it had blossomed into a magnificent tree.

In Piero's fresco, Seth and the Archangel Michael are the two small figures in the middle background. To the right, the dying Adam sits on the ground surrounded by a group of people, including the ancient Eve and the aged Seth. The badly damaged scene of the burial of Adam, during which Seth placed the branch in the earth, is at the left. Linking all these episodes is the great tree that sends its branches across almost the entire upper area of the lunette, dwarfing the protagonists.

Perhaps the most striking aspect of the lunette is the friezelike disposition of its figures across the foreground. The basic rhythms of this fresco are more static, less interesting and varied than any other of Piero's True Cross frescoes, except the *Exaltation of the Cross* in the opposite lunette. It is possible, but not provable, that the two lunettes differ from the other frescoes because Piero followed the general plan of *sinopie* (underdrawings) left by Bicci di Lorenzo. Bicci may well have worked on a scaffold that stretched across the chapel's width and, consequently, have painted on both lunettes simultaneously before abandoning the job. It is likely that Piero did the same thing when he began painting after Bicci's departure.

Even if Piero took over Bicci's friezelike arrangement, he adapted and modified it with consummate skill and he created his own figures, which he worked up from paper drawings to full-scale cartoons. The paradise setting gave him a rare opportunity to display the nude or partly clothed figure, which he executed with a mastery of drawing and a knowledge of anatomy unsurpassed by any other Tuscan artist of the period. Piero's interest in the complex problems of rendering the human figure is demonstrated in the various foreshortened limbs and difficult postures.

In the rendering of the nude, Piero could not find much help from any contemporary painters or sculptors and so turned to the art of the

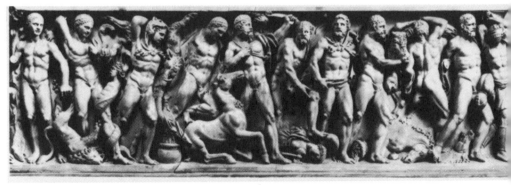

55. Roman sarcophagus with the Labors of Hercules, Palazzo Ducale, Mantua

56. Piero della Francesca, *Adoration of the Sacred Wood and the Meeting of Solomon and the Queen of Sheba,* San Francesco, Arezzo

past, specifically to Roman sarcophagi, which then littered even the smallest of Tuscan towns. In these sarcophagi, especially those that depicted action scenes in relief along their long sides [55], Piero must have found inspiration for the nudes of the Adam lunette (and also for his battle frescoes of the same cycle).[20]

The Roman influence was perhaps tempered by Piero's memory of Masaccio's Brancacci Chapel and the way its figures stood and were grouped. The rooted, solid nature of the bodies and the amplitude of the landscape they inhabit in Piero's Adam painting must derive, in part, from the overwhelming experience of the Brancacci frescoes, especially the *Tribute Money* [5].

Below the lunette, the True Cross legend continues on the right wall in the *Adoration of the Sacred Wood and the Meeting of Solomon and the Queen of Sheba* [56]. According to the *Golden Legend,* Solomon saw the blooming tree that had been planted on Adam's grave and ordered that it be felled and used in the construction of the new temple; this, however, proved impossible, for the wood magically changed shape every time the builders tried to use it. Finally, in desperation, Solomon's architects bridged a stream with it. When the Queen of Sheba came to visit and test Solomon, a vision revealed to her that the Savior would hang upon the wood of the bridge, and she knelt in prayer before it. This is yet another reference to the sacredness of the wood and to the redemptive power of Christ's sacrifice on the Cross, a theme that runs throughout the cycle. Alarmed by Sheba's action, Solomon had the wood buried, but soon a pool with miraculous healing powers attended

57. Piero della Francesca, *Burial of the Wood,* San Francesco, Arezzo

by an angel sprung up around it, still another sign of the salvation offered by the wood. (The burial of the wood is depicted in a fresco on the window wall contiguous to the Sheba and Solomon fresco [57].

Piero's basic conservatism is apparent in the overall design of the Sheba fresco. Like all of the large frescoes of the True Cross cycle except one, the painting is divided roughly in half. To the left is the wide expanse of Tuscan landscape before which Sheba kneels in adoration of the sacred wood. This large void, punctuated only by two trees and the horses and bodies of Piero's stately figures, is opposed to the cubic, man-made environment of Solomon's palace at the right. This juxtaposition of open and closed space is close to that of Piero's *Flagellation* in Urbino [43]. It is also typical of numerous long, horizontal frescoes of the late fourteenth and early fifteenth centuries, where space and architecture are used to order and direct narrative flow.[21]

A good example of a late Trecento fresco with a similar compositional structure is Niccolò di Pietro Gerini's *Death of Saint Matthew* [58] in San Francesco, Prato, painted about 1390. Here the narrative is divided clearly in two: in an open space at the left the execution is ordered and, at the right, it is carried out. The major subdivision of the fresco is through figure grouping and, above all, by architecture. Open space contrasted with closed, architecturally bounded space is the most important means of narrative division and construction in late-fourteenth and early-fifteenth century frescoes. It is therefore not surprising that Piero, who was a traditionalist by nature and training, adopted the compositional principles and method of his immediate forerunners and teachers.

Like all major artists, Piero passed what he borrowed through the lens of his own genius. Although based on traditional types, the Sheba fresco and its orderly, stable elements really resemble only Piero's other paintings. In their stillness and grandeur, the figures of solidity and dignity are the products of Piero's imagination. The architecture is far removed from the spindly framework of Gerini's frescoes, and the splendor of the Tuscan hills and leafy trees, while certainly indebted to Masaccio, is unmistakably Piero's. Moreover, there is a logic and intelligence in Piero's fresco absent from many earlier paintings. The proportional structure of the bodies, the masterful foreshortening of the faces and limbs, the scale and nature of the landscape, and the articulation of the building all form a narrative of sparkling clarity and persuasiveness.

The architecture in the Sheba fresco is also of a new order, with obvious ties to the spare, harmonious Florentine buildings of Brunelleschi, structures that Piero undoubtedly knew when he was working with Domenico Veneziano in Sant'Egidio in 1439. Piero's painted architecture recalls the overall arrangement and proportions of these buildings

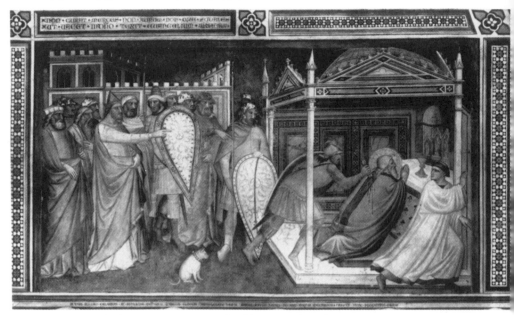

58. Niccolò di Pietro Gerini, *Death of Saint Matthew,* San Francesco, Prato

and their details. The fluted columns and pilasters; the cool, gray color of the stone; and the handsome form and precision of the carving of lintel and capital evoke the serene, ordered atmosphere of a church or chapel by Brunelleschi.

The Sheba fresco also provides insight into Piero's working methods. It is clear from the many *spolveri* (dots of pounced charcoal outlining the cartoon forms) and from various incision marks that Piero used cartoons extensively, a practice we have already seen in the *Madonna del Parto.* Often frescoes worked up from paper drawings and cartoons lose the sense of scale and decoration that earlier frescoes, made from *sinopie* (preparatory drawings made on the wall surface), achieved. This, however, is not the case with Piero's frescoes, especially those of the legend of the True Cross, which are perfectly scaled to the chapel, to each other, and to the spectators. This integration of the frescoes is somewhat surprising, because Piero was among the first artists, if not the first, to make such widespread use of cartoons.[22] The pictorial tasks that Piero set himself would have been impossible without the use of cartoons, as even the most casual observation of the highly complex figures and their intricate drapery in the Sheba fresco reveals.

As in the *Madonna del Parto,* Piero made inventive use of his cartoons by flipping them over and reusing them in different parts of the same

fresco; for example, the three-quarter face of the woman standing behind the kneeling Sheba appears again behind the queen greeting King Solomon. Such flipping of cartoons is frequent in Piero's True Cross cycle, although the faces and bodies were often modified during the actual painting.

The use of these flipped cartoons was not just a labor-saving device; rather, it was indicative of a fundamental characteristic of Piero's art: an overwhelming desire for order and balance, through the subtle repetition of shape. The similarity of many of the faces and bodies in the fresco cycle arrived at through the use of the same cartoon, sometimes flipped but often used more than once on the same side, imparts a harmonious regularity that remains in the mind long after one leaves the frescoes. As in the *Madonna della Misericordia* and the *Madonna del Parto,* there is something satisfying and right about the arrangement of Piero's volumetric forms in the still space of his paintings.

The Sheba and Solomon scene is followed by two frescoes that illustrate the salvation possible only through the Cross and Christ: the *Dream of Constantine* (on the window wall) [59] and the *Battle Between Constantine and the Barbarians at the Danube* [60] (immediately under the Solomon and Sheba fresco). *The Golden Legend* gives two variants of these linked episodes. In the first, an angel appeared to the Roman emperor Constantine on the eve of a great battle between the emperor's army and a much larger horde of barbarians, encamped on the opposite bank of the Danube. An angel awoke the sleeping Constantine and told him to look in the sky, where he saw a "cross described in shining light" and "in letters of gold the legend: 'in this sign shalt thou conquer!' " Hearing this, Constantine had a cross of wood made, and he carried it in front of his army, which, with divine intervention, vanquished the barbarians. After his victory the emperor discovered the Christian meaning of the cross and was baptized. Thus, the battle and Constantine's baptism were episodes of salvation: in the former Constantine saved the empire from the barbarian horde; in the latter he saved himself.[23]

The second version of the story narrated by *The Golden Legend* is similar to the first but describes two different visions: one during a battle near the Pontus Albinus, when Constantine was fighting the army of Maxentius; and a second, when Christ appeared to the emperor during the night.[24] The second version also states that Maxentius died while trying to cross a bridge that had snapped.

Piero's fresco is usually called the *Battle Between Constantine and Maxentius,* but the appearance of the angel to the sleeping emperor, the absence of the necessary bridge, and the two armies divided by a river (the Danube) make it certain that Piero has carefully followed the first version of the story: the *Battle Between Constantine and the Barbarians at the Danube.* Other details confirm this. For instance, the flags identify

59. Piero della Francesca, *Dream of Constantine,* San Francesco, Arezzo

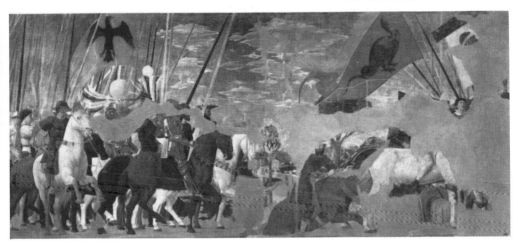

60. Piero della Francesca, *Battle Between Constantine and the Barbarians at the Danube,* San Francesco, Arezzo

the armies. To the left is the imperial eagle fluttering over Constantine's troops (the identical flag appears across the chapel, painted above the heads of the soldiers of another Roman emperor, Heraclius). But the men fleeing from Constantine and the cross carry no imperial standards or banners—Maxentius was a Roman emperor and the story of the battle on the bridge is historical fact—but rather a flag with a dragon and another with a Moor's head; such strange images are often used to identify barbarians or outsiders in fifteenth-century painting.

Whoever chose the subjects for the True Cross cycle in Arezzo must have realized that the first version of the Constantine story, the *Battle Between Constantine and the Barbarians at the Danube,* is a more powerful example of salvation than the second version, the *Battle Between Constantine and Maxentius.* In the first version, forces of good and evil, darkness and light battle as the divinely guided emperor, armed with the cross, fights the pagan barbarians; salvation not only of the individual, but of the state and, ultimately, humankind, is at stake. Consequently, the Constantine story amplifies perfectly the salvation theme expressed in the *Death of Adam* and the *Solomon and Sheba* frescoes; the wood of the Cross and its fruit (the sacrificed Christ) promise, like the Mass said at the choir's altar, the hope of salvation and redemption for all believers.

Light, Piero's visual metaphor for salvation and holiness, makes a striking appearance in the *Dream of Constantine* on the window wall. Here light dispels darkness and fear as the angel appears to the sleeping emperor. An aura of brilliant illumination brings Constantine's tent out of the surrounding night and permeates it with holiness. There is a

purifying power to this light that is a perfect visual symbol for the grace and salvation falling on Constantine, who is about to be awakened to enlightenment and salvation.

This is not a miracle with claps of thunder and flashes of lightning, but rather one of utmost stillness. Time seems frozen as the immobile guards, like life-size statues, stand just outside the radius of the sacred glow. No one moves, no wind blows, all is silent as the apparition hovers in the night sky. Beyond the emperor's tent (whose geometric form reminds one of the cloak of the *Madonna della Misericordia* or of the tent in the *Madonna del Parto*) rise the silhouettes of the tents of Constantine's army, their conical peaks forming a rhythm of shapes across the background.

Order, balance, and symmetry are the building blocks of quietude in the *Dream of Constantine* and in almost all of Piero's paintings. The conical and cylindrical shapes of the tent, the way the tent forms a semicircle around the central pole, the two standing figures who act as brackets, and the opposition of the diagonal of the flying angel to the horizontals and verticals below are part of the pictorial vocabulary of every painting by Piero so far discussed. These shapes, which are the stratigraphy of Piero's works, do not change; it is, instead, their position and relation to each other that are the variables in Piero's paintings. It is precisely because of this fact that it is impossible to discern any clear evolution or development of style in his work. In his earliest paintings, whichever they might be, Piero begins with his artistic premises already formulated, and he works on these, with variations, throughout his career. In this respect, he is exactly like most painters of his time. Imitation, borrowing, and a gradual, unending transformation of one artist's style into another's were the cardinal principles of artistic education and process during most of the Renaissance.

For Piero, order was the probity not only of design, but of life itself; balance, harmony, and equipoise were manifestations and embodiments of goodness, just as light, color, and silence are his metaphors for the divine. This is seen not only in all his paintings, but also in the books he wrote on perspective and geometry: order and balance make sense out of the world and reflect a purer, higher realm. Chaos and imbalance, on the other hand, are the revelations of the disorder that Piero so rigorously excluded from his world. Nowhere in Piero's works are the great opposing forces of order and chaos seen more clearly than in the *Battle Between Constantine and the Barbarians*. To the left, under the divine guidance and protection of the cross held by the emperor, Constantine's cavalry rides into battle. Here all is an adagio of stately riders and their mounts moving forward with flapping banners and multicolored, plumed standards. An accompanying beat is furnished by the beautifully positioned and spaced horses' legs of white, brown, and gray; this is one

of Piero's most memorable passages of rhythm and a masterpiece of abstract composing.

These horses, and indeed the entire left side of Piero's fresco, recall the *Rout of San Romano* [15], by the Florentine Paolo Uccello. The exact date of Uccello's painting is unknown, but informed speculation suggests the mid-1450s; the exact relation, if any, between Piero's fresco and Uccello's painting can only be guessed. There are some striking similarities between the two paintings, especially in the rearing horses to the far left and the majestic mount seen in profile. However, there are major differences in the way each artist has conceived his forms: Piero has avoided the hyperstyle and abstraction of Uccello and, consequently, his figures and horses look less toylike and unreal. Yet both artists have distilled form, making it an exciting series of patterns in the restricted foreground space of their compositions. In the paintings of both, the battle is removed from reality and turned instead into a dignified mime that fascinates rather than repels.

The purposeful cadence of the left half of Piero's fresco, crowned by the abstract pattern of waving lances, contrasts strongly with the melee at the right. Here the dominant emotions expressed by the forms are not the confidence and resolve of Constantine's army, but rather the fear and anguish of those defeated by the power of the cross. Unfortunately, this is one of the most damaged parts of the cycle, but from what remains and from a watercolor after the fresco, made by the German artist Johann Anton Ramboux about 1840 [61], one can get an approximation of what once must have been an extremely exciting passage.

Scrambling out of the water and onto the river's bank, the barbarians

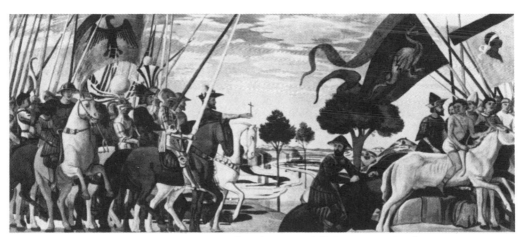

61. Johann Anton Ramboux, watercolor after Piero della Francesca's *Battle Between Constantine and the Barbarians,* Kunstmuseum, Düsseldorf

flee from Constantine's troops. Especially noteworthy are the two riders closest to the river: the bearded figure who urges his horse up the slope and the nearly naked man riding bareback. Looking back in fear, these men are the rear guard of the panicked barbarian cavalry. The other figures to the right also help create this sense of panic and, in fact, all their forms work together to create a jagged, discordant rhythm that is exactly the opposite of the fresco's ordered and congruous left side. One need only look at the flags and spears or at the random interval between the horses at the right to see how Piero has used space and shape to express conflicting emotion. Like Giotto or Rembrandt or any other surpassing artist, Piero has masterfully employed the basic build-ing blocks of painting to express action and states of mind with utmost clarity and with seeming ease. There is a profound simplicity and direct-ness in this fresco, and in every other work by Piero, that is shared by all major artists.

No survey of the *Battle* fresco would be complete without some dis-cussion of the cloud-filled sky and the lovely, if restricted, view of the landscape separating the armies. This peaceful vista with its houses and tree-flanked riverbank makes a strong contrast to the battle raging in front of it. The beckoning Tuscan countryside has already been ob-served in the discussion of Piero's *Resurrection* in Sansepolcro [48] and in the London *Adoration* [36] and *Baptism* [33]. The small, placid river reflecting the trees, houses, and sky is especially close to the River Jordan in the latter.

Thus far the frescoes in Piero's cycle have proceeded in an orderly way from the lunette downward; however, the episode following the *Battle Between Constantine and the Barbarians* begins not in the opposite lunette, as one would expect, but in the middle register of the window wall. This story, the *Torture of the Jew Judas* [62], is the pictorial preface to the adjoining fresco, the *Discovery and Proving of the True Cross* [63], which occupies the middle register of the left wall.

It will be remembered that the wood was buried after Sheba's visit to Solomon. Then, just before Christ's Crucifixion, the wood floated to the top of the miraculous pool that had formed above it, and it was subse-quently used to make the Cross for Christ. Following the Crucifixion the wood was secretly buried and its location almost forgotten. After Constantine vanquished the barbarians in the name of the Cross, his mother, Helen, later Saint Helen, searched for the True Cross. It is this story that is told on the middle register of the window wall and the adjacent middle register of the left wall.

To find the Cross it was necessary to extract its hiding place from one of the few Jews who still knew its whereabouts: this was Judas, the namesake of the man who had betrayed Christ and precipitated his crucifixion. Helen kept this latter-day Judas in a well until hunger forced

him to reveal the Cross's hiding place. This he did with great trepidation, because his father had told him that when the Cross was found, "That day shall be the end of the kingdom of the Jews, and thenceforth they shall reign who adore the Cross, for verily the man who was crucified was the Son of God." After Judas had been freed from the well, he led Saint Helen and her party to the place where the Cross was buried. Here arose a "delightful aroma of spices, and overcome with astonishment" Judas declared Christ "Savior of the world."

The discovery of the Cross was Judas's personal salvation: as one baptized and resurrected, he emerges from darkness into the light that is the manifestation of divinity and salvation. Moreover, the theme of salvation is amplified by the pairing of the *Torture of the Jew Judas* with the fresco placed directly across the window wall, its spiritual and physical opposite, the *Burial of the Wood* [57]; here the holy wood is plunged by unbelievers into the darkness of the earth to await its own resurrection, made possible by Judas's conversion.

Judas's conversion (he eventually became the bishop of Jerusalem) is another important example of the redemptive power of the Cross of Christ. As the communicant heard the Mass and pondered the painted walls, his thoughts must have dwelt on the divine salvation, both for himself and for humankind, made possible through Christ's sacrifice, which was being reenacted through the miraculous rite of the Mass performed at the altar.

The theme of resurrection and salvation through Christ's Crucifixion is also found in the *Discovery and Proving of the True Cross,* the fresco depicting the episodes that followed Judas's revelation of the Cross's hiding place. Three crosses (Christ's and the two thieves') were unearthed, but only the True Cross was able to resurrect a dead youth when it was held over him—yet another example of the restorative power of Christ.

The fresco, divided roughly in half by the two scenes, uses landscape and architecture to both frame and separate the events represented. At the left, Helen and her group watch the crosses being unearthed. Behind are hills and a walled city that are marvels of Piero's reductive style. Each element of the fresco—the gates, the roofs, the red-orange church, and the two looming unfinished arches (strikingly reminiscent of the still incomplete Cathedral of Siena)—helps to achieve the crowded jumble so characteristic of an Italian hill town. Here again Piero's Tuscan world becomes the new Jerusalem; as in the *Resurrection* in Sansepolcro, it is anointed by the events that unfold among its fertile hills and towns.

Piero's hill town is often viewed as something highly innovative, but, in fact, he could have seen a number of such views in altarpieces and frescoes painted in Siena. One of the most famous of these was the *Good Government* fresco [41], painted by Ambrogio Lorenzetti in the Siena

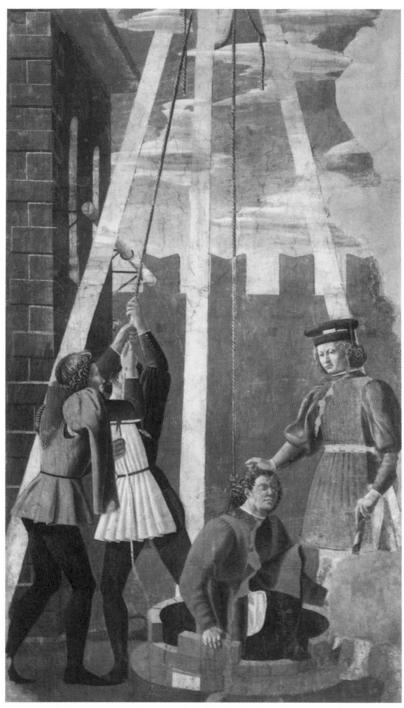

62. Piero della Francesca, *Torture of the Jew Judas*, San Francesco, Arezzo

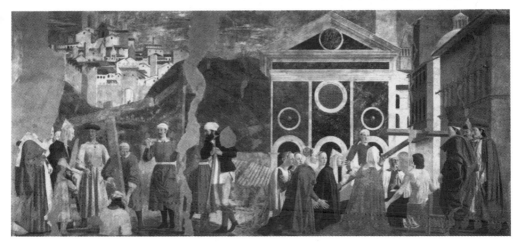

63. Piero della Francesca, *Discovery and Proving of the True Cross,*
San Francesco, Arezzo

Palazzo Pubblico about 1340. From this seminal painting (already noted
in connection with the landscape of Piero's London *Adoration of the
Christ Child*), and others based on it, Piero probably drew inspiration
for the wonderful jumble of his city and the undulating landscape.[25]

The origin of landscape and cityscape painting in Siena can be traced
back to the founder of the Sienese school, Duccio, the artist who was
probably Ambrogio Lorenzetti's master. Duccio's and his followers'
intricate views of city streets, with their bold architectural planes of
contrasting color, probably influenced the conception of the street on
the right side of Piero's fresco, although here their sway was certainly
tempered by the cityscapes of Masaccio's Brancacci frescoes.

In the Brancacci Chapel frescoes, especially the *Saint Peter Healing
with His Shadow* [64], Masaccio endowed the cityscape with a new and
startling sense of reality, as seen in the scale of the buildings, their
texture, detail, and, above all, in the light and shadows filling the narrow
street. This rather uncompromising view of the city was overly gritty
and stark for Piero. In the *Discovery and Proving of the True Cross,* he
veered away from a too literal description of the natural world, an
approach that would have been alien to the formal, refined, and ideal-
ized atmosphere of all his paintings.

Piero's debt to another Florentine, Brunelleschi, is evident in the tem-
ple placed directly behind the Proving of the Cross (this was a tem-
ple of Venus, erected on the site of the Cross's burial to discourage
Christian worship there). In the depiction of his temple Piero was in-
spired by what he had seen of Brunelleschi's architecture in Florence,

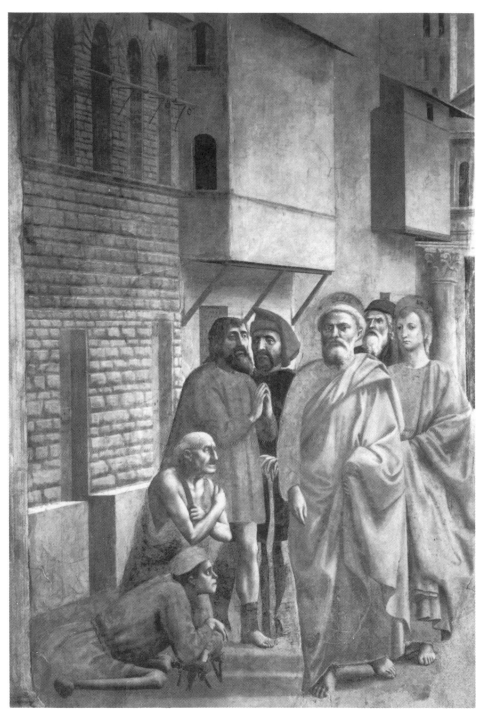

64. Masaccio, *Saint Peter Healing with His Shadow,*
Santa Maria del Carmine, Florence

but again, as in all his many borrowings, he has transformed his debts into credits. With its three soaring arches, its charming round windows, and its pediment, which perfectly counters and finishes the facade of beautiful variegated marble (probably achieved by passing a hot iron over the wet paint), this is very much a painter's temple. It and the graceful, multicolored street flanking it have been elevated above the realm of mere reality into a fitting location for the miracle that silently unfolds before them.

The figures who act in this sacred drama are especially handsome examples of Piero's figurative types. Wearing headgear that allows full rein to Piero's geometric poetry, the group of men at the far right is notable for the complexity and amplitude of garments; here again one senses the many preparatory studies that lay behind such magnificent robes. Piero's fascination with costume is evident in the way he has used clothing to differentiate the various social classes in the fresco: the costly, voluminous robes of the little group at the far right; the sober, but elegant, mantles and veils of Helen and her entourage; and the simple homespun of the workmen, one of whom has rolled his breeches down around his knees to work unencumbered. An arresting figure is the foppish dwarf in pink (dwarfs and midgets were often found in the retinues of Renaissance rulers), who watches the crosses being un-earthed.

The *Discovery and Proving of the True Cross* displays the full range of Piero's ability to use colors as important decorative elements independent of the narrative. The use and distribution of brownish-orange, white, and rose across the fresco's surface create a decorative rhythm in perfect accord with the abstraction of landscape, cityscape, and figures. Piero's harmonious color and his large, patternlike forms are reflected and reinforced by every other painting in the chapel.

The paintings of Piero's True Cross cycle are often interrelated up, down, and across the choir's walls by interconnected meanings. Thus, the *Discovery and Proving* is paired with the opposite fresco of the *Adoration of the Sacred Wood and the Meeting of Solomon and the Queen of Sheba*. The adoration and the meeting led to the burial of the wood by the unbelievers; in the discovery and the proving, believers recover the Cross, and Judas is converted. The recognition of the sanctity of the wood by Sheba and her prophecy that Christ would be crucified on it are confirmed in the *Discovery and Proving of the True Cross*.

There are also connections, although of a different order, between the bottom frescoes of the True Cross cycle. On the right wall, Constantine defeats the barbarians and, consequently, saves the empire and himself. The opposite space on the left wall is occupied by another fresco depicting a battle, the *Battle Between Heraclius and Chosroes* [65]. This occurred after the Persian king Chosroes had stolen the True Cross

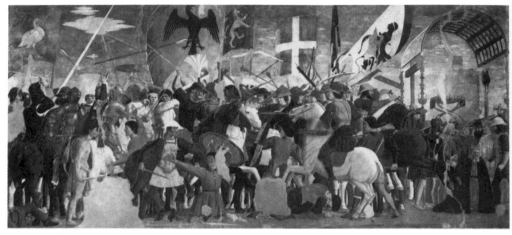

65. Piero della Francesca, *Battle Between Heraclius and Chosroes,*
San Francesco, Arezzo

from Jerusalem and had used it to establish himself as a god, enthroned
in a tower of gold and silver studded with shining gems and images of
the sun, moon, and stars. The emperor Heraclius, according to *The
Golden Legend,* gathered an army and defeated Chosroes and his son in
battle. The captured Persian was given a chance to save himself by
conversion but refused and so was beheaded. The Heraclius and Chos-
roes painting is tied to its opposite, the Constantine story, by the theme
of battle and by the defeat of a dangerous pagan foe. There is also
contrast: Constantine's conversion and Chosroes's refusal to accept
Christianity.

Piero made the structure of each scene quite different: Constantine's
battle is neatly divided by the river and is a studied contrast between
the purposeful and the chaotic. In the Heraclius and Chosroes fresco,
there is, instead, one great central mass of riders and foot soldiers en-
gaged in battle. The sheer scope and scale of this surging, close-knit
combat make the fresco one of the most remarkable scenes of action
from the middle of the fifteenth century.

Certainly there are ties between the Heraclius fresco and Paolo Uccel-
lo's nearly contemporary battle pictures [15], but the latter seem frag-
mentary and toylike in comparison to the undulating mass of Piero's
narrative. For a closer parallel one must look ahead to the huge *Battle
of Anghiari* mural, painted by Leonardo da Vinci in the council chamber
of the Palazzo Vecchio, Florence, about 1500. Known only through
engravings and drawings (the most famous being by Rubens), this im-
portant painting depicted the piled-up, closely packed configuration
seen in Piero's Arezzo fresco, although, to judge from the copies, Leo-

nardo was interested in a kind of demonic energy and violence that did not appeal to Piero's more classical and dispassionate mind. Of course, the compositional similarities between Leonardo and Piero, like those between Piero and Paolo Uccello, cannot be proven but can only be suggested or speculated upon.

The *Battle Between Heraclius and Chosroes* differs markedly from the other side-wall frescoes in the True Cross cycle in its massing at the center, all the others being divided near the middle into two roughly equal parts. In the Heraclius battle, the entire center of the composition is filled with men, horses, and magnificent banners. To either side of this central mass are calmer areas, narrative pauses to the central battle. The leftmost of these contains fighting figures who do battle in a much less violent fashion than the central warriors; at the right, the area is filled with the episode of the beheading of Chosroes.

The overall impression of the fresco is one of controlled and ordered shape and mass. To help imagine such a battle scene, Piero probably studied some Roman sarcophagi. A relief, such as that on the *Ludovisi Battle* sarcophagus [66] or any of the scores of other battle sarcophagi, would have attracted Piero for several reasons. Primarily it would have furnished a compact model of many soldiers in a clearly defined and limited space. The surface quality of the relief and the way in which most of the carving is confined to a very narrow plane would also have been observed by Piero with care, for it was exactly what he himself was after in the Heraclius fresco, where all the major action is restricted to a narrow foreground area. Because Piero understood that his frescoes could work as large scale decoration only if he kept most of the form near the picture plane to emphasize the flat surface of the wall, he rigorously controlled the amount of background space in each painting. Where deeper space was necessary—for instance, between the two armies in the Constantine battle—it is of limited scope; spatial recession of objects or landscape is never allowed to suggest a deep hole in the surface of the wall. Throughout the True Cross cycle there is always a delicate balance between the spatial depth of the frescoes and the surface decoration of the forms and colors. Superior fresco painting, like that at Arezzo, always treads a thin line between narration and formal decoration, and between pattern and spatial recession.

From the ancient sarcophagi Piero also borrowed a vocabulary of gesture. The flailing arms and legs that parallel the fresco's plane and the stiff gestures of combat all seem heavily influenced by Roman prototypes. Piero probably studied Roman art throughout his career, especially the sarcophagi, which were so readily available, but like all artists of considerable gifts, he never simply copied what he studied. Rather, what he took became part of his own creative process; it was sifted through the fine sieve of his mind, refined, and made his own.

66. *Ludovisi Battle* sarcophagus, Musco delle Terme, Rome

It is also possible that Piero realized that the Roman battle sarcophagi that he studied for their form were linked by their content to the Heraclius and Chosroes story. The images in both are about struggle and victory: the battles on the sarcophagi are allegories of the triumph of the individual over death, while the Heraclius battle represents a historical triumph of good over evil, of light over darkness, of Christianity over an anti-Christ in the form of Chosroes.

Throughout the True Cross frescoes the heads are nearly standardized —the result, no doubt, of Piero's love of the repetition of distilled forms across the surface of his paintings. However, in the episode of the beheading of Chosroes (to the right of the battle), three of the men [67] watching the execution are strikingly different from all the others in the cycle. Dressed in the costume of the mid-fifteenth century (the figure at the right wears a hat identical to Federico da Montefeltro's in Piero's portrait of him [75]), these must be members of the Bacci family, the patrons of the True Cross frescoes. Heads clearly recognizable as portraits appear in the same position (the right-hand side of the lowest fresco on the left wall) in Agnolo Gaddi's True Cross frescoes in Santa Croce, Florence; one wonders if this was thought to be the traditional place for donor portraits in large fresco cycles. Inclusion of the portraits in the lowest level of the frescoes would allow the worshiper to see clearly the images of those who paid for the paintings—not an unimportant consideration.

67. Piero della Francesca, *Battle Between Heraclius and Chosroes* (detail),
San Francesco, Arezzo

All three of the figures, each with an individualized, realistic face, stand impassively as the executioner raises his sword to behead Chosroes. At first sight, this seems a curious and grisly episode to contain the donor portraits of the Bacci, but the reason becomes apparent when the death of Chosroes is viewed in relation to the rest of the True Cross frescoes with their triumphal message. The death of Chosroes is the final victory of the Cross, the conclusive triumph of good over evil in the cycle. The Bacci have had themselves immortalized by Piero as they view this moment of physical and spiritual triumph, which they have re-created through their generous commission.

Adjacent to the scene of the execution of Chosroes is the window-wall fresco of the *Annunciation* [68]. Why this painting has been placed here and exactly what its subject is has long been a topic for debate. It has been suggested that the fresco represents, among other subjects, the Annunciation of the Death of the Virgin; the Angel Announcing the Finding of the True Cross to Saint Helen; and the Annunciation to Mary of the Coming of Christ. The latter is certainly the correct identification, but its appearance in the narrative of the True Cross seems out of place until one realizes that it is the key element in the story of salvation and redemption.

The Annunciation to Mary, or the Incarnation, is the moment that signals, through Christ, the possibility of the salvation of mankind from original sin. (Because of her role in the great cycle of redemption, Mary is often called the second, or new, Eve.) The Annunciation is the miraculous hub around which revolves the entire story of the wood of the Cross, from its first blooming on Adam's grave to its final enshrinement in Jerusalem by Heraclius (the subject of the last fresco in the cycle). In the Annunciation, Mary's body becomes the tabernacle for Christ (this is seen even more graphically in the *Madonna del Parto*), just as the stone tabernacle that stood on or near the altar was the location where the Host was preserved. In the Mass, the Host becomes both the body and blood of Christ, who first took human form during the Annunciation. The Annunciation's messages of salvation are also reflected and reverberated in the other frescoes of the True Cross cycle and in the Mass. Moreover, the *Annunciation* is placed on the other side of the window (the source of real illumination for the chapel) from the *Dream of Constantine* [59], another annunciation in which light brings divinity and salvation.

The emphasis on light as a symbol of divinity and salvation is a crucial element in the *Annunciation.* Unlike Piero's Perugia *Annunciation* and many contemporary versions of the story, the *Annunciation* of the True Cross frescoes has no dove of the Holy Spirit flying toward Mary. Instead, the Holy Spirit is borne on beams of golden light emanating from the hands of God. Light as the source of salvation and as a metaphor

68. Piero della Francesca, *Annunciation,* San Francesco, Arezzo

for divinity is an important part of every other fresco on the window wall and functions as a constant symbol for redemption and goodness not only in the True Cross frescoes, where it plays an important role, but also in many of Piero's other paintings. The purity of light, like the rightness of order and balance, was an essential element in Piero's mind and vision.

Mary is separated from the angel in Piero's fresco by both the spatial cube she occupies and the handsome white column dividing the fresco into two major sections. The basic elements of the *Annunciation*—the enclosed and the open space, and the realistically scaled buildings influenced by Florentine architecture—are those that appear repeatedly in Piero's work (for example, in the *Adoration of the Sacred Wood and the Meeting of Solomon and the Queen of Sheba* and the *Flagellation* [43]. In a certain sense, all of Piero's paintings are elegant recapitulations of the several important components of his art: order, balance, harmony of form and color, figures and objects of innate grandeur and dignity. Early in his career, Piero must have arrived at an ideal that he pursued in sophisticated variations until his last work, whichever that might be. Such clear and definitive goals made the body of Piero's work a seamless whole.

Compared to the *Annunciation* or indeed to any other fresco in the chapel, with the single exception of the *Death of Adam* on the opposite wall, the lunette *Heraclius Returning the Cross to Jerusalem* is disappointing. The small size of its protagonists; their division into two very disparate and unequal groups, each with unsure placement in space; and the wide, meaningless gap between the two knots of figures all seem curiously inept when compared to the brilliant figure construction and spatial planning of the other frescoes, again with the exception of the facing *Death of Adam.*

In the discussion of the *Death of Adam* it was suggested that the fresco could have been at least partially based on a plan left by Bicci di Lorenzo before his departure for Florence about 1450. If, as seems likely, the scaffold used by Bicci stretched across the chapel, he might also have done some preparatory work on the *Heraclius Returning the Cross to Jerusalem.* It is hard to imagine Piero willingly following the lead of the mediocre Bicci, but it is impossible to plumb the thoughts of a fifteenth-century artist, especially one as conservative as Piero. It is conceivable that technical or aesthetic reasons also played a part: perhaps it was impossible to remove what had already been put down; or maybe the Bacci wished to keep Bicci's original design for the lunettes. Since the chapel had remained undecorated so long, it is also possible that the patrons were in a hurry to get the job finished. It is even feasible that these two lunettes were Piero's first major essays in fresco painting and that his skill in composing such large paintings, which is so clearly

69. Fra Angelico, *Lamentation,* Museo di San Marco, Florence

evident in the other narratives of the True Cross cycle, was still imper-
fectly developed. Why the two lunettes of the True Cross cycle are
qualitatively inferior to the rest of the paintings remains a mystery, but
the very fact that they are less accomplished signals that something
unusual occurred in their genesis and execution.

Some passages of the *Heraclius Returning the Cross to Jerusalem* are,
however, notable—for example, the vast and imposing stretch of brick-
colored wall at the right. In feeling and form this wall resembles similar
structures in two of Fra Angelico's paintings: the *Deposition* and the
Lamentation [69], both now in the Museo di San Marco, Florence. Piero
probably knew and admired Angelico's work, for it is a mixture of the
conservative and innovative that would have appealed to him. Piero, like
most of his contemporaries, borrowed not only in the early years of his
career but throughout his active working life. Those inspirations and
motifs that he had absorbed in Florence in the late 1430s (the date of
Angelico's *Lamentation*) were continually supplemented and enriched
by new borrowings. This was the expected and natural way to learn and
to improve one's art in the fifteenth century and, indeed, in all periods
of Western art until our own.

Perhaps the most innovative aspect of Piero's True Cross frescoes is
the new importance that he gave to the story. The previous cycles had
treated the history of the Cross simply as narrative filled with charming

anecdote and considerable detail. In them, the events became something to puzzle out, a source of information and amusement. Not so with Piero's frescoes, which, in their narrative and formal properties, emphasized, indeed created, a newly cogitated context of the utmost seriousness.

By the placement and juxtaposition of the paintings and by the orchestration of the objects and figures within each narrative, Piero elucidated the great themes of the True Cross story: sacrifice, revelation, conversion, redemption, and salvation. Instead of being a series of unrelated anecdotal episodes, Piero's cycle is a magisterial statement of the Christian faith and the divine power that informs it. (All of this was brought to a personal and immediate level as the worshiper's gaze left Piero's paintings and contemplated the large fresco of the *Last Judgment* by Bicci di Lorenzo on the chapel's outside entrance arch.)

Moreover, Piero's frescoes embody perfectly the function of the chapel that they grace: to house and protect the altar, the physical and spiritual heart of the church and the sacred location of the Mass. The themes of sacrifice, redemption, and salvation of the Eucharistic ritual are also those of the frescoes, which the communicant saw as he participated in the Mass. These same great themes would, more particularly, have also engendered hope for the eventual redemption and salvation of the Bacci family, both for those still living and for those who already lay buried in the church.

The altar and the frescoes must have been connected through an altarpiece of the Crucifixion—this was the one major event missing in Piero's frescoes—or through a painted crucifix much like the one that hangs in the chapel today. The sacred messages of both ritual and art would have coalesced in the crucified Christ, the central figure of the religion; the unity of Piero's transcending fresco cycle and the church's great ritual would have been complete.

<div align="center">NOTES</div>

1. Technique and history of the fresco: B. Cole, *The Renaissance Artist at Work,* New York, 1983.

2. For a discussion of the history of the Madonna del Parto, see B. Giorni, *La Madonna del Parto ed altre opere d'arte dell'antica Chiesa di Momentana,* Sansepolcro, 1986.

3. Other images of the Madonna del Parto: C. Feudale, "The Iconography of the Madonna del Parto," *Marsyas* 7 (1957): 8–24.

4. For the Madonna as tabernacle of the Lord, see B. Lane, *The Altar and the Altarpiece,* New York, 1984.

5. In the north of Europe contemporary artists worked along similar lines. Statuettes of the Virgin, called Vierges Ouvrantes, opened to reveal a carved Trinity. The Virgin, in an altarpiece by Rogier van der Weyden probably made for a Florentine

patron about 1450, is seated inside a tent whose flaps are held by angels. These flaps must surely have been meant to recall the cloth coverings that hid the Host during the Mass. Here and in Piero's *Madonna del Parto,* the equation of the pregnant Virgin with the Host connects the image with the Mass and its central message of rebirth and salvation.

6. Pomegranate symbolism: J. Hall, *A Dictionary of Subjects and Symbols in Art,* New York, 1974, p. 249. The blood-red juice of the pomegranate might also be an allusion to Christ's blood.

7. For the early history of the Tuscan tomb, see J. Pope-Hennessy, *Italian Gothic Sculpture,* London, 1972.

8. For the history of the Resurrection and its local symbolism, see M. Apa, *La "Resurrezione di Cristo": itinerario sull'affresco di Piero della Francesca a Sansepolcro,* Sansepolcro, 1980.

9. For the melding of the sacred and the civic in the Renaissance, see B. Cole, *Italian Art, 1250–1550: The Relation of Renaissance Art to Life and Society,* New York, 1987.

10. Duccio's *Maestà:* J. White, *Duccio: Tuscan Art and the Medieval Workshop,* London, 1979.

11. K. Clark, *Piero della Francesca,* London, 1969.

12. For contemporary Sienese painting, see B. Cole, *Sienese Painting in the Age of the Renaissance,* Bloomington, 1985.

13. For the cartoon and its use in fresco, see M. Meiss, *The Great Age of Fresco: Giotto to Pontormo,* New York, 1968.

14. For the Bacci family, see E. Battisti, *Piero della Francesca,* Milan, 1971, vol. 2, p. 22; C. Ginzburg, *The Enigma of Piero della Francesca,* London, 1985.

15. For the documents associated with Piero's work in San Francesco, Arezzo, see E. Battisti, *Piero della Francesca,* Milan, 1971, vol. 2, pp. 226, 237.

16. This mention of the finished chapel occurs in a document in which Piero agrees to paint a double-sided banner, now lost.

17. For Agnolo Gaddi's True Cross cycle, see B. Cole, *Agnolo Gaddi,* Oxford, 1977. See also A. Ladis, "Un ordinazione per disegni dal ciclo della Vera Croce di Agnolo Gaddi a Firenze," *Rivista d'Arte* 61, no. 5 (1989): 153–58.

18. For Masolino's True Cross cycle in Empoli, see B. Cole, "A Reconstruction of Masolino's True Cross Cycle in Santo Stefano, Empoli," *Mitteilungen des Kunsthistorischen Institutes in Florenz* 13 (1968): 289–300.

19. For the rites of the Mass, see J. Jungmann, *The Mass of the Roman Rite,* New York, 1959; J. Jungmann, *The Eucharistic Prayer,* London, 1966.

20. For Roman sarcophagi, see R. Brilliant, *Roman Art,* New York, 1974; M. Henig, ed., *A Handbook of Roman Art,* Oxford, 1983.

21. For fresco painting about 1400, see B. Cole, *Masaccio and the Art of Early Renaissance Florence,* Bloomington, 1980, pp. 36–71. See also J. White, *The Birth and Rebirth of Pictorial Space,* Cambridge, Mass., 1987.

22. For the use of cartoons, see B. Cole, *The Renaissance Artist at Work,* New York, 1983, pp. 76–95.

23. Jacobus de Voragine, *The Golden Legend,* New York, 1969, p. 271.

24. Ibid., p. 272.

25. For Ambrogio Lorenzetti's Palazzo Pubblico frescoes, see G. Rowley, *Ambrogio Lorenzetti,* 2 vols., Princeton, 1958.

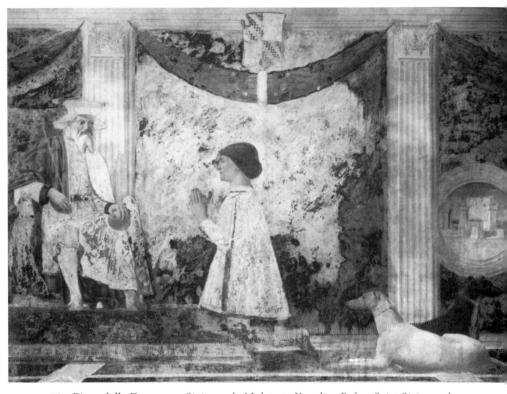

70. Piero della Francesca, *Sigismondo Malatesta Kneeling Before Saint Sigismund,*
Tempio Malatestiano, Rimini

IV

THE PORTRAITS

```
►■=□=■□=□◄█■►□=■□=■◄
```

ortraits of the Bacci family appear in Piero's *Battle Between He-*
raclius and Chosroes [67], and an accurate likeness of the kneeling
Federico da Montefeltro is seen in the Brera altarpiece [42]. But
these examples do not really demonstrate Piero's capabilities as a painter
of the independent portrait: a picture in which the likeness of the sitter
is the dominant feature of the work.

Piero painted at least four independent portraits: the double portrait
of Federico da Montefeltro and his wife, Battista Sforza; the portrait of
Sigismondo Malatesta, duke of Rimini, kneeling before his patron saint;
and a portrait of an unknown worshiper (Gerolamo Amadi?) adoring
Saint Jerome. Each of these portraits adds to our knowledge of Piero's
stylistic and interpretive powers, and all demonstrate his ability to infuse
a traditional type with new meaning.

Even today, in its ruinous state, the fresco portrait of Sigismondo
Malatesta kneeling before his patron, Saint Sigismund, has a compelling
sense of power and personality [70]. Most of this arises from Piero's
talent as a painter, but the motivating force behind the fresco and the
inspiration for its ultimate form was Sigismondo Malatesta himself.

The Malatesta family came to power in the southern areas of the papal
territory of the Romagna in the fourteenth century. Centering their rule
in Rimini, a coastal city on the Adriatic, they gradually gained consider-
able sway over a wide area of surrounding territory. Mercenary captains
for the pope, the family prospered and consolidated its power for over
a century.[1]

Sigismondo Malatesta (1417–1468) was a bastard son of Pandolfo
Malatesta, the lord of Fano, a Malatesta stronghold on the Adriatic. In
1432 Sigismondo succeeded his uncle Carlo as the ruler of Rimini. A
famous and skilled condottiere, Sigismondo, however, lacked diplo-
macy, an essential survival skill for the ruler of a relatively small Renais-
sance territory. He made powerful enemies, including Duke Federico
da Montefeltro of Urbino (Piero's important patron), the Sforza family
of Pesaro, and the Sienese pope Pius II; the latter excommunicated

Sigismondo and had him canonized to hell in 1462. In 1463, all of Sigismondo's territories, except Rimini, were wrested from him, and his power was greatly reduced.[2]

Until recently Sigismondo has been viewed as a sort of Renaissance pagan with perverted moral and sexual practices. Accordingly, much of the art that he commissioned, some of it admittedly ambiguous in meaning, has been seen through this lens. Recent research and common sense have, however, tended to negate this view, which was probably first spread by his many enemies to defame him. Most men and women of the Renaissance, no matter what their moral fiber, were unquestioning believers in Christianity, and the tales of widespread paganism in the period, so beloved by the easily titillated nineteenth century, seem curiously romantic and untrue today.

Sigismondo's enduring accomplishment was not in war or diplomacy but in the patronage of art. The church of San Francesco in Rimini, often called the Tempio Malatestiano, remains a monument to both Sigismondo and Isotta da Rimini, his long-term mistress, whom he finally married in 1456.[3] The earliest plans seem to have called simply for the remodeling of the fourteenth-century church, but apparently by 1450 these were changed to a much more ambitious rebuilding. For the new plans the famous Florentine architect Leon Battista Alberti was consulted, along with Matteo de'Pasti, who probably supervised the construction of the building and did some of its carving. Much of the remaining decoration was done by another well-known Renaissance master, the Florentine sculptor Agostino di Duccio, an almost exact contemporary of Piero della Francesca.

There are several interesting and important conditions concerning Piero's portrait, which was painted in the chapel of Saint Sigismund. First, the chapel was built in fulfillment of a vow made by Sigismondo in 1446; and second, the chapel is dedicated to the donor's patron saint. These circumstances strongly influenced the commission, and, from the moment he arrived in Rimini, Piero must have been aware of the special nature of the fresco he was about to paint. Above all, the *Sigismondo Malatesta Kneeling Before Saint Sigismund* is a votive painting: an offering of thanks, the honoring of a pledge.

A forerunner of Piero's picture, in which a donor kneels before a saint, is now in the Capodimonte Museum in Naples. This large altarpiece [71], by the Sienese artist Simone Martini, dates from the late teens of the fourteenth century.[4] Its subject, which is extremely strange for an altarpiece, is the enthroned Saint Louis of Toulouse crowning his brother Robert of Anjou. The events that prompted the painting help explain its imagery: Louis abdicated the throne of the Anjou kingdom to his brother Robert, in order to become a Franciscan friar (his Franciscan habit is seen under his sumptuous robe embroidered with the

71. Simone Martini, *Robert of Anjou Kneeling Before Saint Louis of Toulouse,* Capodimonte Museum, Naples

Anjou lilies). Doubts were then raised about the legitimacy of Robert's succession to the throne. Simone's altarpiece is, consequently, a visual assertion of the legitimacy of the succession; it demonstrates clearly that the succession was divinely ordained. Louis is given the crown of sainthood at the very moment he places the secular crown on the head of his kneeling brother. The sanctification of Robert's power is presented in a dramatic but straightforward manner that is meant to both instruct and impress the onlooker; this is a very earthly altarpiece, with little of the usual spiritual or liturgical overtones of the type.

Many pictures from the Renaissance depict donors kneeling before

72. Andrea Mantegna, *Madonna della Vittoria,* Louvre, Paris

their patron saints, but most of these are simple commemorations of the donors, dynastic markers in an extensive fresco cycle or a large altarpiece. There is, however, another picture from the Renaissance that, like Piero's fresco in the Tempio Malatestiano, was painted to fulfill a vow: the *Madonna della Vittoria* [72] by Andrea Mantegna, which, although it postdates Piero's work by nearly fifty years, sheds some light on the nature of Renaissance votive painting.[5]

Francesco Gonzaga, the marquis of Mantua and the man kneeling in Mantegna's painting, is the center around which the many and fully documented circumstances of the altarpiece's genesis revolve. Like Si-

gismondo, Francesco was a skilled soldier, but when he found himself in dire straits during a battle with French troops at Foronovo near Mantua in 1495, he implored the Virgin for help; later he attributed his personal salvation and the victory of his troops over the French to the battlefield vow he had made to the Virgin. Even though the skirmish was of dubious outcome and little importance, Francesco considered the action at Foronovo a major victory and saw himself and the Virgin as saviors of his state.

Accordingly, to fulfill his vow and immortalize his own actions, he commissioned a votive painting from Andrea Mantegna, his court painter. Originally planned as a fresco, the work was then changed to an altarpiece depicting the Madonna della Misericordia with the marquis; his wife, Isabella d'Este; and his two brothers. After several other changes in plan, the present version, with a modified Madonna della Misericordia flanked by standing saints and adored by Francesco, was conceived.

The major points of similarity between Mantegna's *Madonna della Vittoria* and Piero's *Sigismondo Malatesta Kneeling Before Saint Sigismund* are several. Both works are the direct results of vows; both depict the donor kneeling; both place the major holy figures above the supplicant; and both depict a physical and psychological interaction between the two principal figures. These similarities are almost certainly not a result of Mantegna's borrowings (although it seems likely that he knew at least several works by Piero); rather, they stem from a common tradition of votive paintings, which had its origins long before either artist was born. (Piero also worked in this tradition when he painted his *Saint Jerome and a Donor* [73], discussed below.)

Piero's painting differs from Mantegna's (but resembles Simone Martini's *Saint Louis of Toulouse*) in that all extraneous figures are suppressed as the donor confronts his patron alone. Moreover, and this seems a result of Sigismondo's powerful personality, the two figures are much more of the same stature than are the marquis of Mantua and the monumental Virgin before whom he kneels (there is also none of the enormous size difference between Louis and his brother Robert of Anjou in Simone's altarpiece).

Perhaps it was Sigismondo who ordered the fundamentally new and unique spatial relation between the two figures in Piero's fresco. In this painting, in contrast to the votive altarpiece of Francesco Gonzaga, the donor takes center stage; he, and not the saint before whom he kneels, is the focus of the scene. This is, in other words, a fresco more about the donor than the patron saint.[6]

Piero has designed this fresco so that Sigismondo Malatesta is the focus of a brilliantly balanced composition. Framed by two finely fluted pilasters with Corinthian capitals, Sigismondo occupies the center of a

composition divided into three sections by the pilasters. The leftmost section, with the seated Saint Sigismund, is opposed and balanced by the rightmost division, occupied by the dogs (both made with the same cartoon) and by the stone roundel that frames a view of the castle of Rimini, built by Sigismondo Malatesta in 1446 and here probably meant to be a symbol of Sigismondo's fortitude and power (an allegorical portrait of the virtue Fortitude appears on the reverse of one of Sigismondo's portrait medals). Sigismondo is the physical and psychic center of this delicately balanced composition; his is the key form that allows the various parts of the work to coexist within the monumental harmony so characteristic of every composition by Piero.

It is unlikely that Sigismondo sat for Piero. Rather, it appears that Sigismondo's likeness depends on one of a brilliant series of medals, by Matteo de'Pasti, that depicts the bust of Sigismondo on the obverse, and on the reverse, the castle of Rimini, which Piero copied for the fresco's roundel. The powerful heraldic quality of the medalic portrait was eminently suitable for Piero's commanding image of the despot.

Contemplation of the fresco's form raises what is perhaps the most important question about the work: What is its function? Certainly it is not a fresco altarpiece, a painting whose imagery is tied to the liturgy: there are no references, obvious or subtle, to Christ, nor to his sacrifice, nor to the Mass. Neither is the fresco a narrative with liturgical and doctrinal references, such as those in Piero's True Cross paintings. It tells no story, nor does it seem to contain any message other than the nominal themes of reverence and supplication. Rather, it is an elaborate portrait of the authority of Sigismondo Malatesta: a document of his physical being, of his power, and of his domination as lord of Rimini. Here is Sigismondo as the forceful, iconic hub around which revolve the castle, the coat of arms, the dogs, and even the saint.[7]

The relief sculptures by Matteo de'Pasti and by Agostino di Duccio in the Tempio Malatestiano may have influenced Piero in this, his most relieflike painting.[8] The limited space (originally the area behind the kneeling donor was painted to resemble marble) that keeps the forms near the picture plane, the strict profiles of Sigismondo Malatesta and the dogs, and the symmetrical, crisply drawn architecture all seem to be the painted equivalents of a finely carved stone relief.

The configuration of the Sigismondo Malatesta portrait is roughly paralleled by a painting by Piero now in the Venice Accademia, depicting a donor kneeling before Saint Jerome [73]. This portrait bears two inscriptions: on the tree trunk, PETRI DE BV[R]GO S[AN]C[T]I SEP/VLCRI OPVS; and below the donor, HIER. AMAI. AVG. It has been suggested that the donor—this is clearly a portrait of a particular individual—was one Gerolamo Amadi, who lived in Venice but was originally from the Tuscan town of Lucca.[9] The Amadi family were major patrons of Santa

73. Piero della Francesca, *Saint Jerome and a Donor,* Accademia, Venice

Maria dei Miracoli, one of the most important Venetian Renaissance churches. There is, however, no documented connection between any member of the Amadi family and the picture now in the Accademia. The matter is further complicated by doubts about the authenticity of both inscriptions and by the fact that nothing is known about the painting before it entered the Accademia in 1850 as a gift of the Renier family.

Whoever its patron, Amadi or someone else, *Saint Jerome and a Donor* is, like the *Sigismondo Malatesta Kneeling Before Saint Sigismund* and the Urbino *Flagellation,* a painting that defies easy classification. All the elements of the work are known in fifteenth-century painting, but the combination of a seated saint and an adoring donor set within a deep landscape is unlike any other contemporary work. The Sigismondo Malatesta portrait in Rimini is, in fact, the closest painted analogue, although in the Venice painting the donor plays a slightly lesser, but still considerable, role.

There are many similarities between the Venice painting and the rest of Piero's work. The extensive landscape—with its rolling hills, dotted fields, and cityscape—is quite close to that of the London *Baptism* [33] and the Sansepolcro *Resurrection* [48]. Also similar is the large tree behind the donor, which in shape and in feel is comparable to the great trees of the London *Baptism* and the Arezzo frescoes. Piero's hand is also immediately recognizable in the figures, which exhibit the same construction and drawing as the figures in all his other panels. Facial types and the careful attention to clothing also attest to his authorship of the Venice painting.

Although the painting is damaged and rubbed, it is evident that *Saint Jerome and a Donor* exhibits the palette and the delicate, luminescent tonality that are hallmarks of Piero's idiom. The subdued earthen colors, the particular gray of Jerome's robes, the rich red hue of the donor's gown, and the lighting of the landscape here, and in all Piero's works on panel, testify to the consistent nature of his art.

This said, it must be admitted that the Venice painting somehow lacks the compelling interest of Piero's other works. What is fascinating here is not an overall conception of great brilliance, such as one finds in the *Flagellation* or the *Baptism,* but, rather, the details. One admires the enchanting landscape and the towered town, but one remains unimpressed by the work as a whole, even though there are superb passages of painting, such as Saint Jerome's arms and the leafy tree. Perhaps this is because Piero was given strict instructions about this work, told exactly what to paint and where on the panel to paint it. Of course, this also must have been true of the Rimini portrait of Saint Sigismund and Sigismondo Malatesta, but in that case Piero produced a masterpiece, possibly because there he was working for an extraordinary patron.

As in the Sigismondo Malatesta portrait and the Venice painting, the

commemoration of the individual is the leitmotif of another of Piero's memorable ventures in the art of portraiture: the double portrait of Federico da Montefeltro and his wife, Battista Sforza. Now so popular that they are almost synonymous with the word *Renaissance,* these two paintings [74, 75] and the Triumphs on their reverse sides [76, 77] are among Piero's most original and beautiful creations.

As with most of Piero's work, there is no documentation to describe when or under what circumstances the double portrait was executed.[10] In fact, one knows only that the portraits were in Urbino, probably in the ducal palace, until the early 1600s, when they passed into the collection of the Medici of Florence.

About 1450 the Renaissance portrait was still in its infancy. Only several decades before, portraiture had consisted of the simple reproduction of types: old, middle-aged, bearded, tonsured, and so forth. As with the figures in Simone Martini's Louis of Toulouse altarpiece, portraits were, for the most part, representations of certain social stations and types rather than the accurate reproduction of the individual's face and body.[11]

About 1430, Florentine artists started to make portraits in strict profile, which represented, albeit in a rather abstracted fashion, the sitter's visage; a good example is the portrait of a young man attributed to Paolo Uccello [78]. The exact function of these portraits is unknown, but at least some of them were made as memorial images. Probably hung in the more private rooms of a home, these were among the first truly secular works of the Renaissance.

Piero's portraits of Federico and Battista are very much in the tradition of the early Florentine profile portrait. Each of the faces is drawn with a high degree of stylization and reduction; the formal properties of the duke's hat are, for example, as much about abstract shape and color as they are about the reproduction of that particular item of clothing. Certainly, one could recognize Federico and his wife from these portraits, but the accurate replication of their faces is not of primary importance. Piero is rather uninterested in the individual, in the accidental quality of the human face and the character of the sitter. One would be, in fact, hard pressed even to speculate upon the personalities of Piero's heraldic Federico and Battista.

Rather, the artist's major intent was to create images that would impress by their aloofness and authority, that would be signs of their subjects' elevated social position. Piero places the strict profile in a context new to the history of portraiture: an extensive, contiguous landscape that, along with the glance of the sitters, unites the panels. (The nineteenth-century frame that at present encloses the paintings separates them too widely. Originally they would have been divided only by a slender strip of framing. This narrow separation would have allowed the

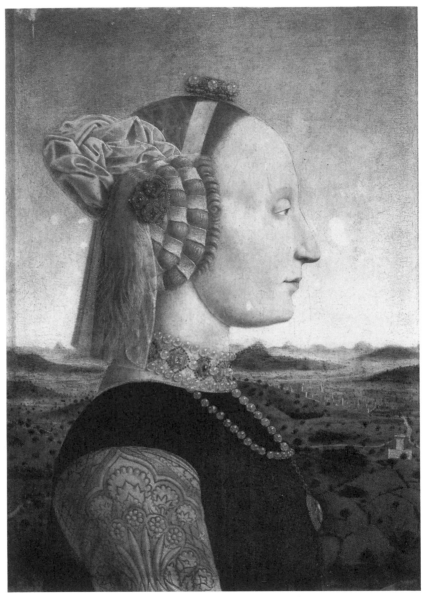

74. Piero della Francesca, *Battista Sforza,* Uffizi Gallery, Florence

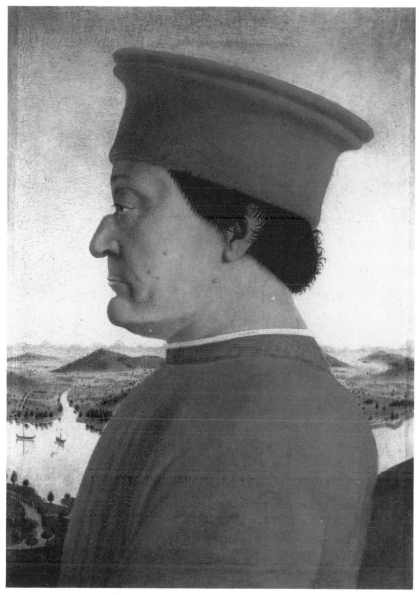

75. Piero della Francesca, *Federico da Montefeltro,* Uffizi Gallery, Florence

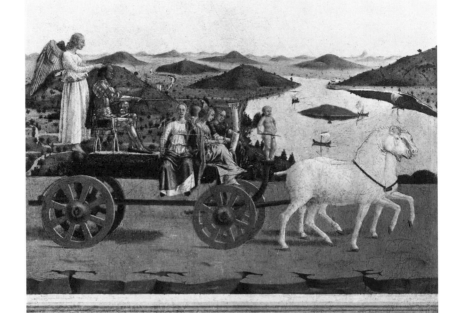

CLARVS INSIGNI VEHITVR TRIVMPHO ·
QVEM PAREM SVMMIS DVCIBVS PERHENNIS ·
FAMA VIRTVTVM CELEBRAT DECENTER ·
SCEPTRA TENENTEM ·

76. Piero della Francesca, *Triumph of Federico da Montefeltro,*
Uffizi Gallery, Florence

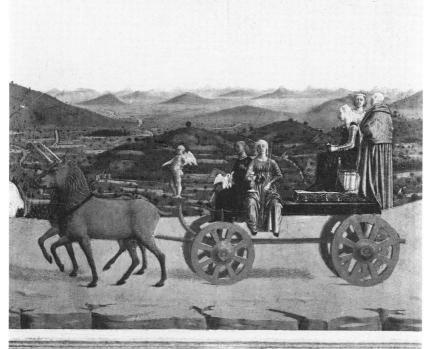

QVE MODVM REBVS TENVIT SECVNDIS ·
CONIVGIS MAGNI DECORATA RERVM ·
LAVDE GESTARVM VOLITAT PER ORA ·
CVNCTA VIRORVM ·

77. Piero della Francesca, *Triumph of Battista Sforza,* Uffizi Gallery, Florence

landscapes, both on the front and back of the panels, to be much more contiguous.)

Because they are so large and so close to the picture plane, the couple dominate the landscape, just as they ruled Urbino and the countryside of their mountainous state. These plains, rivers, and mountains obviously belong to them, and their figures rise above the natural world with a dignity and gravity seldom surpassed in the long history of portraiture.

Representing many square miles within just several inches, the landscapes are marvels of compression; they also offer a panorama and a silvery, moisture-laden atmosphere that is suggested but never fully realized in Piero's other paintings. Each small topographical feature takes on a life of its own: the gleaming, placid lake fed by the wide river; the foggy, fertile plain dotted with cities and isolated buildings; the scattered fauna; and, at the horizon, the mountain range veiled in the bluish mist of the distance. This is not only a vista of the rulers' land, it is also a poetic, loving evocation of a benevolent nature that is the ideal environment for humans.

Piero has established the horizon a little less than halfway up the background; as a result the faces are silhouetted against the broad expanse of blue sky. A cleaning of the portraits in 1986 removed much accumulated grime and varnish, and uncovered a brilliant range of lights in the sky. For the first time in many years the subtle gradation of color from the near-white horizon to the blue of the upper sky became visible, and the artist's original purpose to give movement and variety to the large area of sky-background was revealed. The placement of the heads against such a broad expanse of sky is markedly different from earlier portraits, where the sitters were set before an indeterminate area of dark hue, meant perhaps to represent a wall. The use of the sky-background in Piero's portraits of Federico and Battista is a harbinger of later fifteenth-century portraits, in which the placement of the sitter on a parapet became common.

One fascinating, but ultimately unanswerable, question about the portraits concerns Piero's working method: did Federico and Battista sit for him? The answer seems to be no. Our modern ideas about the need for extensive sittings to capture something of the subtlety of the sitter's mind would have made little sense to a Renaissance artist working about 1450 in the service of a commanding ruler. What was wanted, as in the case of Sigismondo's portrait, was a symbol of power and authority. Accordingly, Piero's faces are so formalized and abstracted that many direct sittings would have hindered rather than enhanced his images; Piero was after reductive form, not realistic representation. The basic concept behind the portrait is, as we have seen, symbolic; they are more anthropomorphic coats of arms than depictions of face and character.

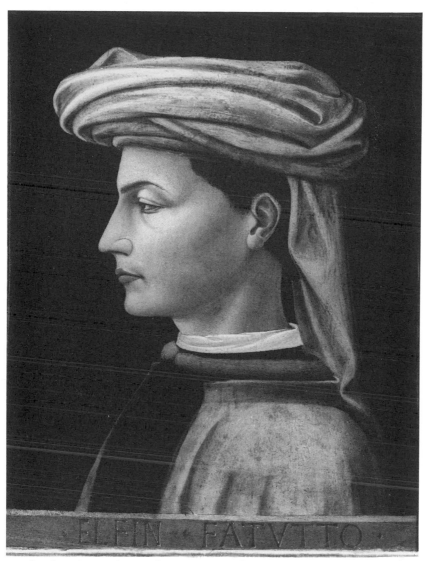

78. Attributed to Paolo Uccello, *Portrait of a Young Man,*
Musée Benoit-Molin, Chambéry

79. Sperandio of Mantua, medal of Federico da Montefeltro

Thus, it seems likely that for his portraits of Federico and Battista (and for that of Sigismondo Malatesta as well), Piero turned not to the sitters themselves, but to other sources. Perhaps the most important of these was the medal.[12]

Federico's likeness was well known from a series of medals that bore his bust-length likeness on the obverse. Piero must certainly have seen these medals during his visits to the court of Urbino, and his painted image of Federico is, in part, probably based on them. One medal [79], by Sperandio of Mantua, seems closest to Piero's portrait of Federico, especially in the rendering of the chin, hair, and overall facial structure. The inscription on Sperandio's medal identifies Federico as duke and thus must date after 1474, the year in which the title was bestowed. There is, of course, the possibility that the Sperandio medal and others of Federico might be based partially on Piero's portrait, but the strict, linear profile and thin, planar character of the painted likeness, so characteristic of medalic art, makes this appear unlikely.

There is no surviving medal of Federico's wife, Battista Sforza, but it is possible that one was commissioned and made; like the painted image of Federico, Battista's image resembles the low-relief profiles so characteristic of fifteenth-century portrait medals. If, in fact, Federico's likeness does depend on the Sperandio medal, which was made after 1474, then Piero's portrait of Battista, who died in 1472, must be posthumous. Such posthumous portraits were often made from death masks (this seems to be the case with the beautiful portrait of Battista carved by Francesco Laurana), and such a source has been claimed for Piero's

image of Battista. But this claim is difficult to prove, because both Federico and Battista are purposefully stylized and iconlike in order to appear as commanding, remote images; each has a masklike quality, highly appropriate for their powerful and elevated status.

Piero's glorification of Federico and Battista continues on the back of the panels: painted there are the *Triumph of Battista Sforza* and the *Triumph of Federico da Montefeltro*. Like the portraits, the Triumphs may be indebted to medals, which sometimes carried a reverse side depicting a Triumph.[13] But the Triumph was a popular subject about the middle of the fifteenth century and could be found, for example, on chests intended for the home, as illustration in manuscripts, on panels, and in frescoes. The Triumph had its origins in the actual triumphal entries and processions of the Roman armies, literary descriptions and carvings of which fascinated the Renaissance. Another important source was Petrarch's *Trionfi,* poems written in the fourteenth century describing Triumphs of fame, chastity, love, truth, time, death, and eternity.[14]

The painted Triumphs of Federico and Battista are glorifications of the rulers that evoke ancient traditions. Federico's cart (an essential part of any Roman or Renaissance Triumph) is driven by a Cupid and carries the four cardinal virtues: Justice, Prudence, Fortitude, and Temperance. Federico's personal triumph is made manifest by a white-robed personification of Fame, who places a wreath on Federico's head. The fact that Federico appears in full armor, perhaps the same white armor that he wears in the Brera altarpiece [42], and carries a baton, the symbol of military command, would not have been lost on the many who knew of his military prowess; the Triumph is a pictorial confirmation of his success and fame as a ruler and as a professional soldier.

Two brown unicorns, symbols of chastity, pull Battista's cart toward the advancing white horses of Federico's Triumph. This movement of the couple toward each other, seen also in the echoing gazes on the fronts of the panels, is one of Piero's most charming inventions; it is the ideal visual metaphor of love and marriage. Seated on a chair placed on a small raised platform, Battista is accompanied by Faith and Hope and two other, unidentified figures, one of whom is probably Charity, the third theological virtue. As in the Triumph of Federico, the cart is guided by a Cupid, a symbol of love.

The two Triumph panels are further unified by the landscape, which, like that of the fronts, is contiguous. By its hills, wide rivers, lakes, and trees we realize this is the same landscape that lies behind the front portraits of Federico and Battista. Thus the Triumphs, although clearly allegorical, are connected with the real domain ruled by the couple.

Beneath Federico's Triumph are these words: HE RIDES ILLUSTRIOUS IN GLORIOUS TRIUMPH * HE WHOM AS HE WIELDS THE SCEPTER WITH MODERATION, THE ETERNAL FLAME OF HIS VIRTUES CELEBRATES AS

80. Piero della Francesca, *Hercules,* Isabella Stewart Gardner Museum, Boston

EQUAL TO THE GREAT GENERALS. Below the Triumph of Battista one reads: SHE WHO OBSERVED RESTRAINT IN SUCCESS FLIES ON ALL MEN'S LIPS, HONORED BY THE PRAISE OF HER GREAT HUSBAND'S EXPLOITS.

Taken together, the inscriptions glorify Federico twice, directly and then indirectly, through his wife. He is extolled for his station equal to the great generals and for the moderate use of his power. The mention of Federico's lasting fame, "the eternal flame of his virtues," suggests that one function of the portraits was certainly memorial: they were made to embody and preserve something of the likeness and the deeds of the couple.

In many ways, Piero's portraits are extraordinary: the overall design of the fronts and backs, while it recalls the medal, is unique in the history of Tuscan portraiture. Moreover, the placement of the two strict profiles on a parapet overlooking a vast panorama appears to be unprecedented. But it is the overall message of both the fronts and the backs that is the most novel and intriguing aspect of Piero's double portrait. By the simple opposition of the sitters, by the contiguous landscape, and by the convergence of their two Triumphs, he has made these two powerful rulers a couple, a husband and wife. He has forever immortalized their physical, conjugal, and dynastic unity.

Piero's *Hercules* [80] is not, of course, a portrait in the same sense as the paintings of Federico and Battista. Rather, it belongs to the ancient tradition of idealized portraits of famous heroes, which first found renewed popularity in the Italian peninsula in the fourteenth century.

It is reported that the *Hercules,* which may be a fragment of a larger fresco (the body seems truncated), was found in a house in Arezzo, one perhaps belonging to a relative of Piero. In 1906, the painting was sold to Isabella Stewart Gardner and became part of the collection of the Gardner Museum in Boston.[15] Regardless of the provenance, which sounds, in this case, highly romantic and perhaps the fiction of an eager dealer's imagination, the fresco seems to be an autograph work, although it has suffered substantial areas of damage, most of them now skillfully concealed.

Originally the fresco probably belonged to a series of heroes and heroines painted on a long wall of a palazzo or villa. Such series were found in large Renaissance dwellings, and one of about 1450, by Andrea del Castagno [81], although it does not contain a Hercules, furnishes some idea of what Piero's series might have looked like.[16] Each of the figures in Castagno's series is placed in a separate niche, and all are linked by the framing architecture. Some similar framing must have surrounded Piero's *Hercules,* but the strip of pilaster to the left, over which the club is placed, seems to be its sole remnant.

Piero's *Hercules* is additive in nature: both the face and body are composed of stock motifs seen in many of the male figures in the Arezzo

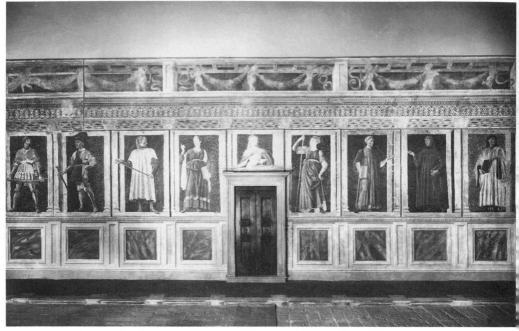

81. Andrea del Castagno, *Heroes and Heroines,* Uffizi Gallery, Florence

frescoes. The lack of individuality or peculiarity makes the Hercules, like the Christ of the Sansepolcro *Resurrection* [48], remote and awesome. These characteristics would perhaps have been more apparent when the figure was whole and was framed by its original painted architecture. One can imagine that a row of similar figures would have made an impressive sight indeed.

Although few in number, Piero's portraits are an important component of his art. The traditional, and usually inexpressive, strict profile portrait type utilized by Piero as the basis for his portrayals of Sigismondo Malatesta and Federico da Montefeltro and Battista Sforza was changed into a new emblem of power and presence. Grounded in conventional types, like his altarpieces and frescoes, the portrait was shaped, in Piero's hands, into something new both in form and in meaning. *Saint Jerome and a Donor* is another work with strong ties to the past that again was altered by Piero's intelligence into something unique. Even the imaginary portrait of Hercules, although still close to the traditional type of a hero portrait, is filled with a character clearly Piero's own. Piero's alteration and modification of conventional types imbued his works with a marked individuality, which was to be the object of imitation and attraction for other talented artists.

NOTES

1. For the Malatesta family, see J. Larner, *The Lords of Romagna,* Ithaca, 1965; P. Jones, *The Malatesta of Rimini,* London, 1974.

2. For Sigismondo Malatesta, see P. Jones, *The Malatesta of Rimini,* London, 1974; M. Tabanelli, *Sigismondo Pandolfo Malatesta,* Faenza, 1977.

3. For the Tempio Malatestiano, see C. Ricci, *Il Tempio Malatestiano,* Milan, 1925; C. Brandi, *Il Tempio Malatestiano,* Turin, 1956. Charles Mitchell has published two articles fundamental for the understanding of the imagery of the Tempio Malatestiano: C. Mitchell, "The Imagery of the Tempio Malatestiano," *Studi Romagnoli* 2 (1951): 77–90, and C. Mitchell, "Il Tempio Malatestiano," *Studi Malatestiano,* Rome, 1977. Professor Mitchell suggested in a conversation with me that the castle is meant to be both a portrait of that building and a symbol of Sigismondo's Fortitude.

4. For Simone Martini's *Saint Louis of Toulouse,* see G. Paccagnini, *Simone Martini,* Milan, 1955.

5. For Mantegna's *Madonna della Vittoria,* see R. Lightbown, *Mantegna,* Berkeley, 1986.

6. This type of painting, with kneeling donors and a seated patron saint in the compass of a rectangular format, had been fully developed in Venice by the late fifteenth and early sixteenth centuries. Probably originating in the fourteenth-century votive portraits of the Doges and perfected in the shop of Giovanni Bellini, an artist influenced by Piero della Francesca, it was fully and subtly explored by many Venetian masters, including the young Titian. For Titian's portrait of Bishop Pesaro kneeling before Saint Peter, see H. Wethey, *The Paintings of Titian,* London, 1969, vol. 1, pp. 152–53.

7. For medals depicting Sigismondo Malatesta, see G. Hill, *A Corpus of Italian Medals Before Cellini,* 2 vols., London, 1930.

8. For the relief sculpture in the Tempio Malatestiano, see note 3.

9. For speculation on the identity of the donor, see E. Battisti, *Piero della Francesca,* Milan, 1971, vol. 2, p. 10.

10. For the history of these panels, see E. Battisti, *Piero della Francesca,* Milan, 1971, vol. 1, pp. 355–71.

11. For the history of Renaissance portraiture, see J. Pope-Hennessy, *The Portrait in the Renaissance,* Princeton, 1979.

12. For medals of Federico da Montefeltro and Battista Sforza, see G. Hill, *A Corpus of Italian Medals Before Cellini,* 2 vols., London, 1930.

13. For medals with Triumphs on the reverse, see note 7.

14. For the Triumph in the Renaissance, see W. Weisbach, *Trionfi,* Berlin, 1919; J. Hale, ed., *A Concise Encyclopaedia of the Italian Renaissance,* New York, 1981.

15. For the history of the *Hercules,* see E. Battisti, *Piero della Francesca,* Milan, 1971, vol. 1, pp. 402–9.

16. For Castagno's frescoes and other cycles of heroes and heroines, see M. Horster, *Andrea del Castagno,* Oxford, 1980.

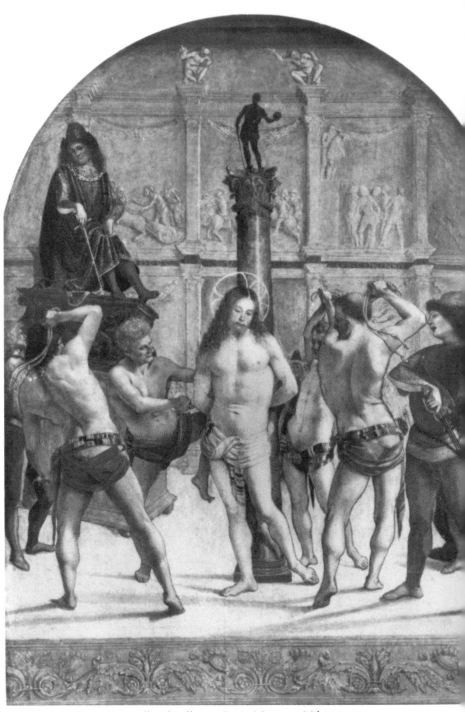

82. Luca Signorelli, *Flagellation*, Brera Museum, Milan

Epilogue

The location of Piero's commissions did much to determine his place in history. Although probably trained in Florence— he certainly was there while still a young artist in 1439—he never again seems to have had much work in that important and influential city, although it is possible that paintings he did in or for Florence have been lost. Undoubtedly, an important component of his art was Florentine and was derived from Masaccio, Donatello, and Domenico Veneziano. Yet, when Piero returned to Sansepolcro, the style that had so influenced him in Florence was already giving way to other, newer idioms, then developing in the city.[1] Masaccio was to be forgotten for decades until his rediscovery by Michelangelo and Raphael; Donatello, who was absent from Florence for much of the 1440s, soon moved in different, darker directions. Perhaps one of the reasons that Piero's works do not appear in Florentine churches is precisely because his painting might, by the mid–1440s, have already seemed just a bit old-fashioned and thus unworthy of major commissions.

This certainly would not have been the case in Sansepolcro, a provincial town set far from the artistic ferment of Florence. What the inhabitants of Sansepolcro wanted was exactly what Piero gave them: a traditional art of traditional forms and conventions. Piero, like almost all of his contemporaries, was a conservative artist. Artistic education, tradition, and practice dictated that art was to be learned from the study and copying of the art of one's teacher. The art of the past was also revered: painters and sculptors of the Renaissance looked upon the past as a great mine to be worked for the benefit of the present; the past was a continuing source of edification and inspiration.[2]

Some artists were never able to free themselves from a simple repetition of the past, and their works are merely derivative. Yet, like Piero, many of the major artists of the Renaissance found the boundaries of tradition quite elastic. Old forms could be reassembled and recombined in new ways, the stories could be thought out afresh, and the artist's personality could be breathed into everything he did.

141

Piero's art offered no surprises to the patrons for whom he worked; it was familiar, comfortable, and traditional, but, and this is not a contradiction, it was also of surpassing quality and profundity. Its component parts, its motifs, its types, and much of the character of its religious and spiritual interpretation can be found in the art of Piero's predecessors; still, it is a highly personal and a unique creation. Piero combined, recombined, and changed all that he borrowed. The way he modified and then infused his borrowing with a new physical and spiritual presence demonstrates how in the Renaissance the old generated the new, how the past propelled the present into the future. In many ways, Piero is the quintessential Renaissance artist. His reverence for the past and its traditions makes him and his art very different from that of the modern artists whose fervent quest for originality is now regarded as the sine qua non of artistic worth.

Although it cannot be proved, there is good reason to think that Piero was chosen to replace in Arezzo the ailing Bicci di Lorenzo because Piero had a good local reputation and because his art was conservative enough to please the wealthy merchants of Arezzo, a provincial city. The conservative nature of Piero's art must also have appealed to the small courts under the tight control of forceful dynastic rulers, and it was the discerning patron Federico, duke of Urbino, who commissioned several of Piero's most memorable paintings. Commissions were also executed for the courts of Rimini and Ferrara, and there may have been other works of this type for other courts that have not survived.

Piero's traditional approach made his work accessible to a group of younger painters who either studied with him or fell under the sway of his style. The most important of these was Luca Signorelli.[3] Born in the Tuscan city of Cortona about 1450, Signorelli was probably apprenticed to Piero while still an adolescent. One of Signorelli's early works, the *Flagellation* [82], now in the Brera Museum, Milan, demonstrates his sizable debt to Piero. Perhaps loosely based on the *Flagellation* [43] by Piero in Urbino, Signorelli's painting reveals his unceasing fascination with the rendering of the human body. The contorted poses of the men surrounding Christ and the detailed attention to their musculature surely must have been engendered in Signorelli's apprenticeship with Piero della Francesca. One can imagine that Piero would have considered drawing and the making of cartoons of utmost importance in the training of an apprentice. Piero's drawing and his interest in rendering and foreshortening the body, although much more restrained than Signorelli's, became one of the elements of Signorelli's art, finding its greatest expression in the twisted, highly complex figures of his fresco cycle in the Duomo of Orvieto.

These frescoes and other paintings by Signorelli were to transmit some of Piero's style and ideas to the masters of central Italian painting

83. Michelangelo, *Doni Tondo,* Uffizi Gallery, Florence

in the sixteenth century. There can be little doubt that the young Michelangelo was attracted and influenced by Signorelli's wiry line and the daring contortions of his painted protagonists.[4] In the *Doni Tondo* [83], an early work by Michelangelo, the nudes in the background and the poses of the holy family itself appear indebted to Signorelli.

Piero's insistence on the art of drawing and the working up of figures from drawings to cartoons was a new element in the history of Tuscan painting and a harbinger for the future. After Piero, as is evident in the works of Signorelli, Michelangelo, and Raphael, who also seems to have known Signorelli's painting, accomplished drawing became something appreciated for its skill outside the context of the picture in which it appeared. Drawings on paper were now saved and collected. Painters now made many drawings of every conceivable type for their paintings; drawing became the way an apprentice learned how to paint.[5] Piero certainly did not originate this, but his interest in drawing and his use of it were a forerunner of this development in the history of Western art.

Piero also had a number of local followers, of considerably less importance than Luca Signorelli.[6] Their work is confined to the Tuscan area around Sansepolcro and Arezzo and is of a uniformly mediocre quality, with the single exception of the Florentine Don Pietro Dei, called Bartolomeo della Gatta, a Camaldolese monk who lived in Arezzo from 1470 until his death in 1502. Most of his works are to be found in the area around Arezzo, with the important exception of a fresco in the Sistine Chapel in Rome, which he did with Luca Signorelli in 1482. There is a resemblance between Signorelli and Bartolomeo della Gatta, who seems to have fallen very much under the former's sway.

In his altarpiece of 1487 showing the Stigmatization of Saint Francis [84]—in the Pinacoteca of the small Tuscan hill town of Castiglion Fiorentino—one sees Bartolomeo's fascinating but still underrated idiom. The large, beautifully rendered figures, which seem frozen in their rather complicated poses, depend originally on Piero della Francesca. There is a preternatural stillness about the scene of the Stigmatization, which, like the illumination, also seems to stem from the tranquillity and luminescence of Piero's work. But in his treatment of the landscape and in the strange faces of the friars, there is an individuality and a charming eccentricity that is all Bartolomeo della Gatta's. There is in the work of Bartolomeo della Gatta and Signorelli a kind of idiosyncratic strain that moves their painting outside the orbit of Piero, even though the foundations of their style rest on their training with him. Both men, it should be added, also looked beyond Sansepolcro and Arezzo for inspiration, and found it in the works of Filippino Lippi, Botticelli, Ghirlandaio, and several other Florentines of the last half of the fifteenth century.

Piero's influence was also felt in the north of Italy. And although

84. Bartolomeo della Gatta, *Stigmatization of Saint Francis,*
Pinacoteca, Castiglion Fiorentino

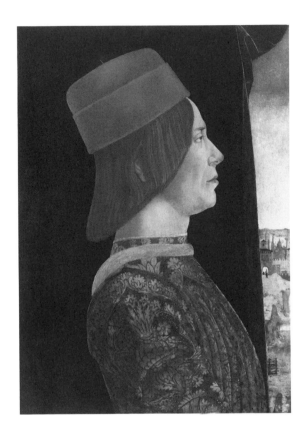

85. Ercole Roberti,
Giovanni II Bentivoglio,
National Gallery,
Washington, D.C.

there is no documentary evidence for a trip by Piero to the north of the
Italian peninsula, there can be little doubt that one took place. Evidence
for a stay by him in the north comes from both literary and visual
sources. Vasari, Piero's early biographer, writing about eighty years after
the artist's death, cites frescoes by Piero in the Estense Castle and in the
church of Sant'Agostino, both in Ferrara.[7] It has been suggested, on the
basis of what has been seen as Piero's impact on Ferrarese art, that these
frescoes must date from about 1450, but the nature of the evidence
precludes any close dating.

One almost certain case of Piero's influence on the Ferrarese school
is found in the portraits of Giovanni II Bentivoglio and his wife, Ginevra
[85, 86].[8] These portraits, which have been attributed to the Ferrarese
painter Ercole Roberti (c. 1455–1496), seem to depend strongly on the
double portrait of Federico da Montefeltro and Battista Sforza. There
is, moreover, a family connection: Ginevra was a Sforza and the sister
of Battista Sforza of Urbino. Conceivably it was because of Piero's

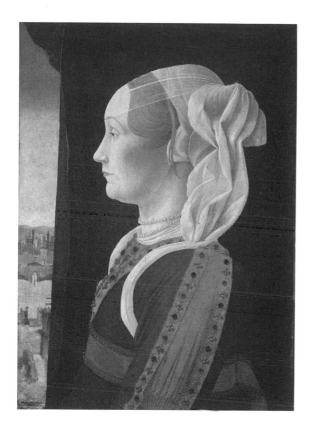

86. Ercole Roberti,
Ginevra Bentivoglio,
National Gallery,
Washington, D.C.

work for Urbino, and especially the great double portrait, that Piero
was called to Ferrara to work, perhaps on portraits.

It certainly appears that the Bentivoglios instructed Ercole Roberti to
make a modified version of the Urbino portraits, or of other portraits
very like them by Piero, ones perhaps made in Ferrara. Moreover, Er-
cole's portraits, like those of Federico and Battista, seem originally to
have formed a diptych. The placement of the figures on a parapet and
the contiguous landscape behind the drapery also seem to derive from
Piero's portraits. The commanding presence of the two figures, the sense
of power and majesty, may depend on Piero's portrayal of the same
characteristics in the Federico and Battista images. There are also sub-
stantial differences between the works, most noticeable in Ercole Ro-
berti's detailed conception and his hardness of design, both character-
istics of the school of Ferrara.

It is quite likely that, while in Ferrara, Piero visited or stayed in
Venice, one of the major centers of power of the Italian peninsula and a

city that held considerable sway over Ferrara. There is, however, no direct evidence for a visit by Piero, no document or contemporary reference to his presence in the city. Rather, speculation on a Venetian visit is based on what is seen as Piero's influence on one of the major figures of Venetian painting of the Renaissance, Giovanni Bellini.[9] Bellini was about the same age as Piero; he was probably born about 1430, but he lived to a great age, working almost two decades into the sixteenth century. Imaginative and receptive to outside influence throughout his career, Bellini absorbed, and made his own, many stylistic influences, including those of his brother-in-law, Mantegna, and Titian, Bellini's greatest pupil.

Piero's influence on Bellini is possibly discerned in the latter's splendid *Resurrection* of about 1480 [87], now in Berlin, in which the freshness of the early morning light and the hypnotic quality of the Christ may owe something to their counterparts in Piero's Sansepolcro fresco, although it is also conceivable that the subject elicited similar ideas and feeling from both artists.

The grandness of Piero's Brera altarpiece (or something similar by his hand), with its dignified architecture, may have exerted an influence on Bellini's later altarpieces, especially the one he painted around 1485 for the church of San Giobbe in Venice [88]. How this influence came about is difficult to ascertain. It is possible, but unlikely, that Bellini could have seen the altarpiece in Urbino (we know that he painted an altarpiece for the nearby coastal town of Pesaro). It is also possible that Piero could have painted a similar altarpiece in Ferrara or perhaps for Venice. Or his influence could have somehow come through Antonello da Messina (c. 1425–1479), a painter from Sicily who did a major altarpiece in Venice—now surviving only in fragments [89]—which appears indebted in structure and in feeling to something very much like the Brera altarpiece.[10] Again, however, there are questions: Where did Antonello see Piero's painting or one like it? Was Antonello's altarpiece influenced by Bellini instead of directly by Piero?

The answers to these questions will probably never be known. Yet the fact remains that, having contemporary church architecture as an articulating and framing element and a light-filled atmosphere of reverential stillness, the late Bellini altarpieces do recall the Brera altarpiece, and it is therefore tempting to suggest influence.

After the demise of Piero's few followers in Tuscany, his name and his work were submerged in the provincialism that was Sansepolcro. Even the short biography in *The Lives of the Painters, Sculptors and Architects,* by Giorgio Vasari, a native of nearby Arezzo, did nothing to rescue his name.[11] For centuries the work and reputation of the artist played no direct part in the practice or the history of art in the Italian peninsula; seldom has an artist who has been judged so important been so neglected for so long.

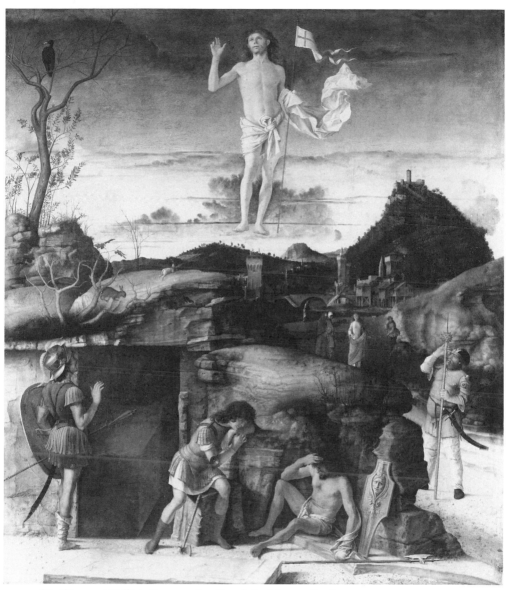

87. Giovanni Bellini, *Resurrection,* Staatliche Museen, Berlin

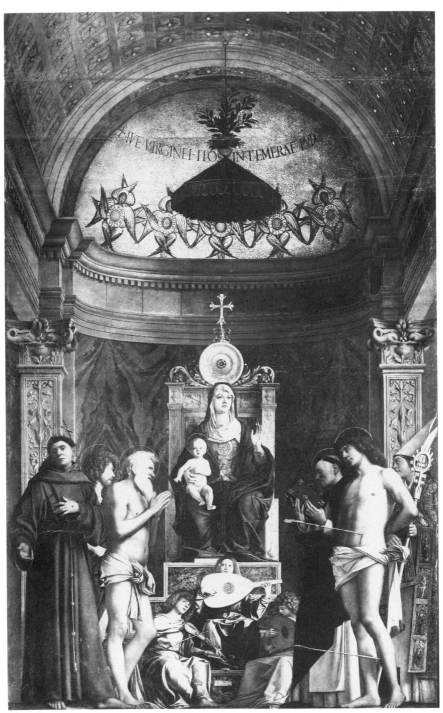

88. Giovanni Bellini, San Giobbe altarpiece, Accademia, Venice

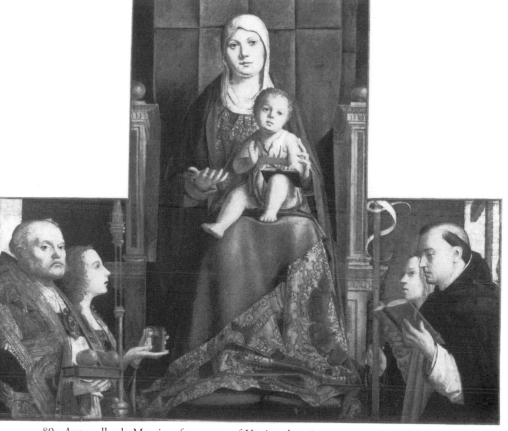

89. Antonello da Messina, fragments of Venice altarpiece, Kunsthistorisches Museum, Vienna

This is incongruous, because Piero had, in several ways, anticipated the style of what is now called the High Renaissance. His extensive use of drawing, especially drawing for the preparation of cartoons, was to become a feature of the art of Leonardo da Vinci, Michelangelo, and Raphael. (Vasari says that Piero's success in drawing "led the moderns to follow him and thereby attain to that high level from which we now view things.") Moreover, Piero's insistence on order, clarity, and balance within a monumental framework was also characteristic of the High Renaissance, as a glance at Raphael's *School of Athens* of 1510 [90] will prove. Piero's interest in the figure and in the highly formal grouping and repetition of the figure was also a trait of central Italian art during the first half of the sixteenth century. Aside from Signorelli's influence on Michelangelo, it is unlikely that there is any direct influence from Piero; there is, rather, a certain communality of spirit between his

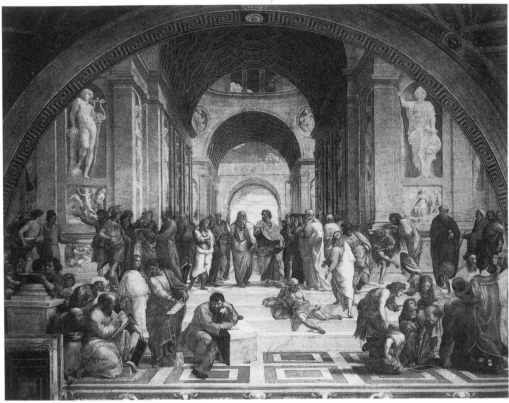

90. Raphael, *School of Athens,* Vatican

works and those of the artists who worked in the half century following his death.

Although in some ways foreshadowing the future, Piero's painting was not revolutionary; it made no abrupt, major breaks with the past. Rather, Piero is the quintessential Renaissance artist: a man innovative well within the framework of tradition. At the time of his death in 1492, when Raphael was nine and Michelangelo seventeen, Piero's painting remained firmly centered in many artistic conceptions that originated in the fourteenth and early fifteenth centuries. Building on the foundations of his Tuscan predecessors and on the art of the first years of the Quattrocento, he held fast to the conventions of pictorial representations that he had learned as a youth, something quite unremarkable in a time when artists learned from and deeply revered the past. In an age like ours, when tradition plays a small role and innovation a very large one indeed, and where there are few guideposts in art, it is sometimes

difficult to appreciate how comfortable artists like Piero could be within the firmly fixed traditions of the Renaissance.

Piero's work elicited only local curiosity until the middle of the nineteenth century, when the first signs of a new interest began to appear. Crowe and Cavalcaselle's *A History of Painting in Italy,* published in 1864–66—a book that was to be of great influence well into the twentieth century—set the foundations for all further appreciation and study of Piero's art. Moreover, in *A History of Painting in Italy* the reader finds the germs of the sort of criticism which was to transform Piero from an obscure and forgotten provincial artist into one of the major figures of the Renaissance. The authors call Piero a "vast genius" and are generally excited by his works, although throughout the mostly laudatory account there are references to what the authors consider Piero's crudeness, a sentiment about most painters before Raphael which was shared by many critics and historians until very late in the nineteenth century.

Shortly after the publication of Crowe and Cavalcaselle's monumental book, Piero was discovered by John Addington Symonds, an influential English writer endowed with superior critical and literary gifts. In his *Renaissance in Italy: The Fine Arts* (1877), Symonds gives a brief but masterly summary of Piero's art, in which he says that the *Resurrection* in Sansepolcro is the "grandest, most poetic, and most awe-inspiring picture of the Resurrection." Overall, Symonds's survey of the artist is among the earliest and most perceptive appreciations of Piero.[12]

It was in the last years of the nineteenth century that one of Piero's great promoters began to contemplate the painter's art and to write about it for a large and receptive audience. Bernard Berenson's *The Central Italian Painters of the Renaissance,* first published in 1897, was a landmark in the study and criticism of Italian art.[13] Its readable, authoritative, and admirably brief text has introduced generations of readers to the notable artists and paintings of the Renaissance and has helped to create an enduring taste for Renaissance painting.

Berenson's paean to Piero in the pages of *The Central Italian Painters of the Renaissance* is a remarkable critical appraisal of the paintings, stressing the structure of the works and acclaiming their undidactic nature. The strong formalism of Berenson's appreciation is paralleled by the increasing interest in strictly formal concerns in the modern art of his day. Berenson was one of the first critics to understand and praise Cézanne, and much of his criticism heralds the preoccupation with formal structure that has characterized art in the twentieth century.

The Post-Impressionists, foremost among them Paul Cézanne (1839–1906) and Georges Seurat (1859–1891), were in search of models that would help them bring a new structure to art.[14] Reacting against what they considered a lack of organization in the painting of the Impression-

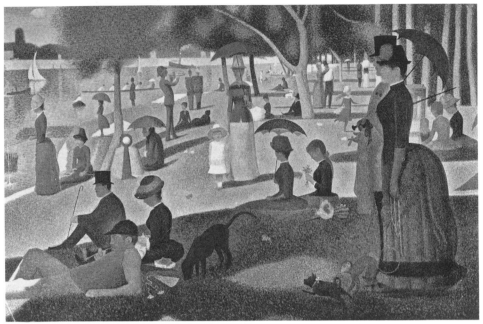

91. Georges Seurat, *Sunday Afternoon on the Island of La Grande Jatte,*
Art Institute of Chicago

ists, they strove, instead, for a new and more rigorous design. Piero was
a model for such aspirations, and his rediscovery during the last decades
of the nineteenth century must have been prompted by the artistic
climate that then existed. In fact, in 1879 copies of the Arezzo frescoes
were made for the chapel of the Beaux-Arts Academy, where Seurat had
enrolled just a year earlier. He must have studied these copies, or even
the originals themselves, because the stillness, tonal luminosity, and
structure of many of his pictures—including his masterpiece, *Sunday
Afternoon on the Island of La Grande Jatte* [91] of 1884–86—may well
depend, in part, on his knowledge of Piero's works.

Seurat's highly analytical approach to the structure of painting was
paralleled by Cézanne, a painter destined to exert an enormous influ-
ence on the subsequent history of Western art. Cézanne stated that he
wanted to "make of Impressionism something solid and durable, like
the art of the Museums" and that the cone, sphere, and cylinder should
be sought by the artist in nature. These sorts of rigorous, analytical
ideals were, of course, to be found in great measure in the newly discov-
ered work of Piero della Francesca, which offered a brilliant model of
reductive, painstakingly planned painting in which the structure was of
paramount importance.

Cézanne's late paintings, especially the great series of bathers [92],
are masterpieces of formal and tonal structure that are, in many ways,

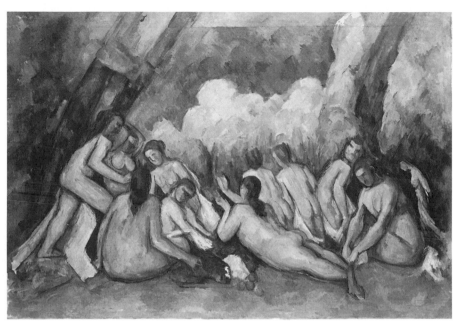

92. Paul Cézanne, *Bathers,* National Gallery, London

not dissimilar to Piero's analytically ordered works of form and color. Cézanne's and Seurat's quest for a new order was to have a major impact on the founders of Cubism, Braque and Picasso, and, hence, a decided role in the formation of the art of the late twentieth century. Of course, the ultimate Cubist reduction of the world to planes, junctures, and tone was an independent development, having only tenuous connections with the art of the past. Nonetheless, the development of both Post-Impressionism and Cubism reconfirmed, for modern eyes, the importance and worth of the newly rediscovered Piero della Francesca, whom the critic Adrian Stokes has hailed as "the first cubist." Piero's painting has, of course, nothing to do with Cubism, but the fact that it was so enthusiastically received during the first decades of the twentieth century (Roberto Longhi's extremely popular monograph on Piero was first published in 1927) clearly demonstrates that it embodied formal characteristics that were seen as prophetic and universal.

The clear, rational, abstracted structure of Piero's paintings so valued by the artists and public of the late nineteenth and early twentieth centuries is still appealing today. It is the aspect of Piero's art that our time has most prized and, because it so coincides with contemporary taste, it has exerted a considerable influence on both the art-loving public and the artist.

The modern taste for art without overt sentiment has also ensured

Piero's place in the pantheon of the history of art. As the reputation of and admiration for artists such as Perugino and Raphael—two near contemporaries of Piero whose paintings are often suffused with religious fervor—have diminished, more austere, less emphatic earlier artists, such as Piero della Francesca and Giovanni Bellini, have come into favor.

Ultimately, every period admires the art of the past that most fully embodies its own values and aspirations. Piero's structured, luminous, and analytical art is in many ways a mirror of ourselves or what we wish to become. It is not surprising, therefore, that the visitors' register of the Pinacoteca in Sansepolcro lists the names of so diverse an array of men and women; these are modern pilgrims, searching not for relics but for the *Resurrection* and the transcendental power of Piero's art.

NOTES

1. For artistic developments in Florence about 1430, see B. Cole, *Masaccio and the Art of Early Renaissance Florence,* Bloomington, 1980.

2. For artistic education in the Renaissance, see B. Cole, *The Renaissance Artist at Work,* New York, 1983.

3. For Luca Signorelli, see M. Cruttwell, *Luca Signorelli,* London, 1907; P. Scarpellini, *Luca Signorelli,* Milan, 1964.

4. For the youthful Michelangelo, see H. Hibbard, *Michelangelo,* New York, 1974; L. Murray, *Michelangelo,* New York, 1980.

5. The great study of Florentine drawing is B. Berenson, *Drawings of the Florentine Painters,* 3 vols., Chicago, 1938.

6. Local followers of Piero della Francesca: B. Berenson, *Italian Pictures of the Renaissance: Central and North Italian Schools,* 3 vols., London, 1968.

7. Vasari on Piero in Ferrara: G. Vasari, *The Lives of the Painters, Sculptors and Architects,* trans. by A. B. Hinds, London, 1966, vol. 1, p. 332.

8. Portraits of Giovanni and Ginevra Bentivoglio: F. Shapley, *Catalogue of the Italian Paintings,* Washington, D.C., 1979, vol. 1, pp. 406–7.

9. Giovanni Bellini and painting in Early Renaissance Venice: S. Freedberg, *Painting in Italy, 1500–1600,* Harmondsworth, 1975; J. Wilde, *Venetian Art from Bellini to Titian,* Oxford, 1979.

10. Antonello da Messina: G. Vigni, *All the Paintings of Antonello da Messina,* New York, 1963.

11. The standard Italian edition of Vasari's *Lives* is the edition by G. Milanese, *Vite de' più eccellenti pittori, scultori ed architettori italiani,* 9 vols., Florence. English translation of Vasari: *The Lives of the Painters, Sculptors and Architects,* 4 vols., trans. by A. B. Hinds, London, 1966.

12. J. A. Symonds, *Renaissance in Italy: The Fine Arts,* New York, 1888. Much of the criticism in this important but almost forgotten book is extremely perceptive and beautifully written.

13. Berenson's text on the central Italian painters can be most conveniently found in his *Italian Painters of the Renaissance,* London, 1959.

14. Post-Impressionists: J. Rewald, *Post-Impressionism,* New York, 1978.

Selected Bibliography

The following is a brief list of books in English; many of these works contain extensive bibliographies that will further guide the interested reader.

RENAISSANCE HISTORY

G. BRUCKER, *Renaissance Florence,* Berkeley, 1983. (A concise, general introduction to the many facets of Renaissance Florence.)

J. BURCKHARDT, *Civilization of the Renaissance in Italy,* New York, 1958. (Since its publication in 1860, the classic and seminal formulation of the Renaissance.)

B. BURKE, *Culture and Society in Renaissance Italy, 1420–1540,* London, 1972. (Important for the study of Renaissance patronage.)

D. HAY, *The Italian Renaissance in Its Historical Background,* Cambridge, England, 1977. (Brief but stimulating introduction.)

J. HOOK, *Siena: A City and Its History,* London, 1979. (A fine, readable introduction to medieval and Renaissance Siena.)

J. LARNER, *Culture and Society in Italy, 1290–1420,* London, 1971. (Much interesting material on art and artists in the Early Renaissance.)

RENAISSANCE ART

B. BERENSON, *Italian Pictures of the Renaissance: Central and North Italian Schools,* 3 vols., London, 1968. (This and the following entry are, along with volumes on Venetian pictures, Berenson's major contributions to the study of Italian art—that is, the reordering and clarification of Renaissance painting. Indispensable source books.)

————, *Italian Pictures of the Renaissance: Florentine School,* 2 vols., London, 1963.

B. COLE, *Italian Art, 1250–1550: The Relation of Renaissance Art to Life and Society,* New York, 1987. (Assays the types of Renaissance art and their relation to the society that produced them.)

————, *The Renaissance Artist at Work,* New York, 1983. (Artists' status, workshops, and productions.)

J. CROWE and G. CAVALCASELLE, *A History of Painting in Italy,* 3 vols., London, 1864–66. (Although written in the middle of the nineteenth century, still indispensable for the study of Italian Renaissance painting.)

s. FREEDBERG, *Painting in Italy, 1500–1600,* Harmondsworth, 1975. (The fundamental study of later Renaissance painting.)

J. HALE, ed., *A Concise Encyclopedia of the Italian Renaissance,* New York, 1981. (Much useful information on art and artists.)

F. HARTT, *History of Renaissance Art,* New York, 1987. (Substantial, perceptive survey of the entire range of Italian Renaissance art.)

J. POPE-HENNESSY, *Italian Renaissance Sculpture,* New York, 1985. (The standard, and most important, work on the subject.)

G. VASARI, *The Lives of the Painters, Sculptors and Architects,* 4 vols., translated by A. B. Hinds, London, 1966. (Vasari's lives of the artists are fundamental sources of information—and sometimes misinformation—and understanding of the Renaissance artist. The starting point for all serious investigation of the Renaissance artist.)

PIERO DELLA FRANCESCA

E. BATTISTI, *Piero della Francesca,* 2 vols., Milan, 1971. (A massive, scholarly compendium, especially useful for the documentation it contains.)

B. BERENSON, *Piero della Francesca or The Ineloquent in Art,* New York, 1954. (Brief, incisive discussion of the elements of Piero's art.)

K. CLARK, *Piero della Francesca,* London, 1969. (Perceptive, beautifully written, and evocative essay.)

R. LONGHI, *Piero della Francesca,* Florence, 1964. (First published in 1927, an important pioneering work. An inadequate English translation exists.)

P. MURRAY and P. VECCHIO, *The Complete Paintings of Piero della Francesca,* New York, 1967. (Like all the volumes in this series, a valuable source of information and photographs.)

INDEX

Note: Italicized page numbers indicate illustrations.